Marilyn

HER LIFE IN PICTURES

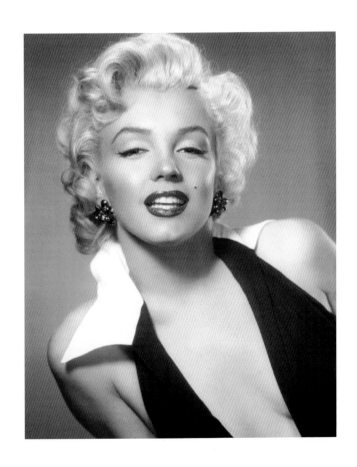

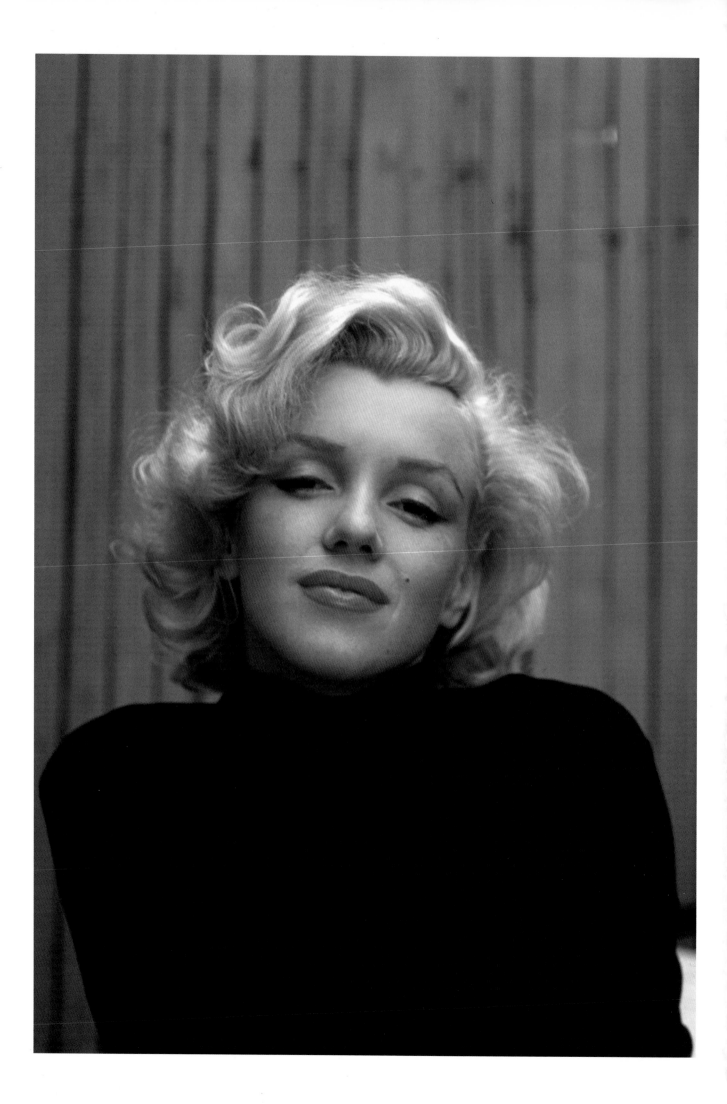

Marilyn

HER LIFE IN PICTURES

MARTIN HOWARD

CHARTWELL
BOOKS, INC.

First published by

CHARTWELL BOOKS, INC.
A Division of
BOOK SALES, INC.
276 Fifth Avenue Suite 206
New York, New York 10001

Copyright © 2013 by Greene Media Ltd.,
34 Dean Street, Brighton BN1 3EG

Cataloging-in-Publication data is available from the
Library of Congress.

ISBN-13: 978-0-7858-3050-4

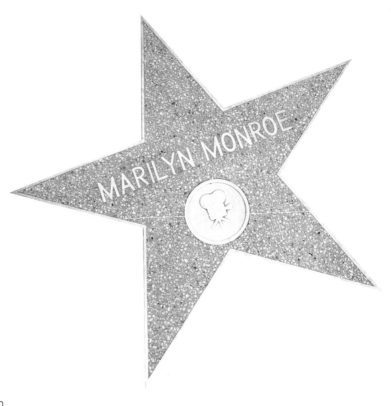

Designed by Danny Gillespie, Greene Media Ltd.

All Internet site information provided was correct when
provided by the Author. The Publisher can accept no
responsibility for this information becoming incorrect.

Printed and bound in China

PAGE 1: Marilyn photographed in 1953—this was a big
year for her as she starred in *Niagara*, *Gentlemen Prefer
Blondes*, and *How to Marry a Millionaire*.

PAGE 2: Marilyn on her patio at home in Brentwood,
California in May 1953.

ABOVE: Marilyn's Star on the Hollywood Walk of
Fame at 6901 Hollywood Boulevard was inducted on
February 8, 1960.

RIGHT: Marilyn in *The Asphalt Jungle*, 1950.

Contents

Introduction

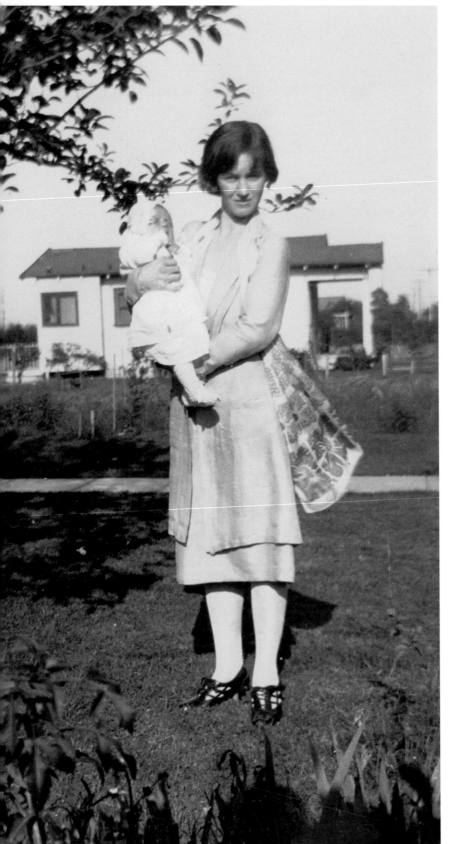

More than fifty years after her death Marilyn Monroe's name still regularly tops magazine and website lists of "world's sexiest women." Images of her are seen every day in the media, in poster stores, and hanging on a million walls around the world. She has even been brought back to computer-generated life for TV advertising campaigns. With every generation new fans become captivated by her story and the movies she made, ensuring that her fame never diminishes. Yet the history of Hollywood is littered with beautiful screen sirens, and tragic actors who died young. Why then, does Marilyn have such enduring appeal? The answer can perhaps be found in the recollections of her third husband, Arthur Miller. Looking back on the days of his early relationship with his yet-to-be wife, Miller says that "She was a whirling light to me then, all paradox and enticing mystery, street-tough one moment, then lifted by a lyrical and poetic sensitivity that few retain past early adolescence."

It's an illuminating observation, for what Miller found in Marilyn Monroe is what so many other people around the world have fallen in love with: a complex woman who often seemed to be a mass of contradictions. She was both the ultimate glamor-girl sex symbol and a vulnerable, fragile figure scarred by life; a curvaceous "dumb blonde" who was only the second woman in Hollywood to open her own production company and who told reporters that she wanted to film Dostoyevsky's *The Brothers Karamazov*. She was also the all-American girl who was once voted Miss Cheesecake and entertained troops in Korea but who was alleged to have Mafia connections and to have had affairs with both President John F. Kennedy and his brother Robert. As an actor, she was often dismissed by critics as a lightweight, yet she was serious about her craft, earning praise even from directors who had been tortured by her constant absence from set. Those who knew her tell of unexpected talents, such as a

ABOVE: Gladys Baker holding her infant daughter Norma Jeane., who was born at LA County Hospital on June 1, 1926, and was given to a foster family twelve days later.

OPPOSITE, ABOVE: Marilyn aged eleven months in April 1927. By this time she was fostered by Ida and Albert Bolender with whom she remained for seven years.

OPPOSITE, BELOW: Marilyn aged two.

flair for cookery (Marilyn's bouillabaisse was famous in Hollywood circles), her underlying sweetness, and a keen intelligence, yet she could be erratic, emotionally cold, and her behavior bizarre—she is reported to have enjoyed flaunting her nude body to strangers. In the few recorded interviews she gave, even her voice changes in tone from one moment to the next. The greatest paradox in her life, perhaps, is that she was known to countless millions around the world, and yet very few people—perhaps not even Marilyn herself—could claim to really know who she was. The reason for that lies in her formative years.

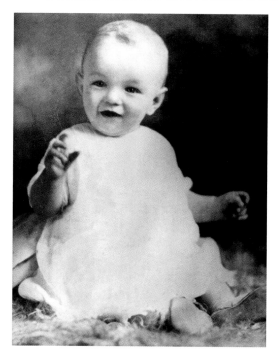

Marilyn was born on June 1, 1926, and proceeded to have the kind of childhood that could not fail to have repercussions in her later life. Confusion surrounded even her name. The third child of Gladys Baker (née Monroe), her birth certificate gave her name as Norma Jeane Mortensen (the Mortenson spelled wrongly) for the husband that Gladys had separated from before falling pregnant. However, her name was almost immediately changed to Baker, for her mother's first husband, while Gladys later told her young daughter that her father was a man called Charles Stanley Gifford, whose thin moustache made him look a little like Clark Gable. Little wonder then that Norma Jeane grew up fantasizing that Gable was her real father.

Unfortunately, the muddle over her name was only the beginning of Norma Jeane's problems. Her great-grandfather had mental difficulties that eventually led to suicide, her grandmother was bipolar, and her mother, too, was prone to mental illness. As well as being unstable, Gladys was a poorly paid film laboratory worker and financially unable to look after her new daughter (her other two children lived with their father in Kentucky) and the baby girl was placed with foster parents twelve days after her birth.

Albert and Ida Bolender lived in Hawthorne, California, close to Gladys's mother, Della. While they were decent, religious folk, and kind to her, they helped make ends meet by taking in other foster children. In all, as well as the Bolenders' own adopted son, thirteen foster brothers and sisters came and went during Norma Jeane's first seven years. The Bolenders were also quick to correct her if she ever made the mistake of calling them "mamma" or "daddy." Her first home then was one of brief, transitory relationships, and while her mother always paid the twenty-five dollars a month for her care and occasionally took her daughter on outings, Gladys remained a distant and somewhat frightening figure. During one episode of mental illness, Gladys tried to abduct her daughter from the Bolenders' care by zipping her in a duffel bag that Ida was forced to wrestle from her in the yard. Norma Jeane's grandmother, too, was known to cause upsetting scenes and, on one occasion, had tried to smother her infant grand-daughter with a pillow.

Nevertheless, in 1933, Gladys saved enough to buy a house close to the Hollywood Bowl and brought Norma Jeane to live with her. The arrangement lasted just three months. The deaths of Gladys's mother, grandfather, and son in quick succession, as well as a strike that left her without work or money, led to Norma Jeane's mother having a massive breakdown early in 1934. Gladys

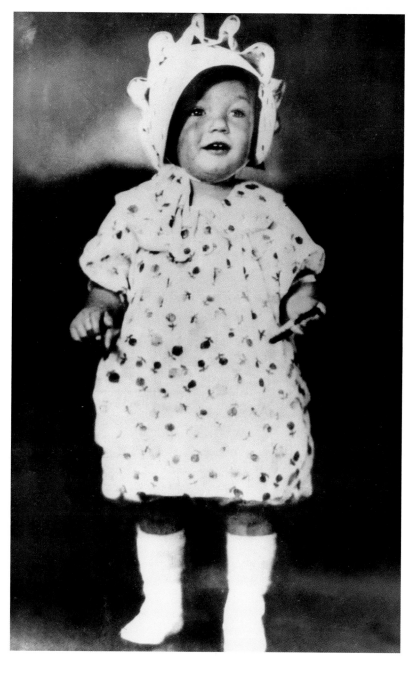

ABOVE: Norma Jeane Baker photographed in about 1938. Just behind her is Ana Lower—Aunt Ana—a family friend with whom she lived for a while.

was hauled away, screaming and laughing, before her daughter's eyes and Norma Jeane became a ward of the state with Grace McKee—Gladys's best friend—appointed her legal guardian.

Although no replacement for a loving family, Grace took her friend's daughter into her home and allowed her freedoms she had never had before, treating her with trips to beauty parlors, hairdressers, and to the cinema—sparking a lifelong love of the movies in her young ward. When she was alone, Norma Jean began to act out the parts she had seen on the screen and, in 1935, dropped the last "e" from her name as a tribute to her favorite actress, Jean Harlow. Happier times, however, were about to come to an end. In the same year, Grace McKee married Ervin Silliman Goddard, also known as "Doc." A distraught Norma Jean was sent to the Los Angeles Orphans' Home. She later recalled in an interview that, "They had to drag me in because I knew I wasn't an orphan." She also remembered that she could see the RKO studio through her window, and crying because her mother used to work there.

Although numerous couples were interested in adopting the now nine-year-old Norma Jean, Gladys refused to sign the papers, condemning her daughter instead to a succession of foster homes that Grace found for her before she and Doc Goddard reclaimed her in 1937. Again, the arrangement was short lived. It is thought that her stay with the Goddards came to an end because of Doc's attempts to molest Norma Jean. She was sent, instead, to stay with Grace's great-aunt, Olive Brunings, in Compton: another short-lived arrangement during which Norma Jean was beaten (and possibly sexually assaulted) by one of Olive's sons.

After years of living a peripatetic life, never knowing where she would be living next, in early 1938 some stability and kindness finally entered Norma Jean's life in the shape of another one of Grace's aunts. Ana Lower, or "Aunt

"I was brought up differently from the average American child because the average child is brought up expecting to be happy."

MARILYN

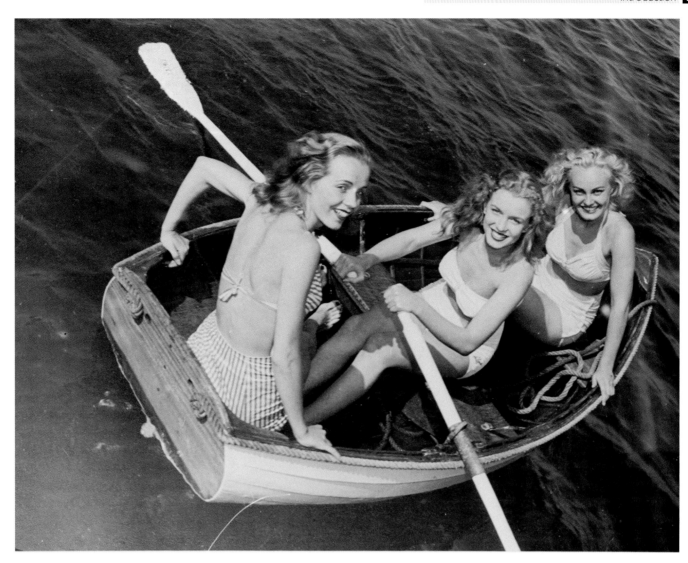

ABOVE: A photo taken in about 1941 of Norma Jean and friends enjoying a sunny day on the water.

Ana" as Norma Jean called her, was a devoted member of the Christian Science faith and a principled, kind woman. During the following years, until her health failed in 1942, she became the closest thing Norma Jean had ever had to a caring mother and provided much needed stability. Until the end of her life Norma Jean spoke of her Aunt Ana with great love.

Nevertheless, Ana Lower's care could not undo the damage of the years that had come before. Norma Jean had developed a delight in an inner fantasy world that revolved around Hollywood and the stars of the silver screen, but to most people she appeared quiet and shy. Her science teacher at Emerson High School later recalled that she was withdrawn, and her rather shabby clothes marked her out as different from her classmates. Despite the traumas of her life, Marilyn still managed to achieve steadily average grades. She was, however, extremely physical and enjoyed athletics (in the early 1940s she would even train with a former Olympic weight lifter).

As she entered her teens Norma Jean blossomed into an extremely attractive young woman, a fact that didn't escape the attention of the boys around her. By the time she reached the age of fifteen, she had developed a romance with a twenty-year-old man called Jim Dougherty. At the same time Ana Lower's health deteriorated badly and, consequently, Norma Jean was returned to the home of Grace and Doc Goddard. Goddard had, however, been offered a job in Virginia and the couple could not afford to take Norma Jean with them. Grace was also worried about having Norma Jean living beneath the same roof as her husband, who had already proved himself susceptible to her charms. Instead, Grace suggested a solution that she hoped would end her guardianship and extract Norma Jean from foster care once and for all: she would marry Dougherty.

Dougherty was quickly persuaded into the marriage by his mother and the couple were wed on June 19, 1942, just eighteen days after Norma Jean's

sixteenth birthday. Her dress was made by Aunt Ana and the Bolenders were also present as she changed her name once again. Gladys, sadly, remained in hospital.

Unsurprisingly, the marriage did not last. Although Jim Dougherty maintained until the end of his life that he and Norma Jean had been in love and that the studios had forced her to divorce him, in later life—by which time she had become Marilyn Monroe—his former wife said he had "bored" her. After marrying Dougherty she was obliged to quit high school and become an inept housewife. Though her husband was not an unkind man, he was a man of his age and ruled the roost in his own home. His new wife remained socially awkward around his family and friends and as she grew from a teenager into a young woman, she came to blame Grace Goddard for arranging the marriage for her own convenience. Although Norma Jean did not petition for divorce until 1946, the couple spent little time together during the four years they were married. In 1943, with World War II raging, Dougherty became a Merchant Marine and shipped out across the Pacific, leaving his wife living with his mother.

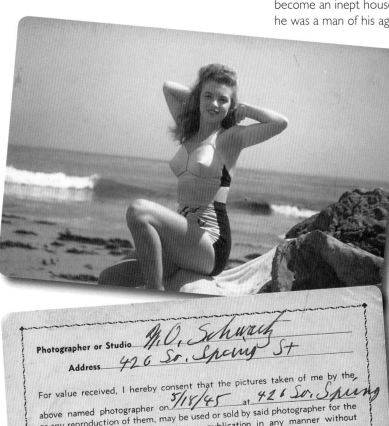

At around the same time, Norma Jean joined the war effort by starting work at the Radio Plane Munitions Factory. Her first job paid $20 for a gruelling sixty-hour week spraying fire retardant chemicals onto airplane parts and checking parachutes, but it also opened the door to her second job, which set Norma Jean on the road to international superstardom.

In 1944, Captain Ronald Reagan of the First Motion Picture Unit, sent his head photographer, David Conover, to Radio Plane to capture images of the work that women were doing to aid the war effort. There, Conover snapped some pictures of Norma Jean and, although they were never published, was impressed enough with the fresh-faced young brunette to advise she try a modeling career, suggesting the Blue Book Modeling Agency. She was accepted by Emmeline Snively, the agency's founder, who liked Norma Jean's clean-cut, wholesome appearance and set about teaching her how to carry herself, how to pose for the camera, and also told her how to modify her smile as it was slightly overshadowed by her nose. The result was a new, slightly tremulous smile that would later become a Monroe trademark. Emmeline also advised her new model to lighten her hair. For the first time, the girl who would become Marilyn Monroe became a blonde, though the striking platinum "bombshell" look was still some way off. For the time being she became a darker, golden blonde.

The camera loved Norma Jean, and so, too, did the Blue Book Modeling Agency's clients. As Snively later recalled, Norma Jean worked extremely hard and by 1946 she had become one of the agency's most popular models, featuring on the covers of numerous men's magazines. Her public profile rising, she was auditioned by the actor-turned-executive Ben Lyon for Twentieth Century-Fox (before 1985 the company name was hyphenated) in July of that year, who was impressed enough to call her back the following day for a Technicolor screen test. Comparing Norma Jean to her idol, Jean Harlow, he offered her a six month, $75 per week contract, with an option to renew at $125 per week. Shortly after, Lyon invited her to spend the weekend with himself and his wife. It was during this weekend that Norma Jean was discarded for good, and Marilyn Monroe was born.

Believing that the name "Norma Jean Dougherty" was lacking in star quality and sex appeal, Lyon was insistent on a change for his newest starlet.

ABOVE: An early photograph and signed model release form dated May 18, 1945. On August 2, 1945, as Norma Jeane Baker, Marilyn was signed up by Emmeline Snively of the Blue Book Modeling Agency. She quickly realized that blondes were most in demand, so she changed her hair color and became one of their most successful models, appearing on the cover of numerous magazines.

Norma Jean suggested her mother's maiden name—Monroe—and initially wanted to pair it with Jean, again in tribute to Harlow. Ben Lyon vetoed the idea, preferring "Marilyn" partly because he believed that alliterative names were lucky. Although she wasn't so keen, Norma Jean acquiesced. Soon after, James Dougherty returned home from the war to discover that the brunette housewife he had left behind had become a blonde pin-up girl with a brand new name. He also found divorce papers waiting for him to sign. Marilyn Monroe was now free to pursue the movie career she had dreamt of since Grace McKee began taking her to the cinema.

When Marilyn's contract ended, early in 1947, Twentieth Century-Fox renewed, which meant a weekly raise. More importantly for the young actress, she was given her first movie work in a couple of low-budget productions. Released later in 1947, the first—*The Shocking Miss Pilgrim*—was set in nineteenth century London and starred Betty Grable. Marilyn's role was unnamed and non-speaking. The second was a romantic comedy, released in 1948, called *Scudda Hoo! Scudda Hay!* The movie is unremarkable save for the fact that it contains the first line ever spoken by Marilyn Monroe on film: "Hi, Rad." A small part (as Eve, a dance hall employee) followed in 1948's *Dangerous Years*.

After these modest appearances, Twentieth Century-Fox allowed Marilyn's contract to lapse in July 1947. While still working as a photographic model, in March the following year she signed with Columbia Pictures—again on a wage of $125 per week—and was cast in a co-star role in a musical called *Ladies of the Chorus*, a movie she hated and which was mauled so badly by critics on its release that Columbia dropped her. She left the studio with her slight overbite corrected and having formed a bond with Natasha Lytess, Columbia's head drama coach. Lytess would, in future, be constantly at Marilyn's side on set.

BELOW: Raymond Burr, Marilyn, and Groucho Marx in a scene from the last Marx Brothers movie *Love Happy* in 1949. Marilyn had a 39-second walk-on part but was heavily used in the advertising and promotion.

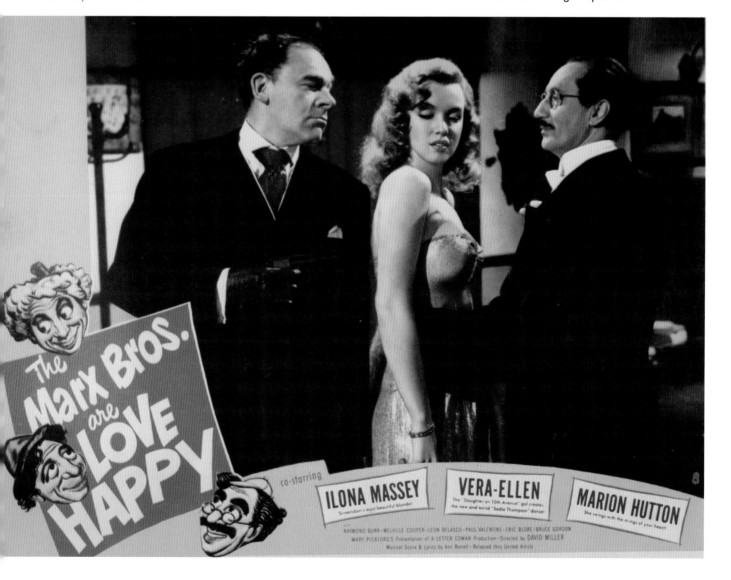

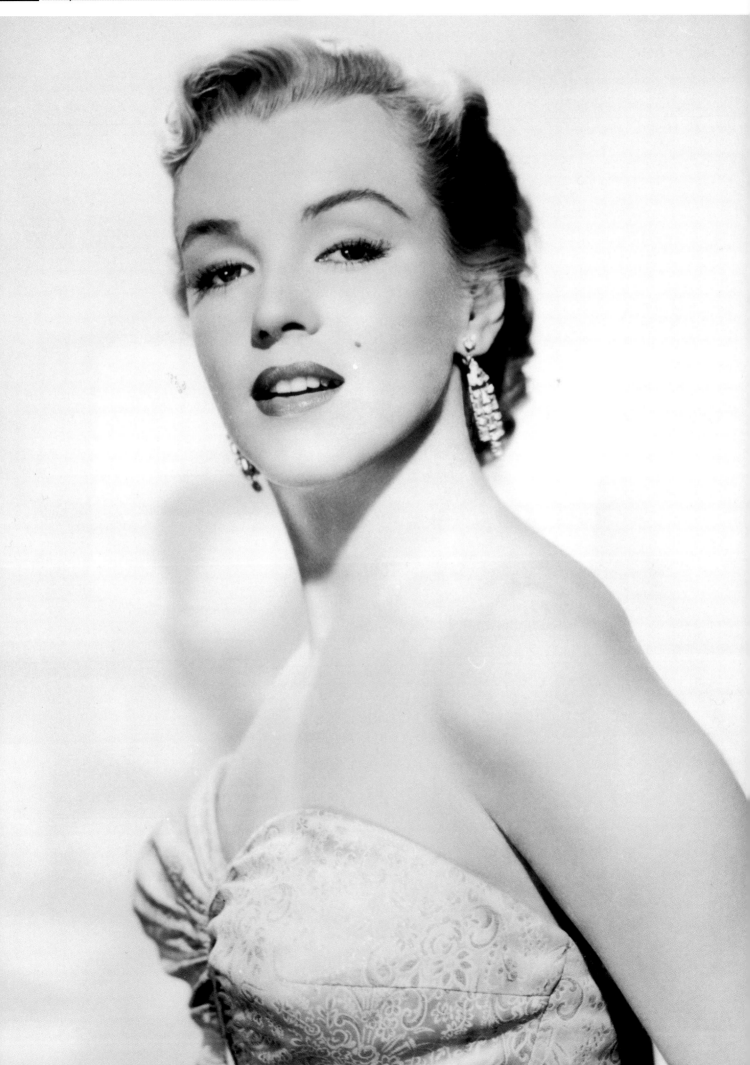

LEFT: A promotional still for the movie *All About Eve* in which Marilyn plays a starlet. Although the part was small she was an important member of the promotional campaign.

Notwithstanding a walk-on role in the Marx Brothers movie *Love Happy*, Marilyn was forced to rely on photo shoots to provide an income. Late in 1948, behind with her rent and in debt, she acceded to a request from photographer Tom Kelley that she pose nude. She was paid $50 for the shots, that would cause a minor scandal and serious concern at her studio when they resurfaced in 1952. Marilyn defused the situation brilliantly, winning public sympathy by explaining her financial struggles. She also famously joked, "It's not true I had nothing on. I had the radio on."

In December of 1948, Marilyn was the beneficiary of a great stroke of luck when she met the influential Hollywood agent Johnny Hyde during a modeling shoot at the Racquet Club of Palm Springs. Hyde was entranced and signed her up quickly, persuading Marilyn to have a minor surgical alteration made to the tip of her nose in early 1949. Both romantically and professionally smitten (Hyde would later leave his wife for Marilyn and propose to her, despite being thirty-one years older), he also started promoting her and landed her minor roles in three low-budget movies. In October, however, he scored a coup on her behalf: a speaking role as Angela Phinlay, the mistress of a crooked lawyer, in the John Huston movie *The Asphalt Jungle*. A film noir heist caper that was critically lauded and nominated for four Academy Awards, it considerably raised Marilyn's profile and provided a springboard for her career.

Her next role was one that arguably shaped her movie career, causing Marilyn to be frequently typecast as the sexy-but-stupid blonde. For Joseph Mankiewicz's *All About Eve* she was cast in a supporting role as Claudia Carswell, an aspiring actress, alongside Bette Davis and Anne Baxter in the lead roles. Her hair noticeably lighter than it had been in *The Asphalt Jungle*, Marilyn played the dumb blonde graduate of the "Copacabana School of Dramatic Art" to perfection and, although it wasn't a serious dramatic part,

BELOW: Out on the town, Marilyn with her husband—retired baseball legend Joe DiMaggio. They first met at Italian restaurant Villa Nova on Sunset Boulevard on March 8, 1952. DiMaggio proposed on December 31, 1953, and they married fourteen days later in a civil ceremony.

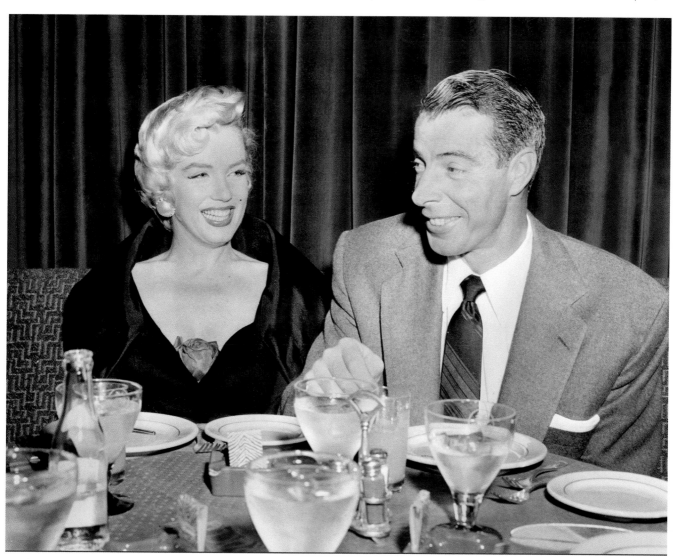

"Square-cut or pear-shaped, these rocks won't lost their shape. Diamonds are a girl's best friend."

LEO ROBIN

BELOW: Marilyn poses on a Singer automobile on the set of the romantic comedy *How To Marry A Millionaire* that was released in 1953.

she had more screen time and more lines than she had ever had before. Released in October, 1950, the movie was a massive hit with audiences and critics alike, and was nominated for an unprecedented fourteen Academy Awards (it won six). The film's success gave Marilyn's career the boost it had been waiting for: Hyde swiftly negotiated a contract for her with Twentieth Century-Fox , the studio that had dumped her three years previously.

Eight days after the new contract was signed, Johnny Hyde died unexpectedly, on December 18, 1950. Without her supportive agent helping to win her the best parts, Marilyn's career seemed to go into a brief slump. Although she was in the public eye as a presenter at the 1951 Academy Awards, the roles she secured were small parts in low-budget movies that made little impression at the box office. In the same year, the girl who had never graduated high school also enrolled for a literature and art appreciation course at the University of California, where she was so quietly studious that her teachers failed to even recognize her. One later remarked that he thought she had come "from a convent school."

The following year—1952—saw an upturn in Marilyn's fortunes. In April, she made the cover of *Life* magazine billed as "The Talk of Hollywood" in an issue that also ran a story called "There is a Case for Interplanetary Saucers." Movies in which she had worked for better directors and been given better parts were also released, including the Fritz Lang drama *Clash By Night* and —the most commercially successful—a Howard Hawks screwball comedy called *Monkey Business*. For the latter, she reprised the dumb blonde role, this time as a ditsy secretary alongside Cary Grant. She also, however, won her first starring role in a thriller that should have proved to the world that Marilyn had a wider artistic range. In *Don't Bother to Knock*, she played Nell, a

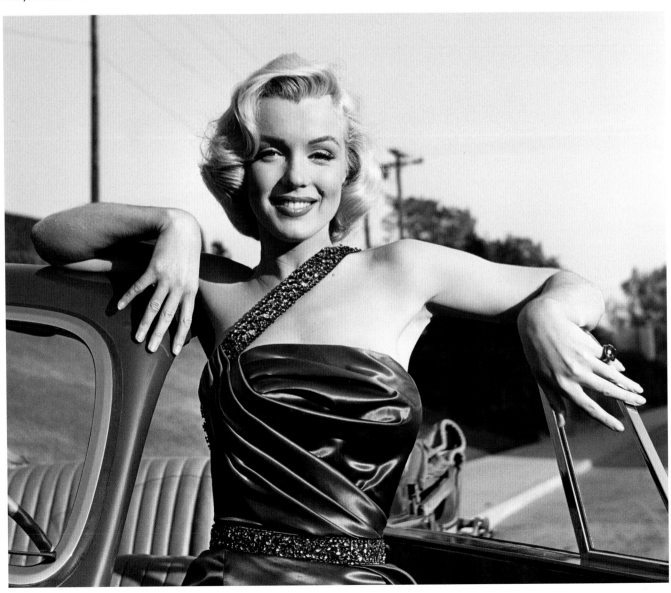

mentally unhinged babysitter. Unfortunately, what should have been a pivotal role turned out to be a disaster. With neither the director nor writer giving her any background for the character, Marilyn floundered. The critics panned the movie.

Even so, as 1953 dawned Marilyn's star had risen to new heights. By now she was dating baseball legend "Joltin' Joe" DiMaggio, much to the delight of the Press, and the parts she was being given were more substantial. That year saw the release of *Niagara*, a movie she had shot in 1952 and which saw her again in a lead role, this time playing the murderous and adulterous Rose Loomis in another noir thriller (unusually shot in Technicolor). This time, the critics were less brutal, with most reviews crediting it as a passably good movie before dwelling in rather more detail on Marilyn's physical attributes. The part was, however, an aberration in her career. Her following two movies—*Gentlemen Prefer Blondes* and *How to Marry a Millionaire*—returned her to the now-typical, dumb blonde role.

Although she was billed alongside Hollywood greats Betty Grable and Lauren Bacall in *How To Marry a Millionaire* and Jane Russell in *Gentlemen Prefer Blondes*, Marilyn stole both movies, her on-screen charisma putting her co-stars in the shade. The two films were thematically similar, both revolving around attempts to land a rich husband, but *Gentlemen Prefer Blondes* remains by far the most artistically satisfying of the two, and showgirl Lorelei Lee one of Marilyn's most iconic roles, rivaled only by Sugar Kane in *Some Like it Hot*. Paired with Jane Russell, with whom Marilyn would share a long friendship, the movie proved the perfect vehicle for the pair's onscreen chemistry. At first glance a straightforward musical comedy, in the expert hands of director Howard Hawks, *Gentlemen Prefer Blondes* also provided a subtle critique of 1950s gender roles. *How to Marry a Millionaire*, by way of contrast, was a more frivolous movie though Marilyn turned in a good performance as the amusingly near-sighted Pola Debevoise.

Critical considerations aside, both movies were massive box office hits, catapulting Marilyn into the Hollywood stratosphere. On June 26, 1953, she and Jane Russell added their hand and foot prints to the sidewalk outside Grauman's Chinese Theatre, and she was listed for the first time that year in the "Quigley Poll of Top Ten Money Making Stars."

After making two "blonde" movies in quick succession, Marilyn hoped that her next role would be more dramatically significant. Instead, Twentieth Century-Fox cast her in *River of No Return*, alongside Robert Mitchum (who, interestingly, had once worked with Marilyn's first husband, Jim Dougherty). Disappointed, Marilyn quickly fell out with director Otto Preminger and later described the movie as, "a grade Z cowboy movie in which the acting finished second to the scenery and the CinemaScope process." Next, the studio lined her up for the role of Jenny in the movie adaptation of the Broadway musical, *The Girl in the Pink Tights*. When Marilyn repeatedly failed to turn up on set, she was suspended.

On January 14, 1954, Marilyn Monroe married Joe DiMaggio at San Francisco City Hall. Mobbed by fans, the couple immediately flew to Japan for a honeymoon, where Marilyn received an invitation to perform for U.S. troops in Korea. Learning that his new bride would be performing close to the front line, which was still extremely dangerous despite the recent armistice, DiMaggio was reluctant. Marilyn, however, insisted, and arrived in

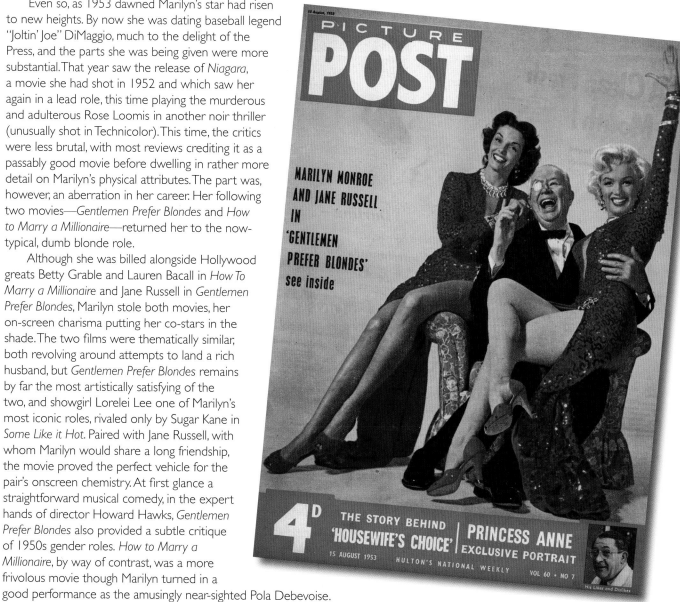

ABOVE: *Picture Post* cover for August 15, 1953. Taken while filming *Gentlemen Prefer Blondes*, it features Dorothy Shaw (Jane Russell) and Lorelei Lee (Marilyn) on either side of Sir Francis "Piggy" Beekman (Charles Coburn). The matching red sequin gowns were designed by Marilyn's favorite designer, Billy Travilla, who worked with her on eight movies.

"He treated me like something special. Joe is a very decent man, and he makes other people feel decent, too."

MARILYN

OPPOSITE, ABOVE: Marilyn and Joe DiMaggio leave San Francisco City Hall after their wedding on January 14, 1954. Although they divorced within the year they become good friends and remained fond of each other. DiMaggio reportedly proposed to her again just four days before she died.

OPPOSITE, BELOW: A tearful Marilyn is driven away by her lawyer, Jerry Giesler, after announcing her separation and application for divorce from Joe DiMaggio on October 6, 1954.

the war-battered country in February. Wearing just a tight, low-cut dress, she gave ten performances, singing and bantering with servicemen in sub-zero temperatures. She also posed for photographs with anyone who asked, and visited the wounded in hospital. In the words of one soldier, Marilyn Monroe "made thousands of GIs feel like she really cared." Always an extremely nervous performer, Marilyn later credited her live Korean performances with helping her develop a new confidence in her acting.

Rejoining her husband, Marilyn returned to California and patched things up with Twentieth Century-Fox, agreeing to appear in the musical *There's No Business Like Show Business* on the understanding that she would be awarded the female lead in director Billy Wilder's adaptation of the Broadway hit, *The Seven Year Itch*. Her instincts proved accurate. She had accepted the role in *There's No Business Like Show Business* under duress and the movie was a critical and commercial flop. *The Seven Year Itch*, on the other hand, was the perfect part for her. Cast as "The Girl" opposite Tom Ewell as a middle-aged publishing executive fantasizing about cheating on his wife, she was again playing her typecast role, but this time she was allowed to be more natural. The result was one of her finest performances and, in the scene where her skirt is blown up over a subway gate, one of movie's most iconic images. The film did well at the box office (taking an estimated $8 million) and won Ewell a Golden Globe for Best Actor. Less happily, the shoot also brought to a head simmering tensions between Marilyn and her husband. DiMaggio had always disliked Marilyn's reputation as a sex symbol and watching her film the skirt scene with Ewell over and over again infuriated him. The couple rowed openly that night and a few weeks later, in October 1954, announced their divorce. After just nine months, Marilyn's second marriage had collapsed.

At loggerheads with Twentieth Century-Fox and more determined than ever to take control of her own career, in December 1954, Marilyn formed a new company—Marilyn Monroe Productions—with her friend, the photographer Milton Greene. By now, she was spending most of her time in New York and, in February 1955, joined drama coach Lee Strasberg's Actors Studio. She had not, however, given up all her contacts in California, and the following month returned there to fulfill a promise she had made to the owner of the nightclub Mocambo in West Hollywood. Marilyn had told him that if he would book the African-American singer Ella Fitzgerald despite her color, she would take a front row seat every night. When Fitzgerald appeared, Marilyn was as good as her word, and helped bring the great jazz singer to a wider audience. As if to burnish her new, serious, credentials, in May Marilyn began secretly dating the playwright Arthur Miller who was ten years her senior, a respected intellectual, and married. This was reportedly a peaceful, happy period for Marilyn. Although she didn't make a movie all year, she enjoyed her life in New York, shopping, reading, studying, and visiting a therapist.

Despite the strained relationship between the actress and studio, at the end of the year, after protracted negotiations, Marilyn Monroe Productions concluded a four-picture deal with Twentieth Century-Fox, for which she would be paid $100,000 per movie. Marilyn would also have the right to reject scripts and directors and to work with other studios. Her first choice of picture was another adaptation from a stage production called *Bus Stop*. The filming process was very different from Marilyn's previous movies. Natasha Lytess was dismissed, to be replaced by Paula Strasberg (Lee Strasberg's second wife), and the chosen director was Joshua Logan who approved of the Strasberg's brand of "method" acting. In the picture she played Chérie, a talentless nightclub singer abducted by a headstrong and naïve young cowboy who believes he is in love with her. Although not the greatest of successes, the movie is notable for the quality of Marilyn's acting, which—at last— brought her some highly favorable reviews. As Bosley Crowther wrote in *The New York Times*, "Hold on to your chairs, everybody, and get set for a rattling surprise. Marilyn Monroe has finally proved herself an actress."

Between the completion of *Bus Stop* and the start of her next movie, Marilyn finally took the time to formally change her name from Norma Jeane Mortenson (as it was spelt on her birth certificate) to Marilyn Monroe, and —on June 29, 1956—she married the now-divorced Arthur Miller in a civil service that was followed two days later by a Jewish ceremony.

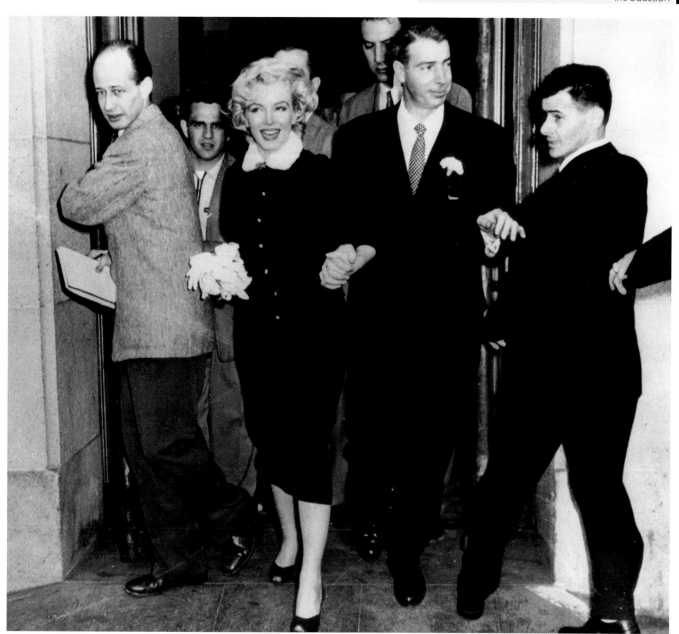

Two weeks later, amid a whirl of press
attention, the couple flew to England where
Marilyn had agreed to star in *The Prince and the
Showgirl* alongside Laurence Olivier in a movie
the great actor also directed. Whatever happiness
Marilyn might have felt at the time, dissipated
quickly. Racked by nerves at performing with
English Shakespearean actors, and alienated
by Olivier's strident direction, she turned to
prescription drugs and was frequently absent from
the set.

At the end of filming, Marilyn gave a heartfelt
apology to the crew for her behavior. Despite
the difficult shoot, she won plaudits for her
performance as showgirl Elsie Marina opposite
Olivier's Prince Charles of Carpathia, and was
nominated for awards in Britain, France, and
Italy. Olivier also praised her effusively though
she had driven him to distraction during filming.
Commercially, however, the movie performed
only moderately well, with some critics
complaining that it was slow and looked dated.

Marilyn would not set foot on a movie set for
more than a year. In the meantime, she and Miller
settled in a rented cottage in Amagansett, New
York. Amid turbulent times Miller began work
on *The Misfits*, while the couple tried to make
their marriage work. It wasn't easy. In early 1957,
Miller was repeatedly called before the House
Committee on Un-American Activities (HUAC)
and was eventually indicted for contempt in May.
Marilyn's relationship with Milton Greene broke
down, leading to her buying his share of Marilyn
Monroe Productions. On August 1, she suffered
the first of three miscarriages. She also found one
of her husband's notebooks, in which he wrote
of his disappointment in her during their time in
England. Marilyn was devastated. By now, she was
growing increasingly dependent on prescription
drugs to help her sleep.

The marriage limped on, however, and in
early 1958, Miller persuaded his wife to return
to the studio. One of her greatest successes had
been *The Seven Year Itch*, and the new project was
another Billy Wilder movie. Entitled *Some Like It
Hot*, it followed the adventures of two musicians
(played by Jack Lemmon and Tony Curtis)
attempting to escape a Chicago mobster by
dressing as women and joining an all-female band
for an engagement in Florida. Marilyn played Sugar
Kane, the band's singer and ukulele player.

Filming was a nightmare. Marilyn was
frequently absent and, often resorting to alcohol
and drugs to fight her nerves, wildly erratic.
Sometimes a complicated scene might be finished
in two takes. On other occasions she needed
up to sixty takes to deliver simple lines such as
"It's me, Sugar." Wilder swore he would never
work with her again (they later patched up their
differences) and her co-stars were often left
hanging around a hot set for hours in full make
up. Marilyn's relationship with Curtis in particular
suffered when she heard that he had joked that

ABOVE: A still from *Some Like It Hot.* Marilyn was Sugar Kane Kowalczyk, with Jack Lemmon (as Josephine) and Tony Curtis (as Daphne) playing two musicians on the run from the Mob

LEFT: Clad in a tightly fitted gown, Marilyn arrives at the Astor Theatre (now demolished) at 1531 Broadway, on March 9, 1955, for the benefit premiere of *East of Eden.* As part of the publicity Marilyn served as an usherette with the proceeds going to the Actors Studio.

kissing her was "like kissing Hitler" (even so, it is rumored that the pair had an affair on set and that the third of Marilyn's miscarriages was of Curtis's child).

Against all the odds, *Some Like It Hot* was a massive success, becoming one of the biggest hits of 1959 and, in time, a classic of the Golden Age of cinema. Shot in black and white, Marilyn lit up the screen at her incandescent best and won her first major American award—a Golden Globe for Best Actress in a Musical or Comedy. Every review glittered with praise.

As the new decade began, the gulf between Marilyn's public success and private pain had never been more yawning. A surgical attempt to help her carry a child to term failed, and her marriage was in terminal decline. She had begun daily psychiatric treatment with Dr. Ralph Greenson that included an attempt to wean her off drugs and alcohol. By this time, Miller had finished a screenplay for *The Misfits*, which he had written for his wife. John Huston had agreed to direct it and the movie had been cast. Plans to begin shooting were, however, upset when Twentieth Century-Fox demanded a new movie under the terms of their contract with Marilyn Monroe Productions. The result was *Let's Make Love*, a movie that only deepened Marilyn's depression. It was a lightweight confection of a movie that even Arthur Miller's rewrite could not greatly improve, and Marilyn was reluctant to work on it, though that did not stop her having an affair with her co-star, the French actor Yves Montand. Surprisingly, however, she was far more professional on-set than she had been for years.

In July, 1960, filming finally began on *The Misfits.* Also starring were Clark Gable, Montgomery Clift, and Eli Wallach, Miller had based aspects of the movie on his wife's life and the plot revolved around Marilyn's character, divorcee Roslyn Tabor, and her relationship with the three men, including the older Gay Langland, played by Marilyn's original fantasy father, Clark Gable. If the movie was semi-biographical it was hardly an exuberant celebration of Marilyn's life.

Again, the atmosphere on set quickly broke down, and this time it was not entirely Marilyn's fault. Shot on location in Nevada in summer, the heat was fierce and Huston drank, gambled, and was known to fall asleep on set. Marilyn's behavior certainly didn't help though. Away from her psychiatrist, her own drinking and drug use became heavier. Once again she became unreliable and sometimes failed to show up altogether. In August she was hospitalized with a mysterious illness that sent gossip columnists into a frenzy over her fragile condition. She returned to the set after ten days and finished the movie, but too much damage had been done to her relationship with Miller. The couple left Nevada on separate planes and a few days later Marilyn announced their divorce. Nine days after shooting finished, Gable died of a heart attack and the press was soon running reports that his widow blamed Marilyn for the stress she had caused on set, though Marilyn was later invited to his funeral.

The Misfits—Marilyn's last completed movie—opened in 1961 to mixed reviews and sluggish box office performance, though Marilyn gave an extraordinarily heartfelt performance in a complex role shot under extremely trying conditions. Nevertheless, it was hardly a fitting end to her career.

The remaining months of her life were marked by confusion. She was admitted to a mental hospital in February 1961, soon after her divorce was finalized, and "rescued" by Joe DiMaggio. Marilyn had known Frank Sinatra for years and while shooting *The Misfits* they had re-established their friendship. Now she became an unofficial member of his "Rat Pack", and—through Peter Lawford, another Rat Pack member and brother-in-law of President John F. Kennedy—was introduced to both the President and his brother, Attorney General Robert Kennedy. It is generally accepted that the President and the actress began an affair in 1961 and that Kennedy was only one of the numerous men that Marilyn was seeing.

At the beginning of 1962, she moved into the first house she had ever owned, bringing with her a white baby grand piano that had once been in the home she shared for a few brief months with her mother. In April, she started shooting a new movie, *Something's Got to Give*, opposite Dean Martin. She was, however, using prescription drugs almost constantly and, in now-typical Marilyn fashion, rarely showed up on set. The surviving footage —including a scene where she swims naked in a pool—shows her looking as beautiful as she had at any point in her career, but with a new fragility. Even so, her behavior was too much for Twentieth Century-Fox and when she showed up at Madison Square Garden in New York on May 19, to sing "Happy Birthday, Mr President" to Kennedy while claiming to be sick, the studio sacked her.

Marilyn was, again, devastated, and doubly so when Kennedy ended their affair shortly after. Now dependent on drugs it is thought that she sought solace in Bobby Kennedy and was also considering remarrying DiMaggio.

On the evening of August 4, 1962, Marilyn Monroe made a series of calls to friends. Reports are somewhat confused but the consensus is that as the evening progressed her voice began to sound more slurred. Later that night, she was found dead by her housekeeper, Eunice Murray, still clutching the telephone receiver. She was thirty-six years old. At 4.25 am on August 5, Dr. Greenson reported her death to the LAPD and her blanket-covered body was removed from the house amid the popping of Press photographers' flash bulbs. Attended by just a handful of friends and family, including her half-sister Berniece Miracle, Marilyn's funeral was held three days later.

Within days, the press began to report irregularities in the events surrounding her death, that had been officially recorded as suicide. Most prominent among them was the fact that the toxicology report showed massive levels of Nembutal and chloral hydrate in her system, but no sign of any pills in her stomach. The implication was that the drugs had been injected. Other vital evidence mysteriously went missing. Since then a plethora of conspiracy theories have been proposed, with the Kennedys, the Mafia, and Marilyn's doctors variously accused of her murder.

While it is most likely that Marilyn was so fuzzy on drugs that she did not realize she had taken far too many, the truth of Marilyn's death will probably never be known. What is certain is that her legacy is greater than the sum of its parts. She had starring roles in just a handful of movies, few of which can

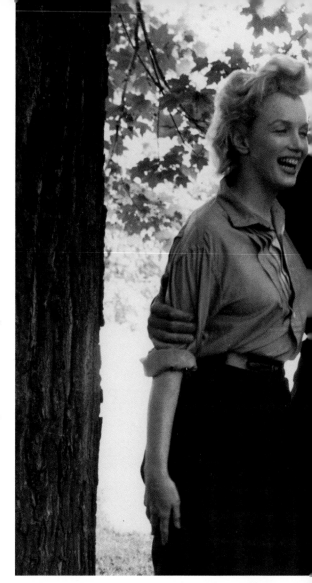

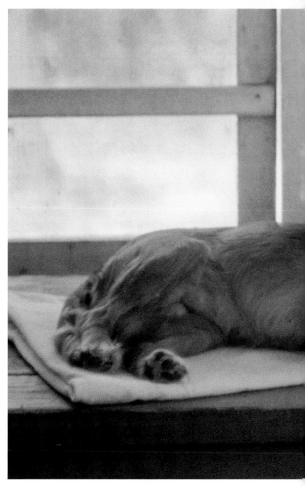

be described as "classics," yet she has come to embody an age of glamor as well as capturing the hearts and imaginations of millions who weren't even born when she died.

All that is left of her now are photographs and images on film, yet no-one before or since has been able to light up the screen in quite the same way. Marilyn herself was aware of it. Walking down a New York street with a friend once, he remarked that it was strange how no-one noticed that Marilyn Monroe was among them. In reply, Marilyn said, "Would you like to see *her*?" As if she had switched on an inner light, a transformation took place. People stopped to stare. Within minutes she was mobbed. Other friends, photographers, and movie makers also remarked on the fact that she was naturally unassuming, but that when a camera was pointed at her, she seemed to instantly become a different, dazzling, person. Maybe, then, in some strange way, the images are the real Marilyn.

LEFT: Marilyn and her husband, playwright Arthur Miller, out for a walk near his home in Roxbury, Connecticut, on July 2, 1956, a few days after their wedding. They had been dating since May 1955.

BELOW: Marilyn cuddling up to a small dog during shooting of *The Misfits* on location in the Nevada Desert, 1960. She was frequently unwell throughout the shoot and her co-stars Montgomery Clift and Clark Gable also suffered poor health.

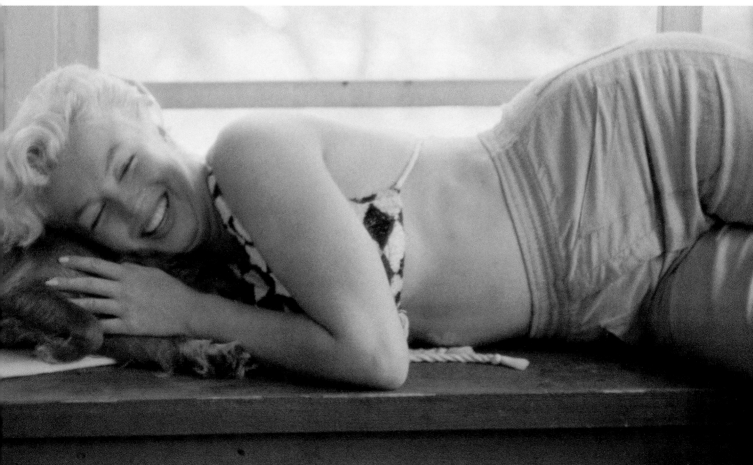

The Early Years (1926–1946)

Born on June 1, 1926, to a single mother with little money and a family history of mental illness, Norma Jeane's early life was often difficult and saw her shuttled between numerous foster homes and the orphanage. By the time she entered an arranged marriage a few days after her sixteenth birthday she had almost certainly been sexually abused and the rest of her life would be blighted by emotional problems and bouts of erratic behavior.

Her childhood also gave her a rich inner fantasy world, and, growing up in and around Hollywood, the young girl dreamed of emulating the glamorous stars of the screen, particularly her heroine: Jean Harlow. Fantasy began to turn into reality in 1944 when she was spotted by a photographer while working at Radio Plane Munitions Factory, and she signed with the Blue Book Modeling Agency soon after. The brunette became a blonde and over the next two years she graced the covers of magazines with names like *Cheesecake* and *Glamorous Models* (which featured "the world's most alluring girls").

"I knew I belonged to the public and to the world, not because I was talented or even beautiful, but because I had never belonged to anything or anyone else."

MARILYN

Timeline 1926–1946

1900

Gladys Monroe, Marilyn's mother, born to Otis and Della Monroe.

1919

July 30 Berniece Baker (Marilyn's half sister) born.

1924

October 11 Marriage of Edward Mortenson to Gladys Baker.

1926

June 1 Norma Jeane Mortenson born at LA County Hospital. By this time, Gladys's husband has left her and the child is probably not his.

June 13 Gladys gives her daughter over to a foster family, Albert and Ida Bolender, where she will stay for the next seven years.

1935

January Gladys is committed to Metropolitan State Hospital in Norwalk, LA County, with a diagnosis of paranoid schizophrenia."

June 1 Gladys's close friend Grace McKee becomes the court-appointed guardian to Gladys, and Norma Jeane's guardian.

June Grace McKee marries Ervin Silliman Goddard aka "Doc."

September 13 Norma Jeane enters the Los Angeles Orphan's Home.

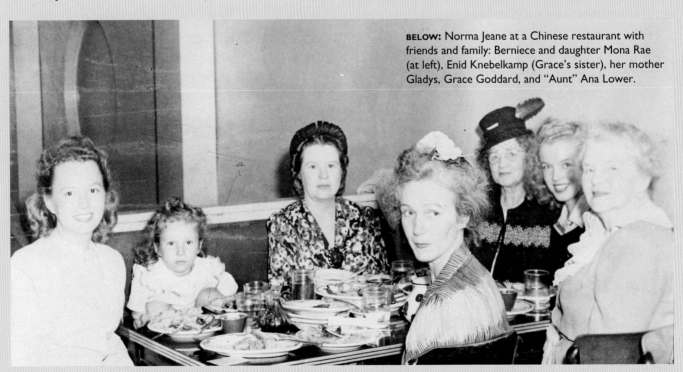

BELOW: Norma Jeane at a Chinese restaurant with friends and family: Berniece and daughter Mona Rae (at left), Enid Knebelkamp (Grace's sister), her mother Gladys, Grace Goddard, and "Aunt" Ana Lower.

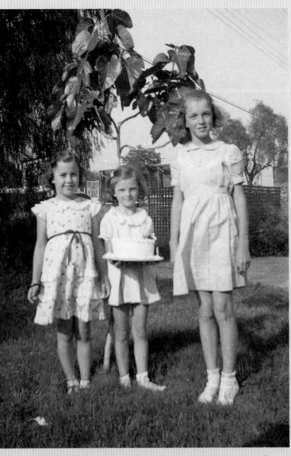

ABOVE: Norma Jeane Baker (right), with two small friends and a birthday cake, around 1936.

1937

June 26 Norma Jeane leaves the orphanage to live with Grace McKee.

1942

June 26 Grace and Doc move to West Virginia .

June 19 Norma Jean marries James E. Dougherty to enable her to stay on the West Coast.

1943

Dougherty enters the US Merchant Marine and after basic training is stationed on, Catalina Island. He and Norma Jean move into an apartment.

1944

April 18 Dougherty is sent to the South Pacific. Norma Jean moves in with her mother-in-law, Ethel, and gets a job at Radio Plane Munitions Factory in Burbank

1945

June 26 David Conover, on an assignment for *Yank* magazine, the Army weekly, photographs Norma Jean.

August 2 Norma Jean signs with the Blue Book Modeling Agency and leaves the Radio Plane Munitions Factory.

December Norma Jean has her hair bleached for a hair salon advertisement.

1946

July 19 First screen test for Twentieth Century- Fox.

August 26 First studio contract with Fox, at $75 a week.

Marilyn's Mother

Movie technician Gladys married Edward Mortenson on October 11, 1924. Norma Jeane Mortenson was born at LA County Hospital on June 1, 1926. By this time, Gladys's husband had left her and the child was almost certainly not his. Gladys would have a history of mental issues but outlived her daughter, dying on March 11, 1984, in Gainesville, Florida, aged eighty-one years.

LEFT: This photograph shows sixteen-year-old Gladys Pearl Monroe. Born in 1900 to Otis and Della Monroe she became Gladys Baker when she married Jasper Baker in May 1917. They divorced in May 1923.

BELOW: Gladys divorced Edward Mortenson on June 1, 1927. This photo, taken around 1929, shows Norma Jeane (below right) and her mother Gladys Baker (above right) with sister-in-law Olyve and her daughter Ida Mae.

RIGHT: Gladys in the 1920s.

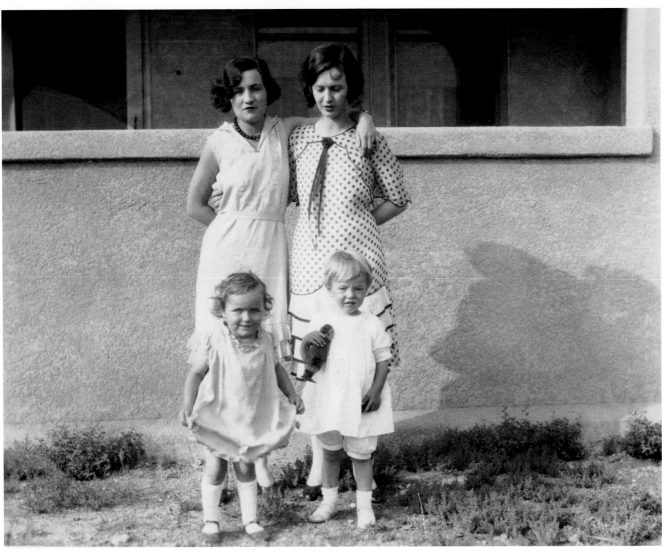

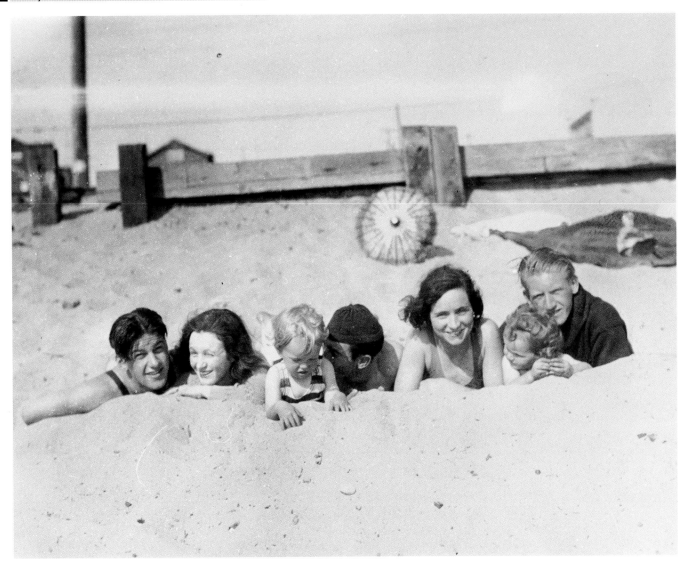

On The Beach

Well when you're in Santa Monica, where better to take the kids? Norma Jeane was fostered to Ida and Albert Bolender from 1926 to 1933. They lived in Hawthorn, CA, but Gladys saw her daughter regularly, staying when she came at weekends. One such time was in 1928 when Gladys, her brother Marion, his wife Olyve, and their daughter Ida Mae went to the beach with friends.

"I learned also that the best way to stay out of trouble was by never complaining or asking for anything."

MARILYN

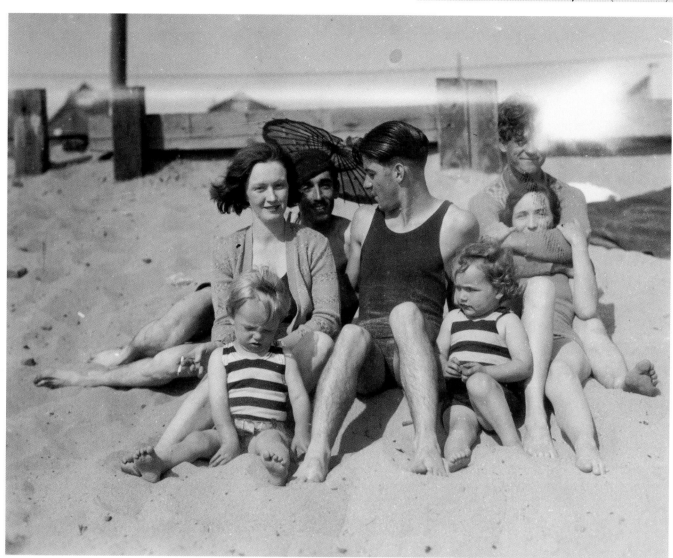

Norma Jeane loved animals, particularly dogs. Albert Bolender gave her the black and white Tippy who was later shot by a neighbor. When she lived with the Goddards she had a spaniel, and Jim Dougherty bought her a dog named Mussie.

Marriage

Norma Jeane's troubled childhood ended abruptly on June 19, 1942, a short time after her sixteenth birthday. By this time living with Grace and "Doc" Goddard, when they moved to West Virginia, Norma Jeane married Jim Dougherty so that she wouldn't have to move back to the orphanage. The wedding invitations were sent by "Aunt" Ana Lower—who also made the wedding dress—and the service itself was celebrated at the home of Chester Howell, an attorney friend of Grace, with Reverend Benjamin Lingenfelder, from the Christian Science Church, officiating. Best man was Jim's brother, Marion, and although her mother couldn't attend, the Bolenders were there. After a honeymoon weekend fishing beside Sherwood Lake, they moved into their first home in Sherman Oaks, CA.

"The first effect marriage had on me was to increase my lack of interest in sex …Actually our marriage was a sort of friendship with sexual privileges."

MARILYN

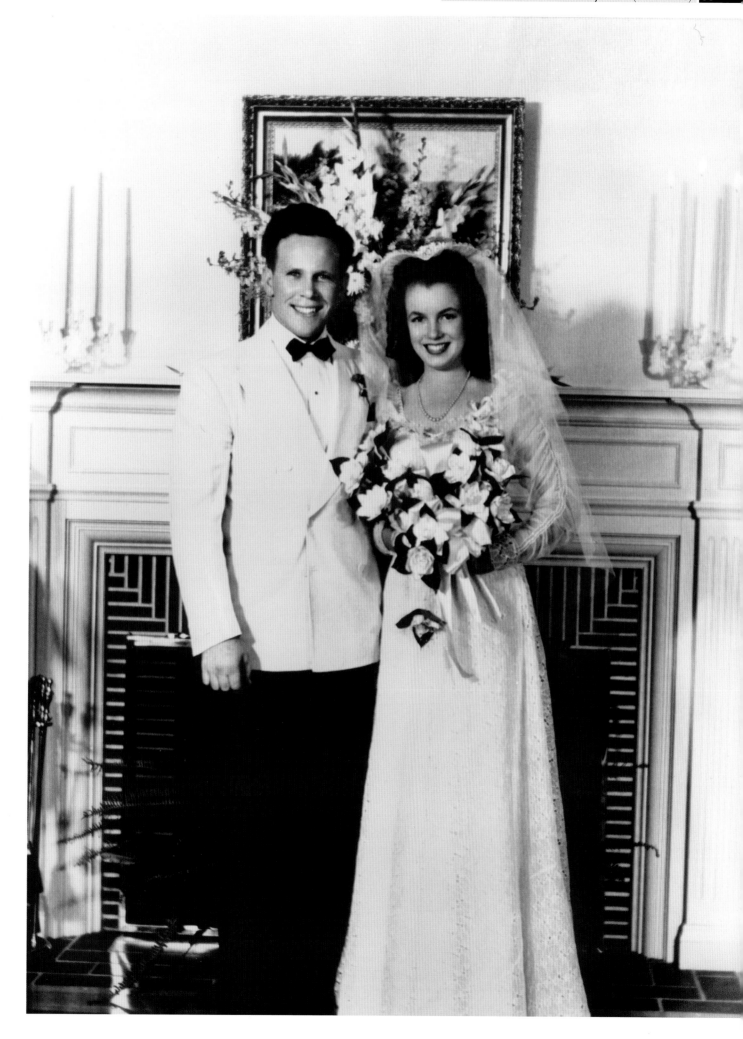

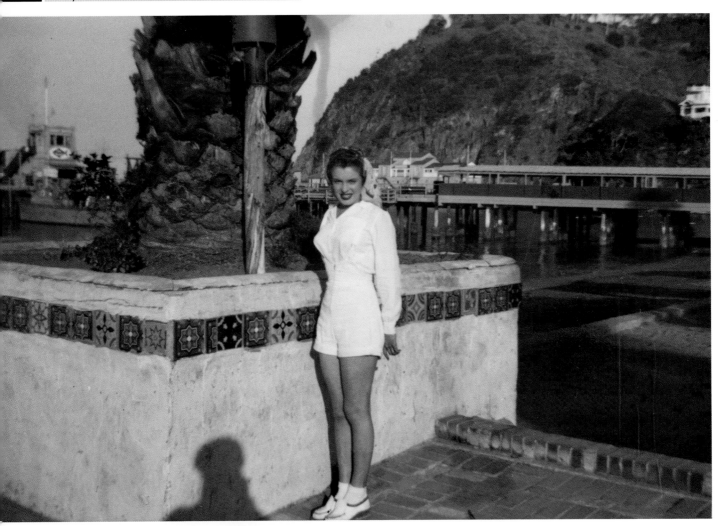

Avalon, Santa Catalina Island

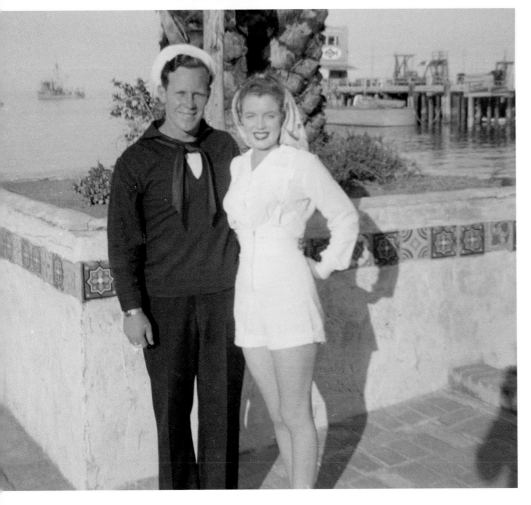

In 1943 Dougherty entered the US Merchant Marine and was stationed on Catalina Island off the state of California. He and Norma Jeane moved into an apartment. These photographs were taken at that time and show well-known Catalina sights in the background—the famous green pleasure pier (this page) and the Avalon Casino (right). Norma Jeane took the opportunity to enjoy the outdoor life and keep fit—she studied weightlifting with a former Olympic champion named Howard Corrington.

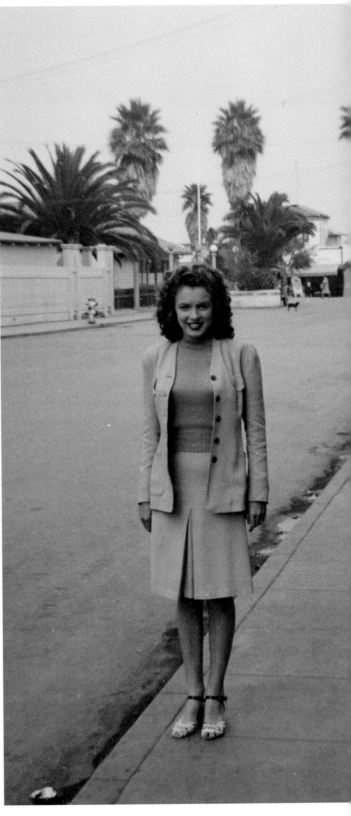

ABOVE AND ABOVE RIGHT: Norma Jeane Dougherty out and about on Catalina Island. Here she is seen in a smart outfit talking to a Mrs. White and her baby. She was a regular babysitter while on the island to earn some spending money. The Catalina Island Museum showcases Norma Jeane's life on the island, and mentions a letter she wrote to Berniece in which she remembered visiting the island—and the island casino—with her mother when she was seven, going on to say "at Christmas time, the Maritime Service held a big dance at the same Casino and Jimmie and I went. It was the funniest feeling to be dancing on that same floor ten years later, I mean being old enough and everything." By all accounts, she was the belle of the ball and Dougherty was rather jealous.

RIGHT: The dark-haired, teenaged, Norma Jeane waiting for stardom. Ten years later, in a 1952 *Life* magazine article, she remembered, "I was a child nobody wanted. A lonely girl with a dream—who awakened to find that dream come true."

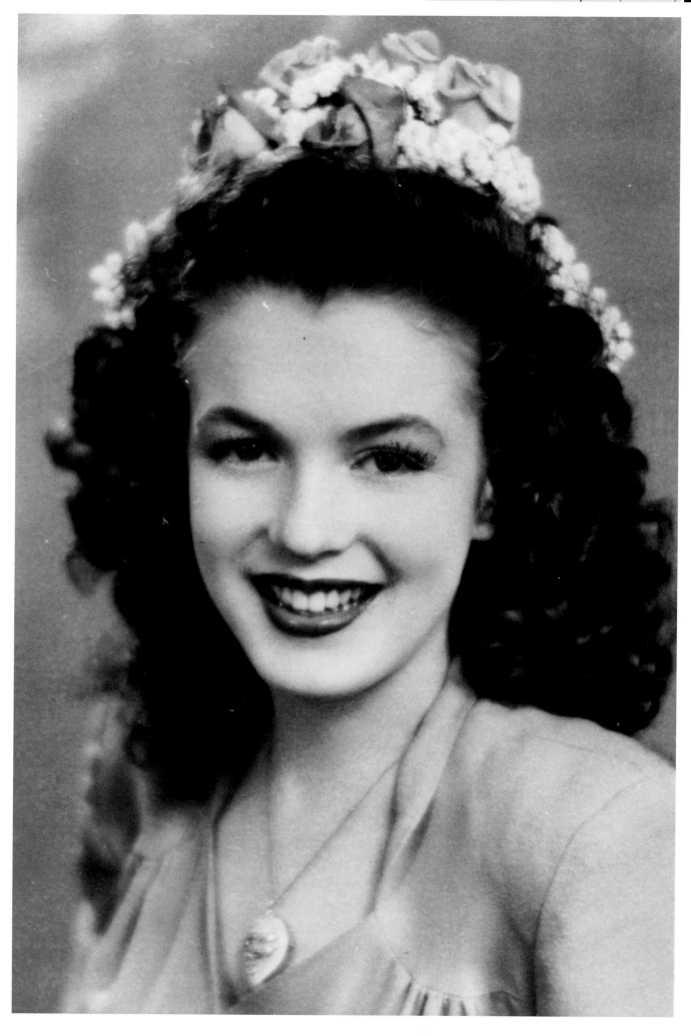

At the Zoo

Norma Jeane first went to the zoo on Catalina Island when she was seven, with her mother. She returned as a young married woman in 1943. She and Jim made a number of friends on the island—particularly the Whites (see page 36) and the Gaddis family: indeed, Jim became godfather to James Edward Gaddis, seen at left. Soon, however, as the war moved into 1944, more men would be needed in the Pacific, and Jim was one of them.

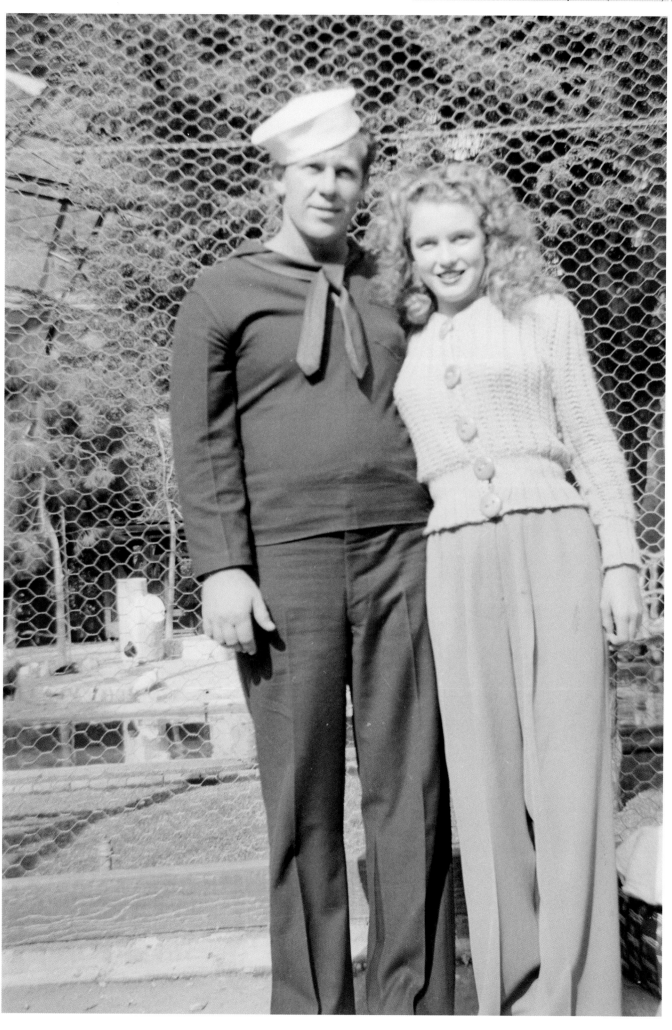

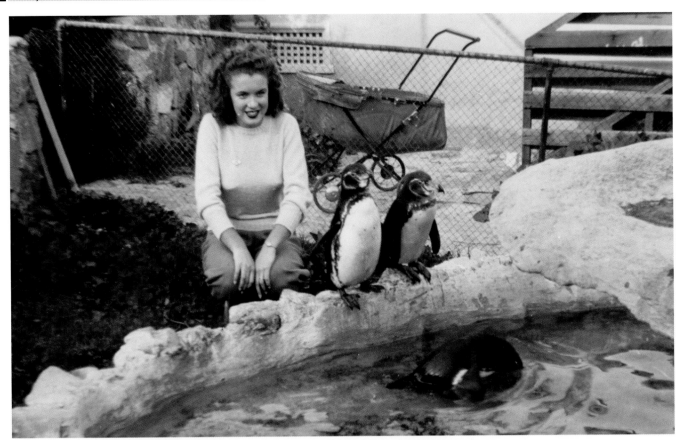

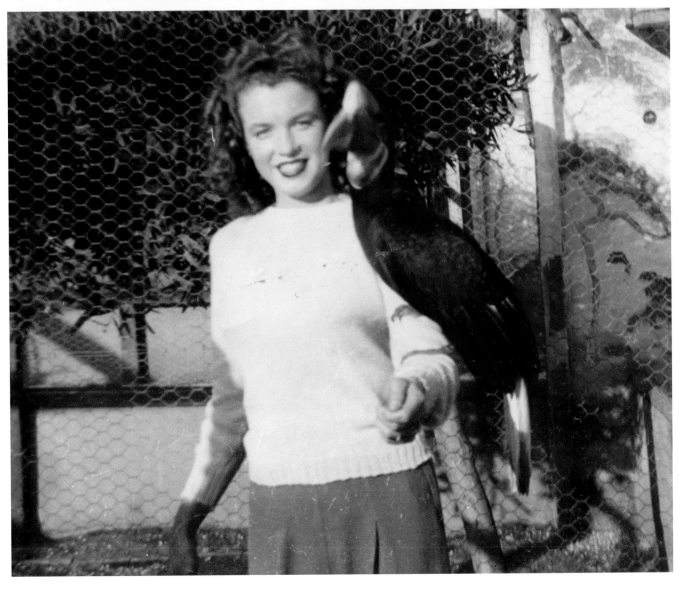

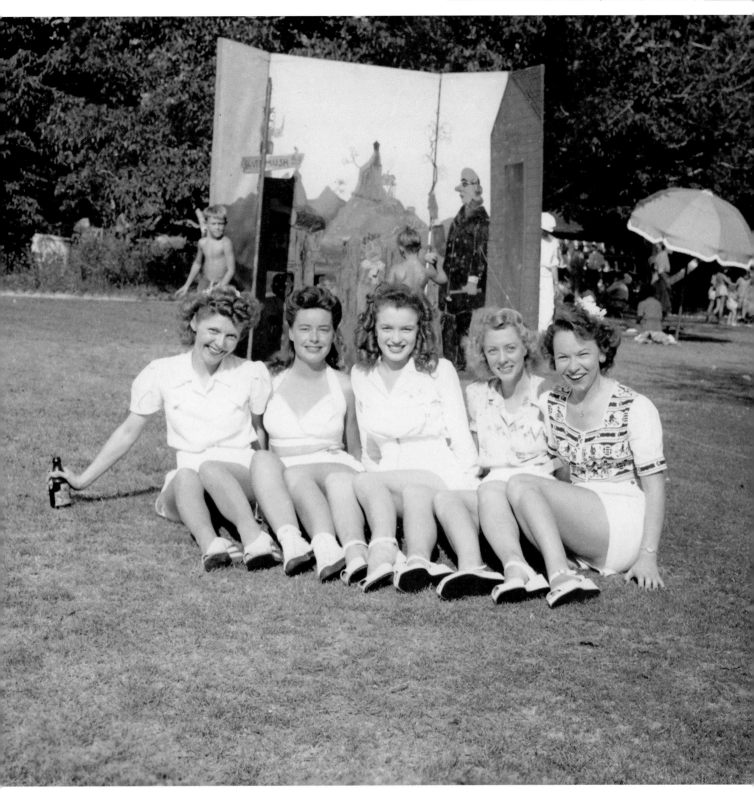

Radio Plane
Munitions Factory

On April 18, 1944, Dougherty was sent to the South Pacific.
Norma Jeane had to move back to the mainland, where she
went to live on 5254 Hermitage Street, North Hollywood with
her mother-in-law, Ethel. She got a job at Radio Plane Munitions
Factory in Burbank earning $20 a week. Here (above) she is seen
with some of her fellow workers from the factory at a picnic
in Balboa Park, San Diego, CA. It was at the factory on June 26,
1945, that David Conover first photographed Norma Jeane.

*"There was a luminous
quality to her face, a
fragility combined with
astonishing vibrancy."*

DAVID CONOVER

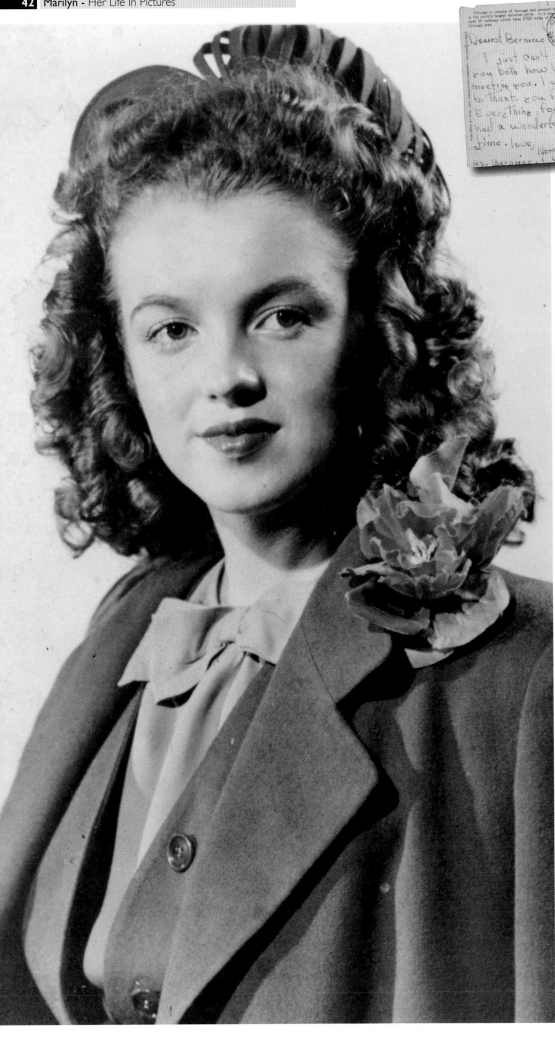

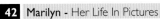

Summer Holiday

In the summer of 1944 Marilyn visited her relations—her foster sister, "Bebe" Goddard, in Huntington, VA, and met her half-sister Berniece for the first time. She wrote to Berniece when she got home and the postcard (above), addressed to Mr. and Mrs. Paris Miracle, postmarked October 28, 1944, survives. Little did Norma Jeane know that her life was about to change and that the pretty teenager would soon be on the path to stardom. After she returned to work, in the fall, she was approached by *Yank* photographer David Conover, who took photographs of her at work. Later, in early 1945, he took more images of her, all around California.

William Carroll

As fresh as the day they were taken in July 1945 ... Here (right and overleaf) is Norma Jeane Dougherty, a beautiful nineteen-year-old, photographed by William Carroll in Castle Rock State Park, CA. Norma Jeane received $20 and Carroll took over a hundred pictures, some of which went towards an advertising campaign. Carroll had discovered Norma Jeane through his friend, David Conover.

"I used to think as I looked out on the Hollywood night, there must be thousands of girls sitting alone like me, dreaming of becoming a movie star. But I'm not going to worry about them. I'm dreaming the hardest!"

MARILYN

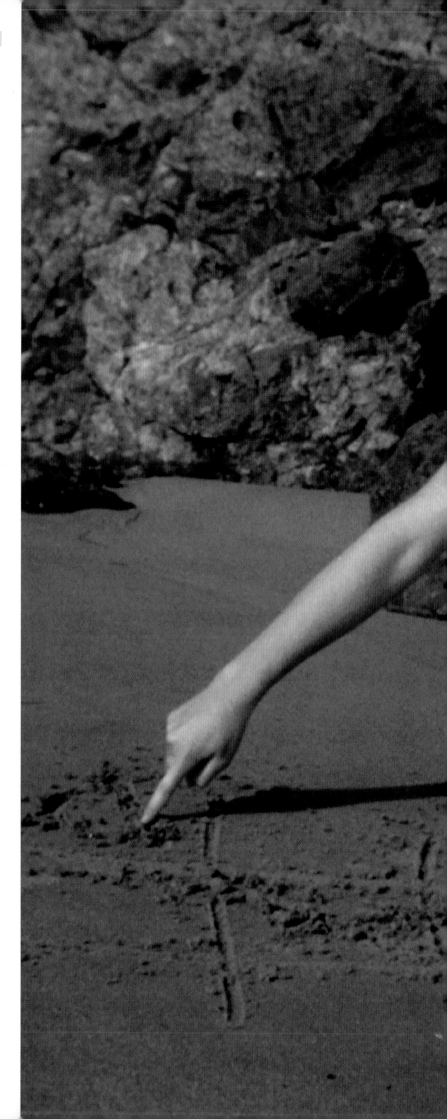

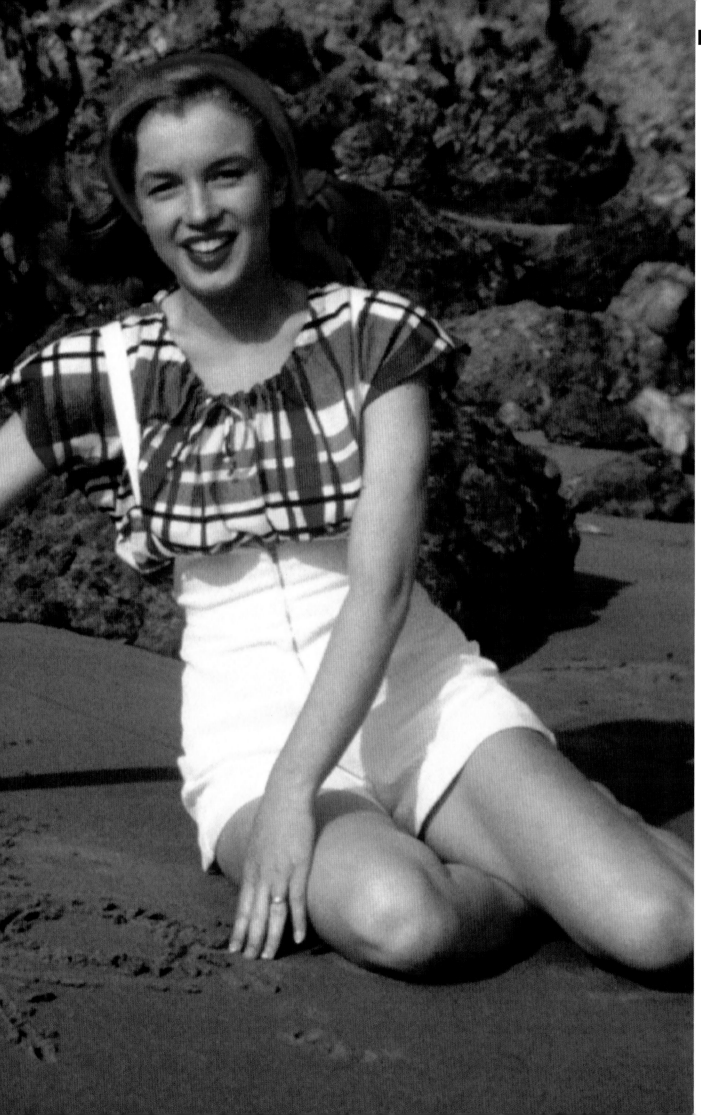

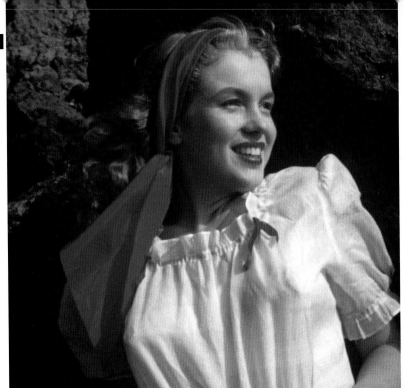

"Norma Jeane was a good model and a friendly person with whom to share a hamburger."

WILLIAM CARROLL

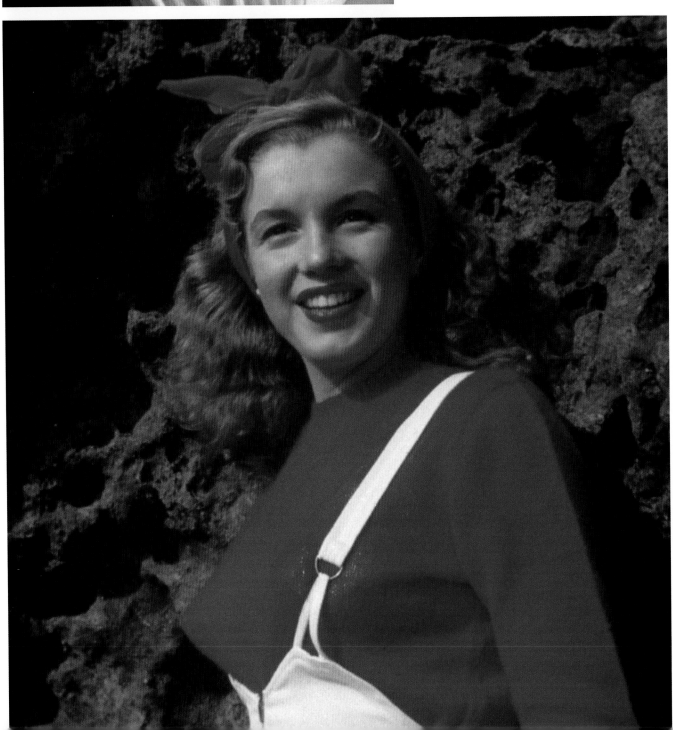

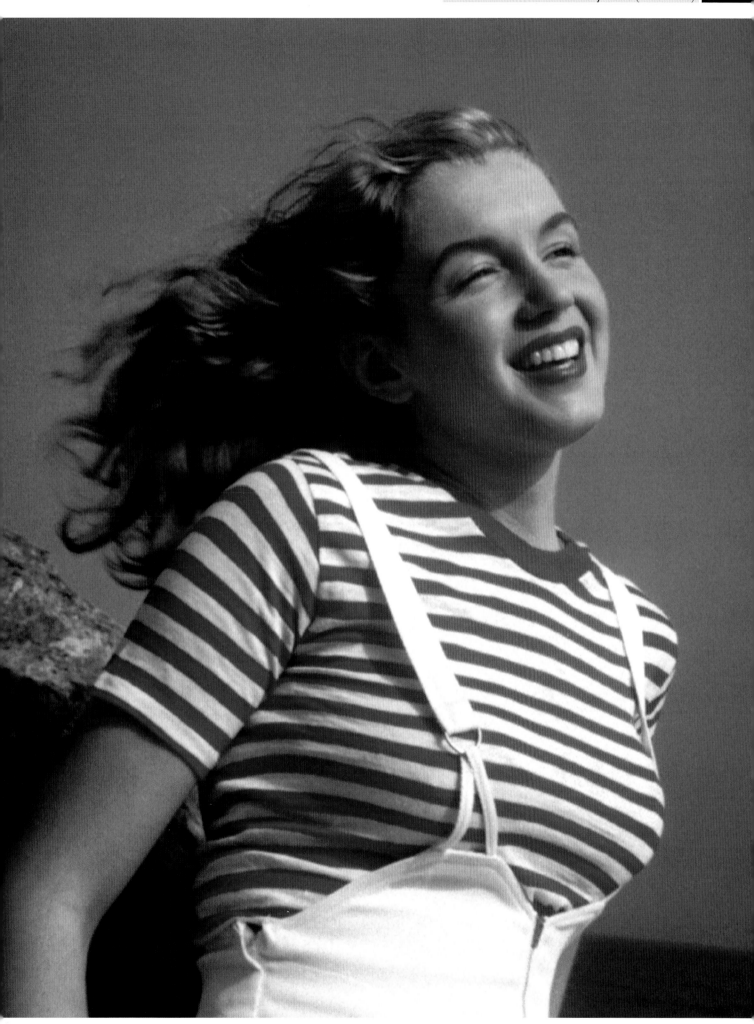

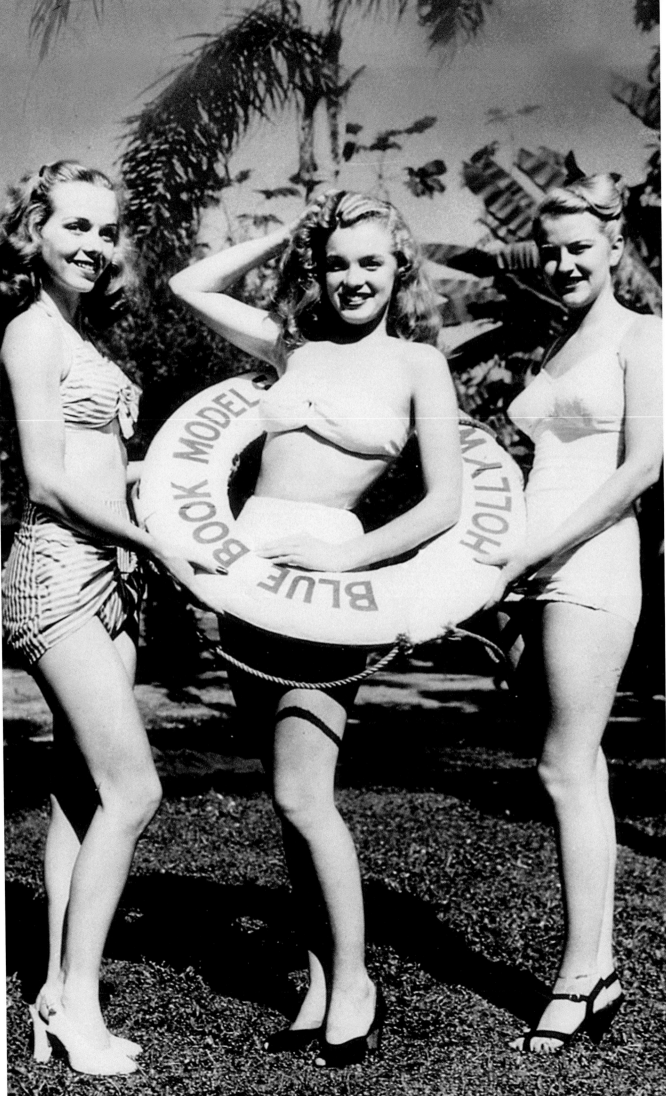

Blue Book Modeling

David Conover's enthusiasm for his new young model led him to show her photographs to William Carroll and others, including Potter Hueth, a commercial photographer who knew Emmeline Snively of the Blue Book Modeling Agency. On August 2, 1945, Norma Jeane signed up with the agency, and left the factory in Burbank. Soon after she would go blonde and success was around the corner. In 1946 she and Jim were divorced and she threw herself into her modeling career. She had the world at her feet.

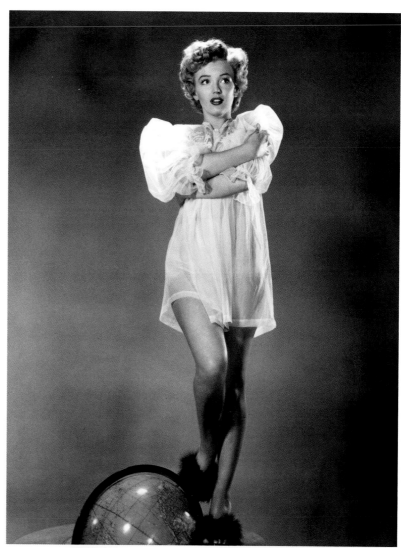

RIGHT: Marilyn with the world at her feet—a 1952 photo by Frank Powolny.

BELOW: Norma Jean (at extreme left) sitting on a table next to Joan Caulfield and four other young women at the KFI Camera Clinic in 1946. Sent there by the Blue Book agency, the talk was on photo-artistic techniques.

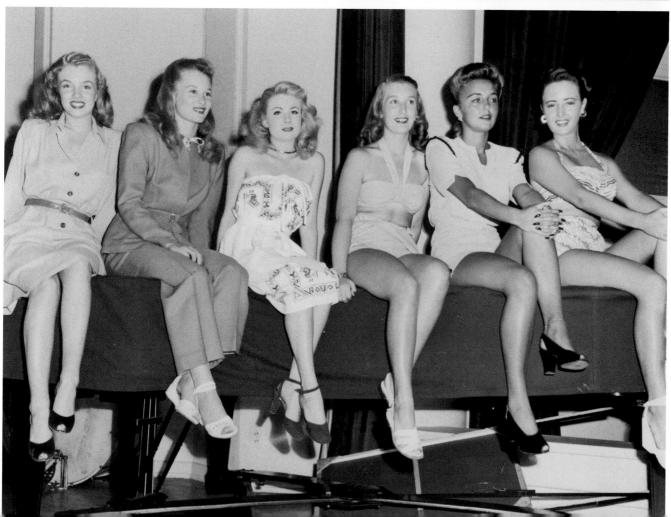

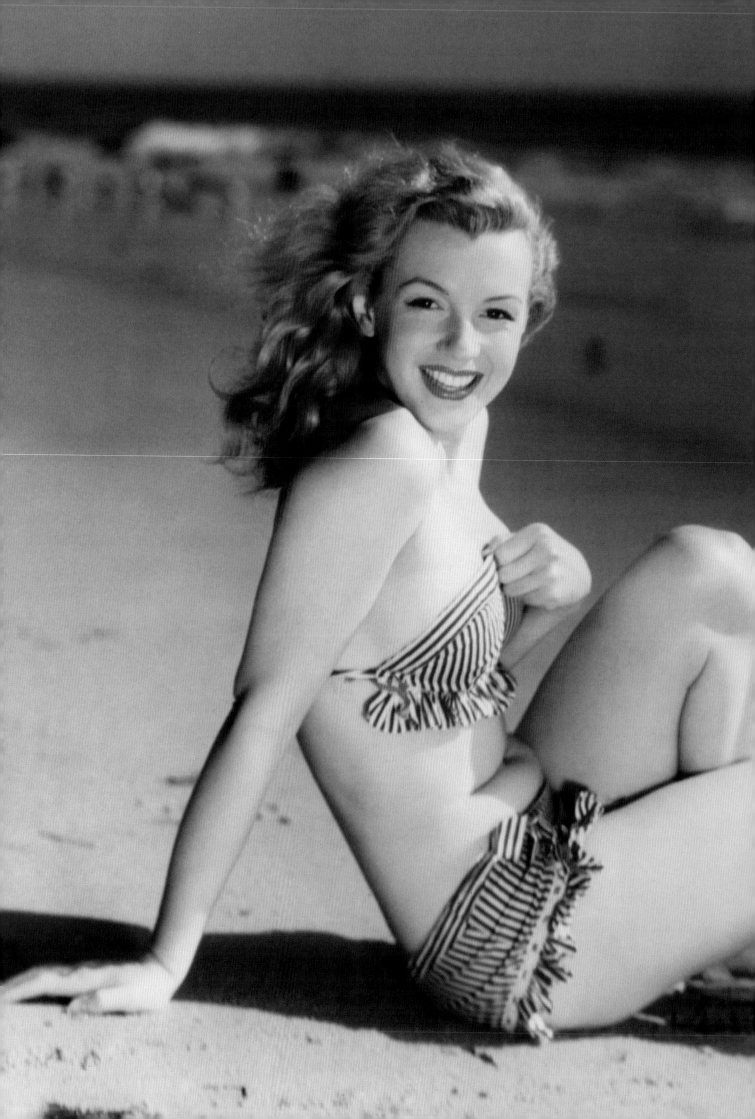

Getting a Break (1946–1950)

In July, 1946, the twenty-year old Norma Jean was screen tested at Twentieth Century-Fox and signed up on a six month contract, which was later extended to a year. During that time, her name was changed to Marilyn Monroe and Hollywood's newest starlet was given walk-on parts in a handful of movies. In fact, throughout the duration of her first stint at Twentieth Century-Fox, she only spoke two words on film.

Dropped by the studio, she was signed by Columbia for a brief time and was quickly let go when her first movie for them (and Marilyn's first starring role) was released to terrible reviews. Forced to return to modeling she was so poor that she agreed to do a nude photo shoot, which would later appear in the first edition of *Playboy*.

With an influential Hollywood agent now steering her career, Marilyn's luck turned in late 1949 when she won a small speaking part in the well-received John Huston movie, *The Asphalt Jungle*, that was followed by a slightly larger role in what would become a Hollywood classic. *All About Eve* was released in 1950 to critical acclaim. Suddenly Marilyn was being noticed.

"I've been on a calendar, but I've never been on time."

MARILYN

Timeline 1946–1950

1946

September 13 Divorce granted from Jim Dougherty.

1947

January 4 Marilyn's first movie, *The Shocking Miss Pilgrim*, premieres. She appears uncredited, as a telephone operator.

August 25 Marilyn's Fox contract is not renewed.

December 7 *Dangerous Years* premieres. Marilyn speaks her first lines.

1948

January 28 *You Were Meant for Me* premieres. Marilyn appears as an uncredited extra—although her involvement is disputed by some sources.

March 9 Marilyn signs a standard six-month contract at $125 a week with Columbia, probably thanks to her mentor, Joe Schenk.

March 11 *Scudda Hoo! Scudda Hay!* premieres.

March 14 Marilyn's "aunt," Ana Lower, dies.

April Marilyn meets Natasha Lytess, head drama coach at Columbia.

September 8 Marilyn is dropped by Columbia. The story goes that she refused to spend a weekend on head honcho Harry Cohn's yacht.

December 30 *Ladies of the Chorus* premieres in San Francisco. Marilyn plays a showgirl in her first sizeable role, and sings "Every Baby Needs a Da Da Daddy" and "Anyone Can See I Love You."

December 31 Meets Johnny Hyde ... who buys her contract and leaves his wife.

ABOVE: Marilyn and Natasha Lytess.

1949

May 27 Poses for Tom Kelley nude on a red velvet drape for calendar photos.

October Marilyn's big break: she signs a contract with MGM for a role in John Huston's *The Asphalt Jungle*.

1950

April 7 Release of *Love Happy* in New York. Marilyn is part of the film's promotional campaign and she visits New York, Chicago, Detroit, Cleveland, and Milwaukee.

April 18 *A Ticket to Tomahawk* premieres in Denver, CO because so much of the filming took place on the Denver & Rio Grande at Durango, CO.

May 23 *The Asphalt Jungle* premieres at Grauman's Egyptian Theater. "There's a beautiful blonde too, name of Marilyn Monroe, who plays Calhern's girlfriend, and makes the most of her footage." (*Photoplay*)

October 6 *Right Cross* premieres. It's a boxing drama in which Marilyn has a small, uncredited role.

October 7 Premiere of *The Fireball*—a roller-skating vehicle for Mickey Rooney—in Los Angeles.

October 13 Simultaneous premiere of *All About Eve* in New York and in Paris, France.

December 10 Signs a new contract with Fox.

December 18 Johnny Hyde dies suddenly. Marilyn is distraught.

LEFT: Marilyn and Groucho Marx during filming of *Love Happy*.

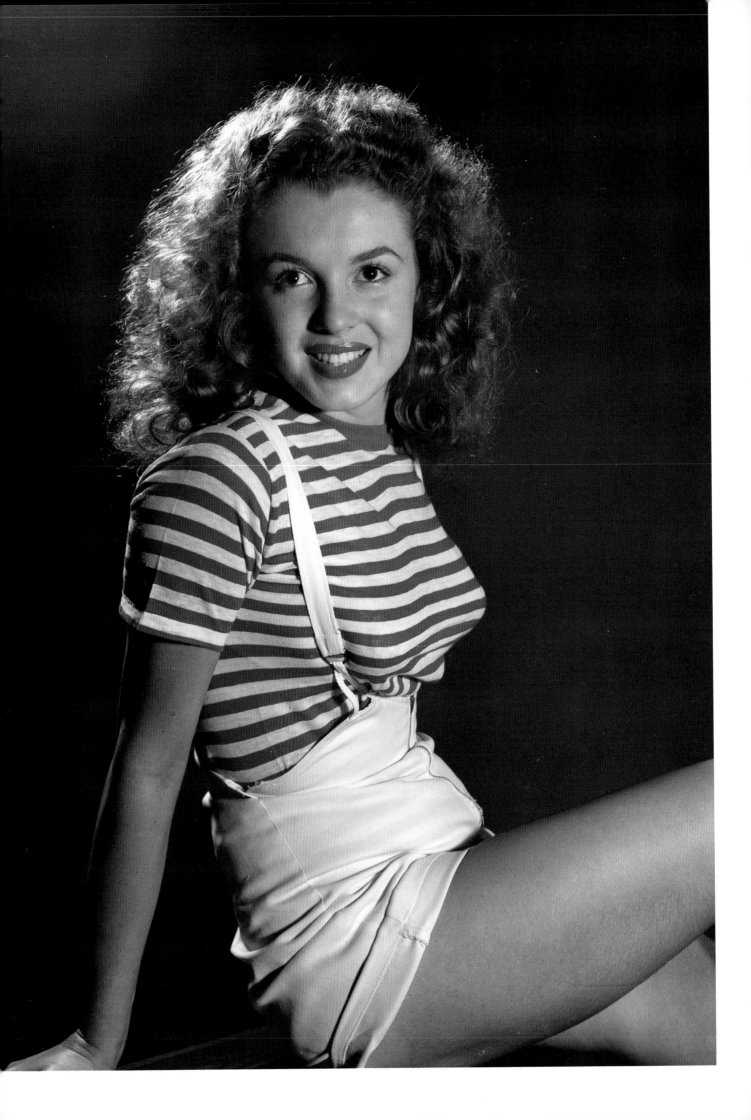

Film Test

During 1945 and early 1946, Norma Jean had done much to improve her chances in the cutthroat world of modeling, lightening her hair color and listening carefully to the advice of the many photographers who were wowed by her vivacity and beauty. They suggested she tried out for the movies, but that to do so, she'd need to be single … so from May 14 she lived with Ana Lower's Aunt Minnie in Las Vegas so that she could obtain a "quickie" divorce. On July 17, she went to Twentieth Century-Fox to see Ben Lyon, who presided over her first interview. On the 19th, she went for a screen test where she was watched by cinematographer Lyon, Leon Shamroy, make-up artist Allan "Whitey" Snyder, Walter Lang, and Charles LeMaire, head of wardrobe. Head of production Darryl F. Zanuck wasn't keen, but Lyon and Shamroy convinced him to get her signed up. On August 26, Norma Jean signed her first contract with Fox … or rather her legal guardian, Grace McKee, signs the contract as she was under age at twenty. Ben Lyon and Norma Jean also decide on a new stage name—Marilyn Monroe (Marilyn after actress Marilyn Miller and Monroe was her mother's maiden name).

"I got a cold chill. This girl had something I hadn't seen since silent pictures. She had a kind of fantastic beauty like Gloria Swanson, when a movie star had to look beautiful, and she got sex on a piece of film like Jean Harlow."

LEON SHAMROY

LEFT: Norma Jean poses for David Conover wearing her trademark stripy top. This 1946 shot shows her as a brunette.

RIGHT: Her hair color changed by the time of her screen test—although the earlier outfit was undoubtedly more flattering than the dress she wore on July 19.

BELOW: Norma Jean Dougherty's temporary parking pass for Twentieth Century-Fox studios from November 1, 1946, with stamped signature of casting director Ben Lyon, who presided over her first interview at Fox on July 17, 1946.

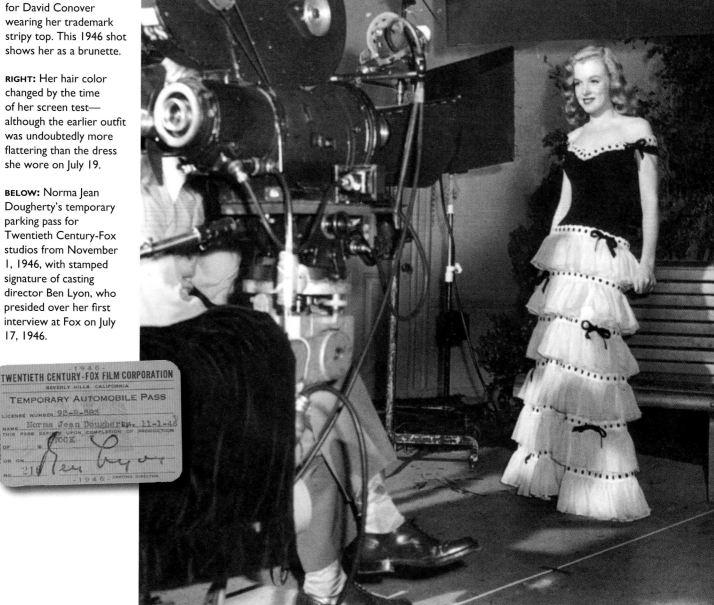

From babysitter to actress

At the start of 1947, Twentieth Century-Fox publicist Harry Brand started to push their new young starlet, and a picture from this sequence was published in the *Los Angeles Times*. The official caption reads:

"Lovely Marilyn Monroe, former baby sitter now turned actress, proves that she hasn't lost any of her appeal for children. Marilyn landed a contract with Twentieth Century-Fox several weeks ago when she made a routine call to the home of a Twentieth Century-Fox Casting Director who had called for a sitter. One look at the charmer convinced the director that she should have a screen test. Marilyn is now working with June Haver and Lon McCallister in the film, *Scudda Hoo, Scudda Hay*. The interested little Miss is three-year old Joanne Metzler, daughter of a fellow studio co-worker."

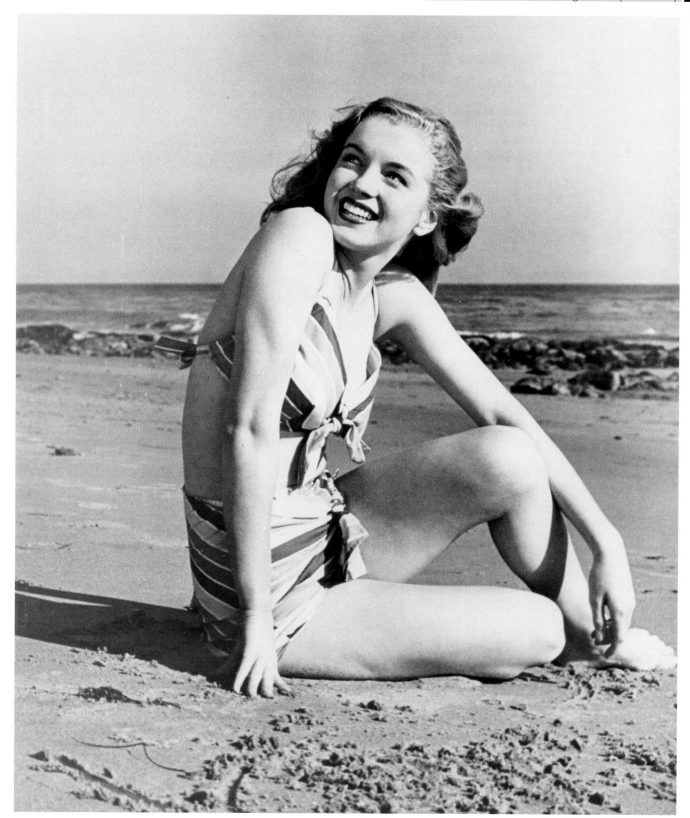

Publicity Shots

Marilyn arrived in Hollywood at the end of the great "Studio System"—a conveyor belt from talent spotting to stardom. The system allowed the big Hollywood studios to groom stars for success, holding them to long-term contracts but teaching them acting skills and promoting them through a series of smaller movies before being given major roles. From the late 1940s, Hollywood was under threat from TV, inflation, but in particular, the US government anti-trust rulings on theater

ownership, block-booking of movies, and price fixing. This studio system became untenable after the 1948 Paramount Decree—the Supreme Court antitrust ruling—but as will be seen in the following pages, Marilyn initially benefited from the power of the big studio she signed for.

Publicity was key to becoming a star, and Marilyn received a lot of it—helped by her earlier modeling career—she knew how to make the camera love her.

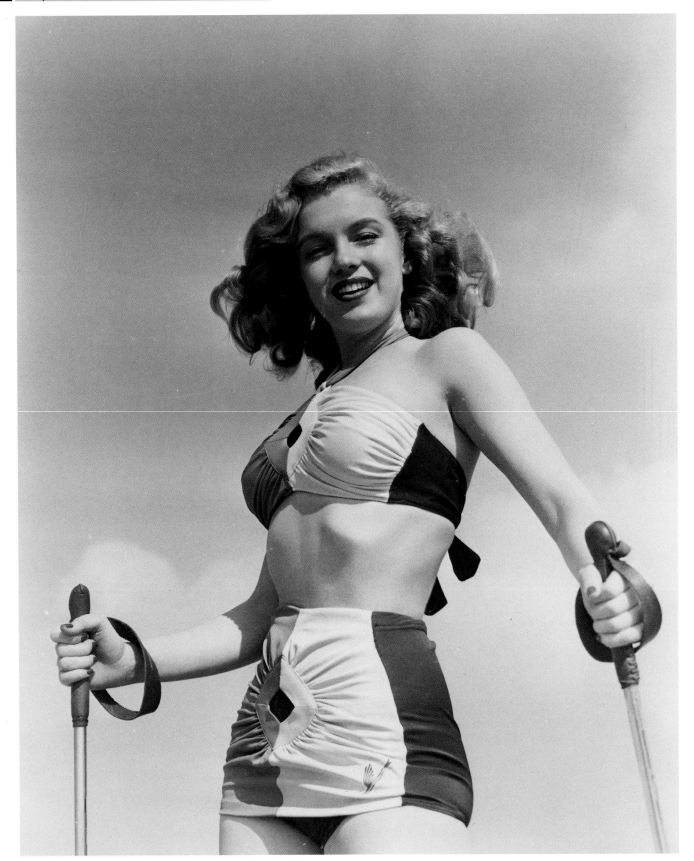

Sand Skiing

Joseph Jasgur, one of the great Hollywood photographers, had taken many pictures of her, including those in March 1946 for the Blue Book Agency that she had used in her Fox interview (such as the one on page 59). He was typical of the photographers of the period and took many publicity photos of her, including these of her sand skiing … in platform shoes … and the more typical glamor shots overleaf.

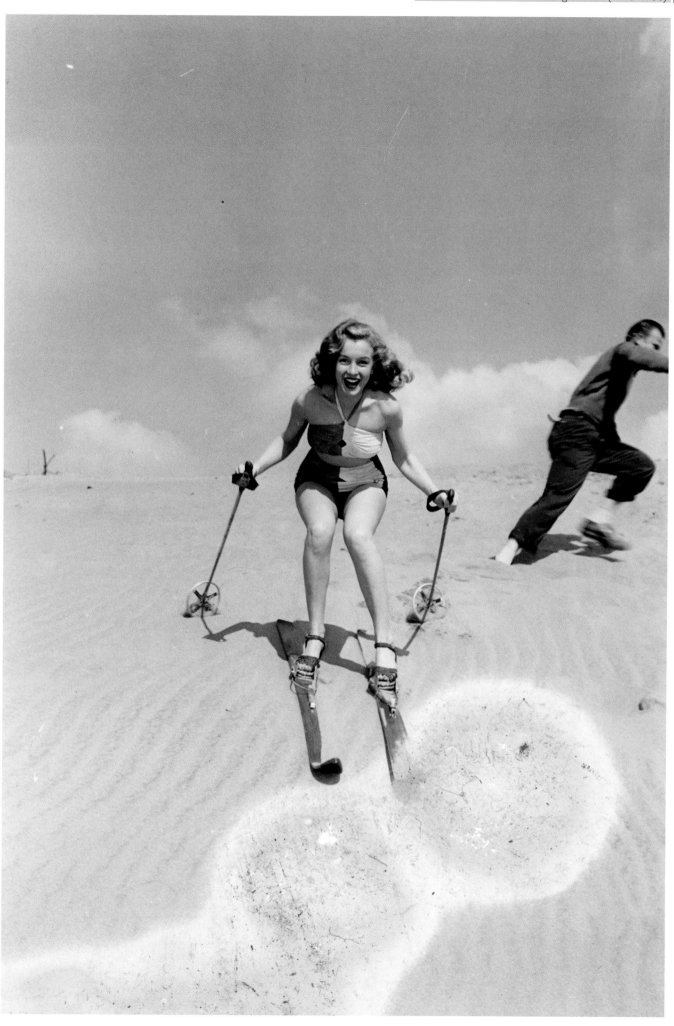

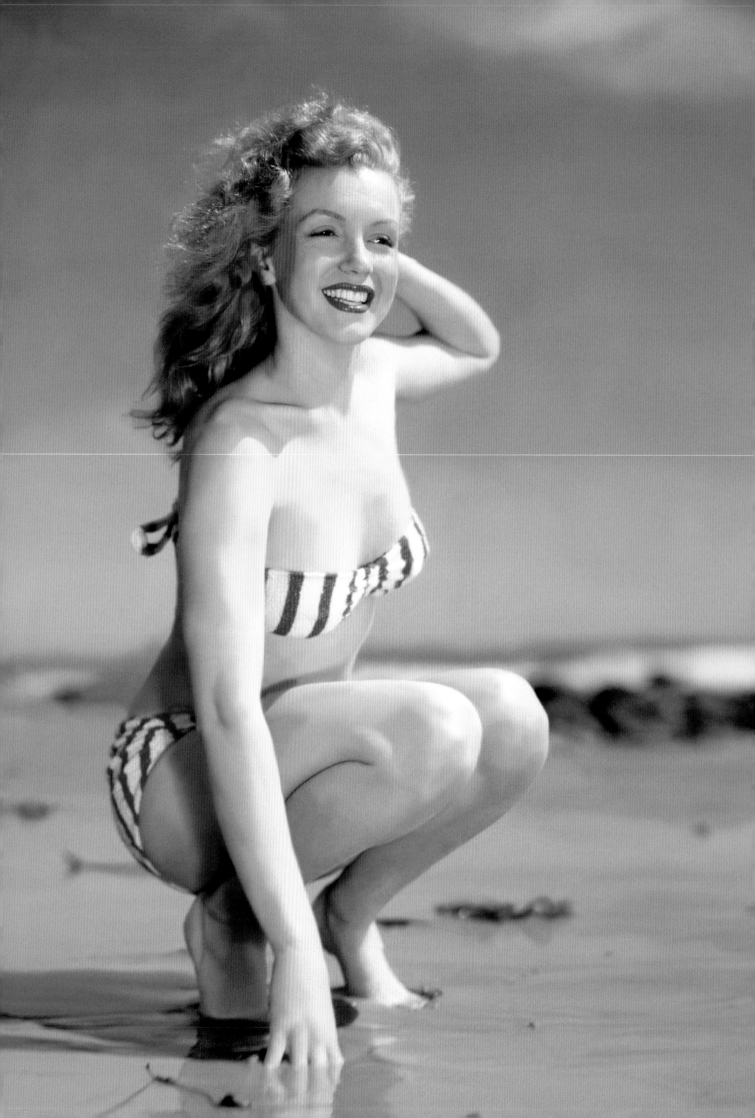

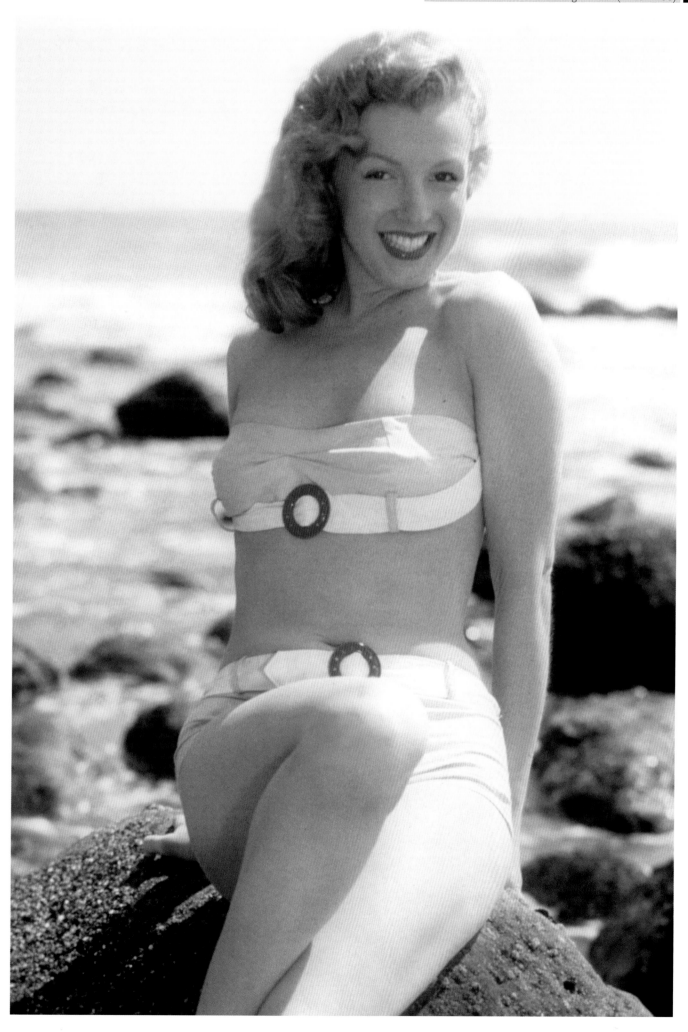

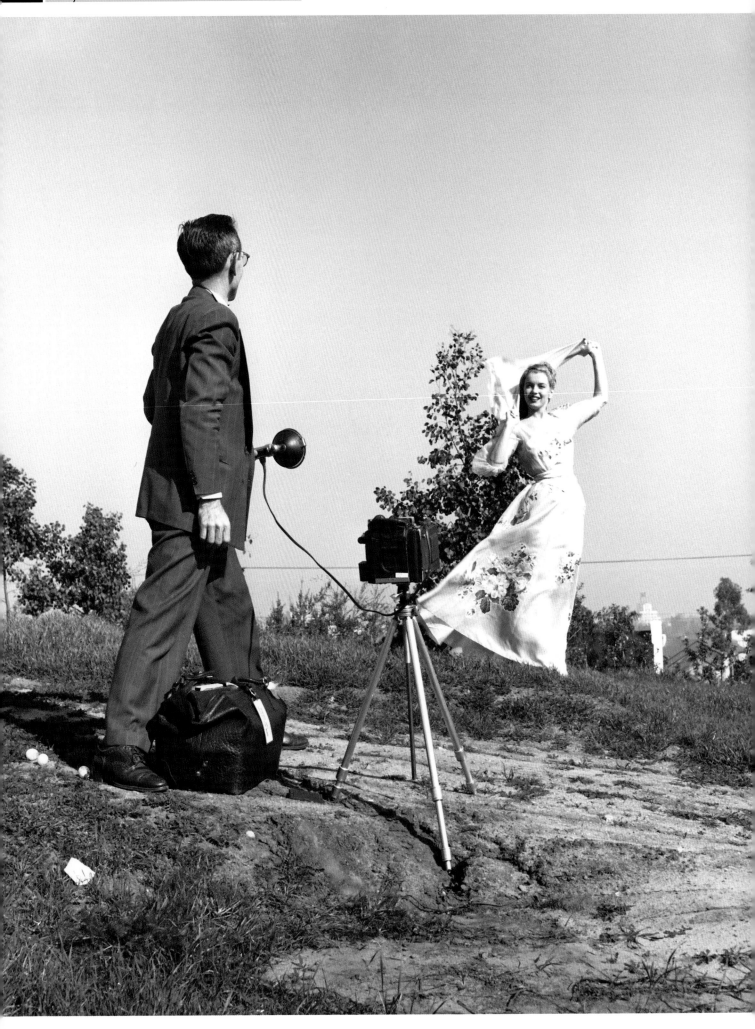

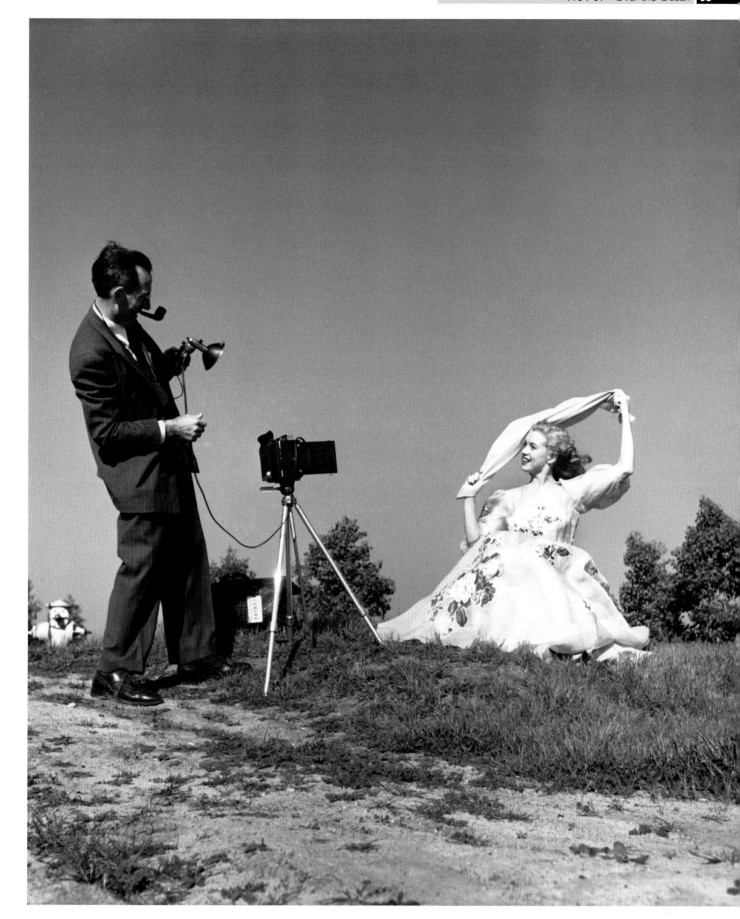

Earl Theisen photo session

In 1947 Earl Theisen photographed Twentieth Century-Fox's newly signed Marilyn Monroe for *Look* magazine—the first of a number of portrait sessions he had with Marilyn. The results—particularly the color images overleaf—showed what a prospect Fox had.

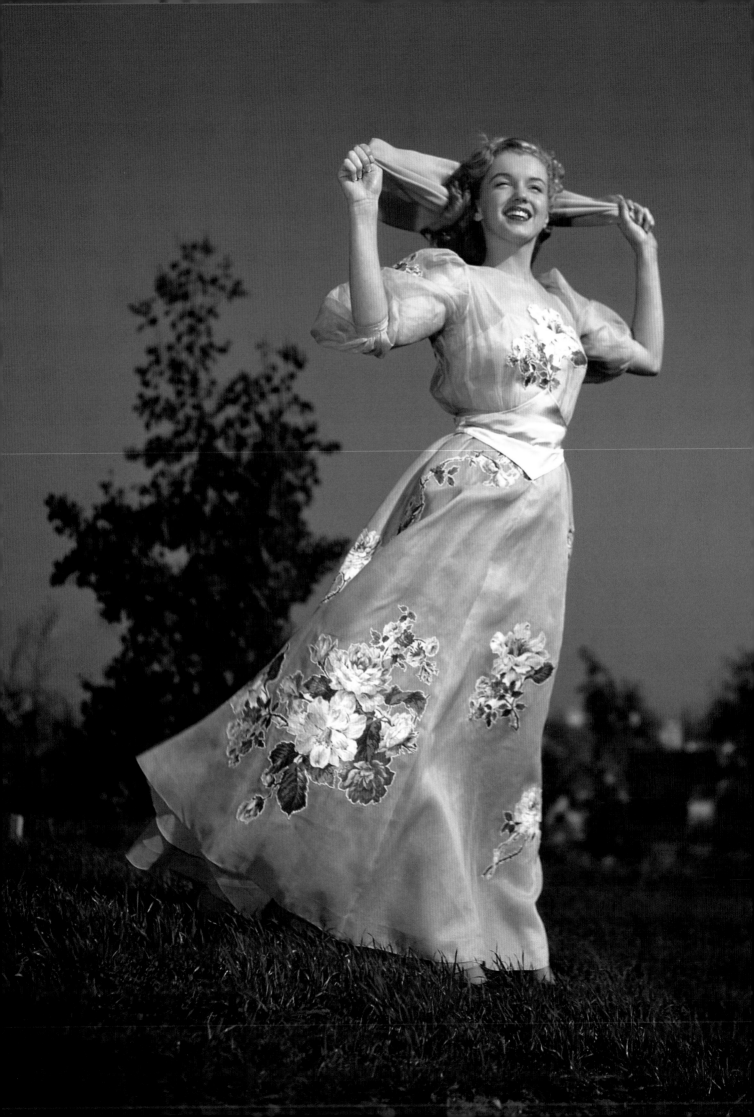

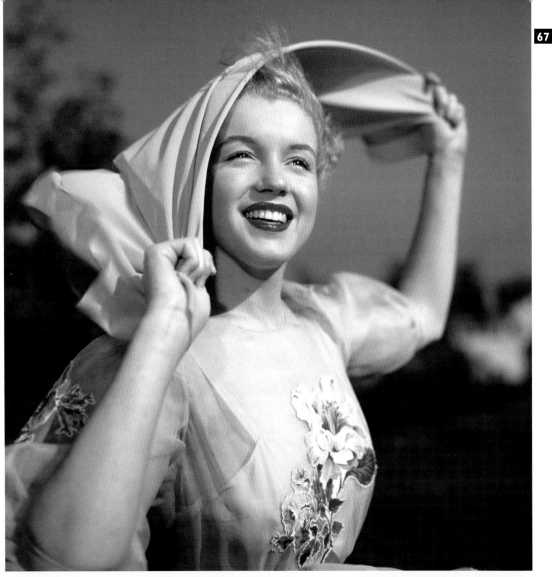

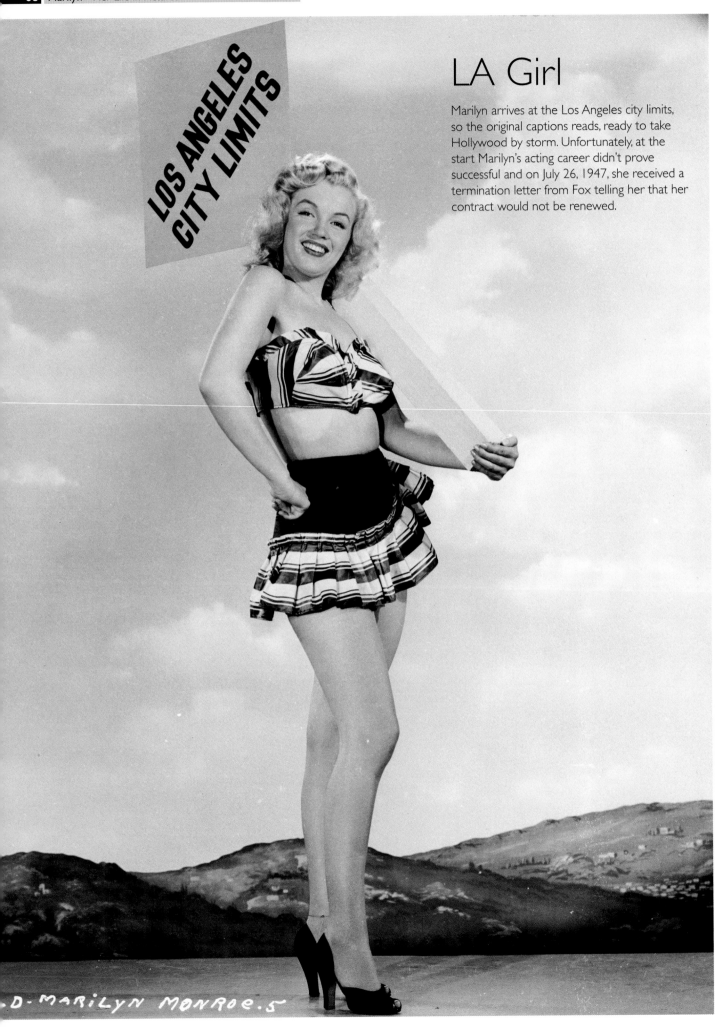

LA Girl

Marilyn arrives at the Los Angeles city limits, so the original captions reads, ready to take Hollywood by storm. Unfortunately, at the start Marilyn's acting career didn't prove successful and on July 26, 1947, she received a termination letter from Fox telling her that her contract would not be renewed.

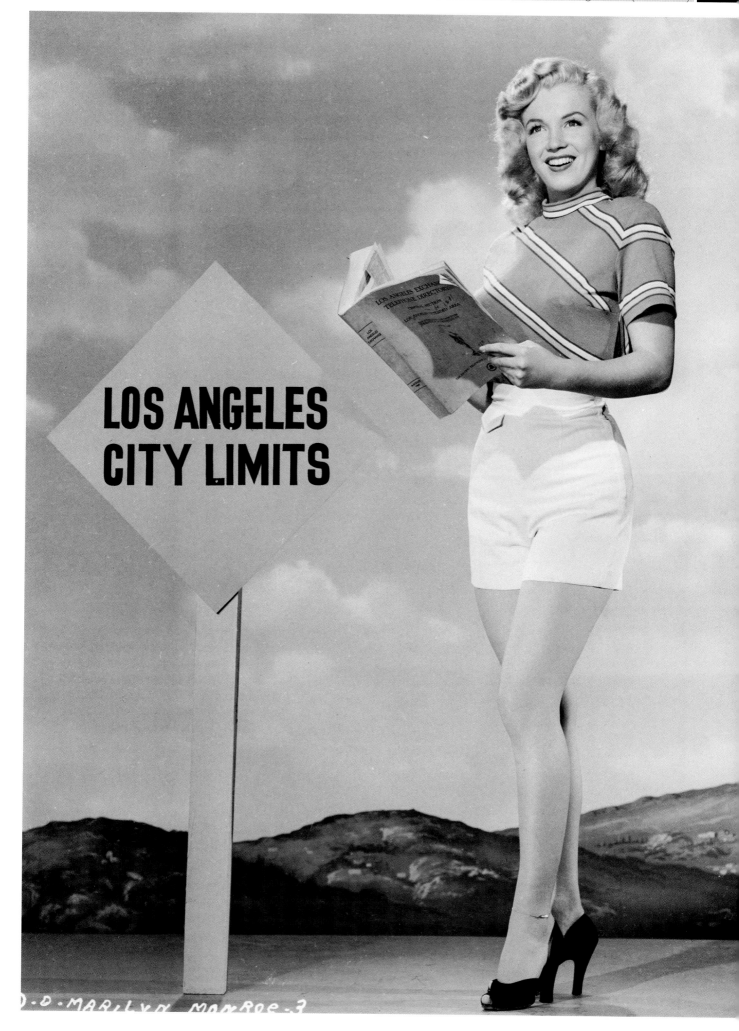

Yoga

Marilyn was hired by Columbia for six months in March 1948, thanks to her influential friend (and possibly lover) former Twentieth Century-Fox head Joe Schenck, who was friendly with Columbia boss Harry Cohn. Columbia made her blonder and then started on the publicity photos—including these of her practicing yoga. Marilyn was an early devotee of the discipline, and it is said she was taught by Indra Devi, who opened a studio on Sunset Boulevard in 1947. Devi was a Swedish-Russian Bollywood movie star who also taught Greta Garbo and Gloria Swanson—but there are no pictures of them together and the yoga scene in Los Angeles was flourishing, so she could have learned from other famous teachers such as Yogi Vithaldas, Clara Spring, or Rishi Singh Gherwal. Whoever her teacher was, the lessons learnt were important, and Marilyn would use yoga as a permanent part of her workout regimen for the rest of her life.

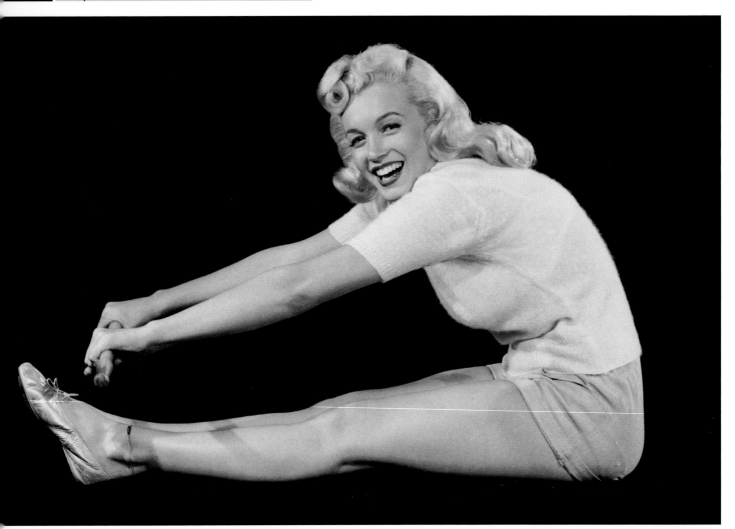

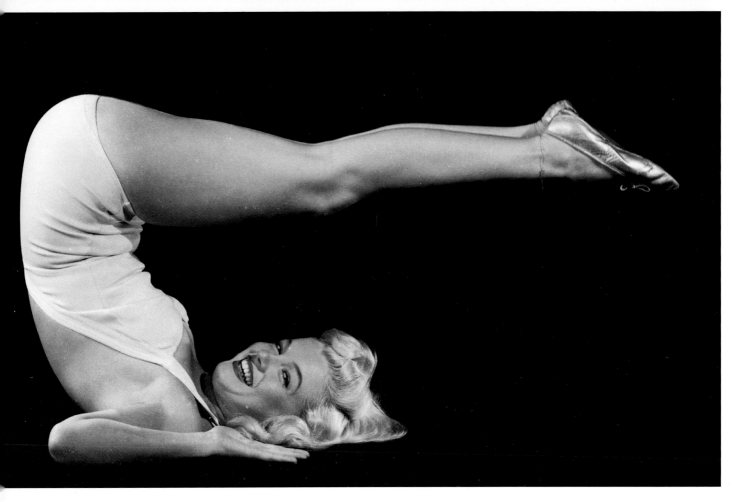

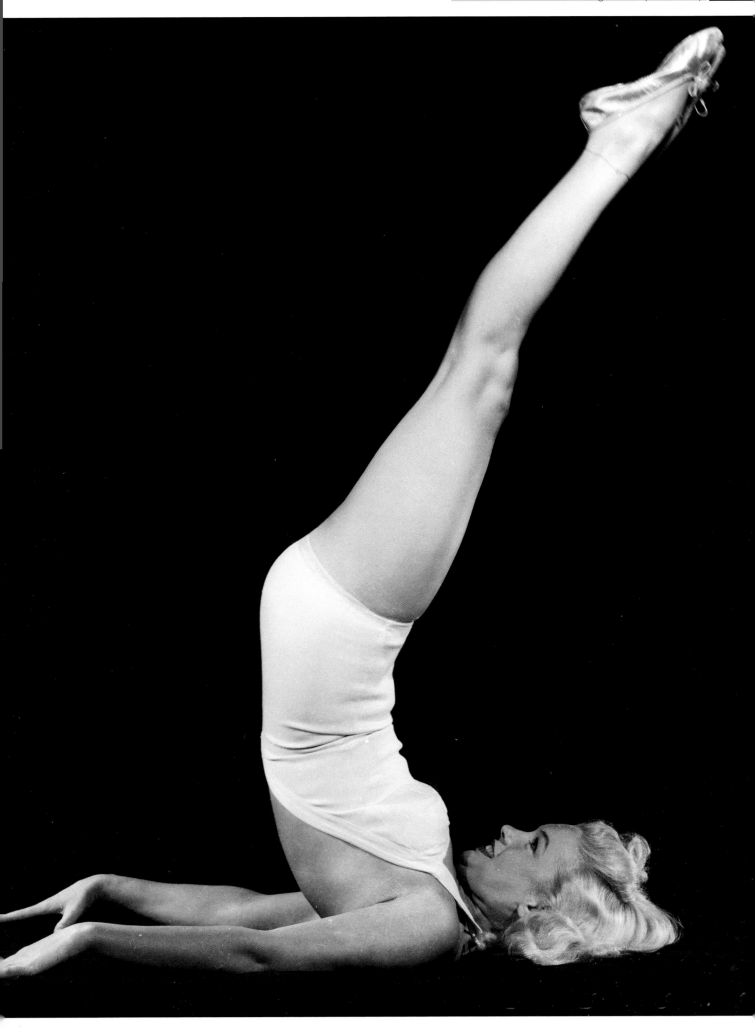

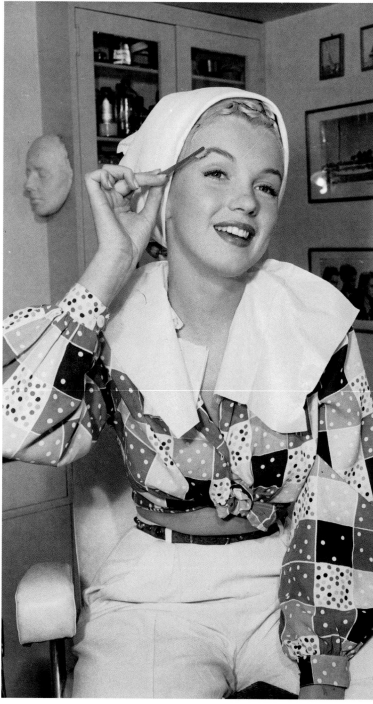

Makeup Test

Marilyn auditioned for *Ladies of the Chorus* after signing for Columbia and won a co-starring role. Here she is photographed by William Edward Cronenwerth in June 1948. She met a number of people who would be important in her life at this time, including the designer Jean Louis, then head of Columbia's costume department. Marilyn and he worked together some years later on *The Misfits* and he designed her "nude" evening gown in which she serenaded President John F. Kennedy during his 1962 birthday celebration. Marilyn's best-known makeup artist was her friend Alan "Whitey" Snyder, a pallbearer at her funeral, who helped her create her style: high, arched eyebrows; heart-shaped face; full red lips—and, of course, the beauty spot. She started with a primer—either Vaseline or Nivea—that gave her skin a glow under lights. By the end of her life she could spend up to three hours preparing her makeup.

"It was all an illusion: in person, out of makeup, she was very pretty but in a plain way, and she knew it."

WHITEY SNYDER

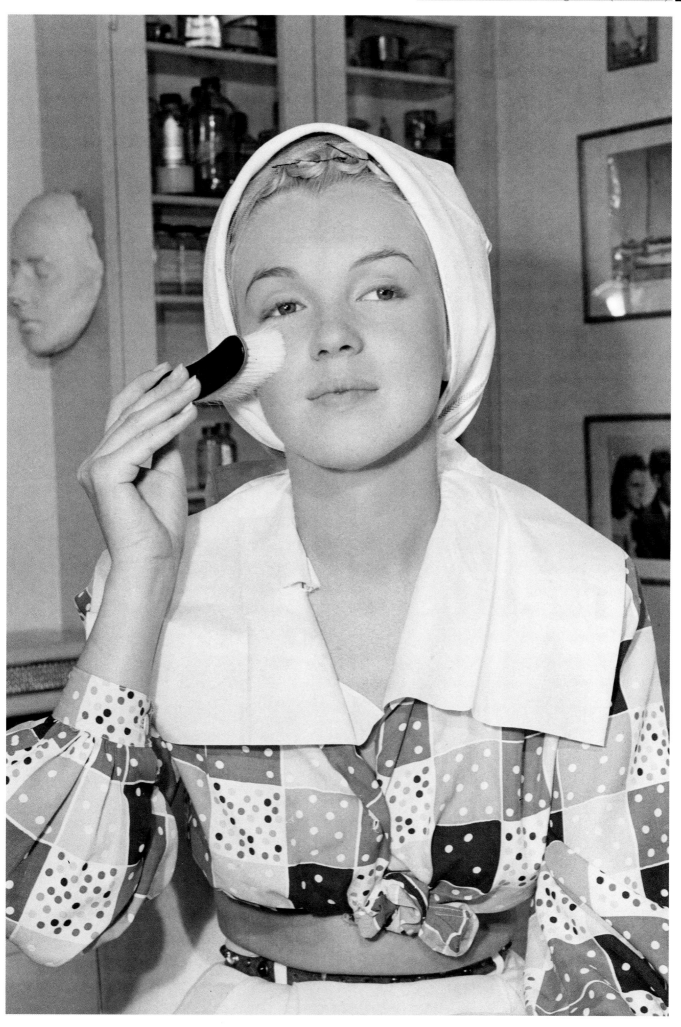

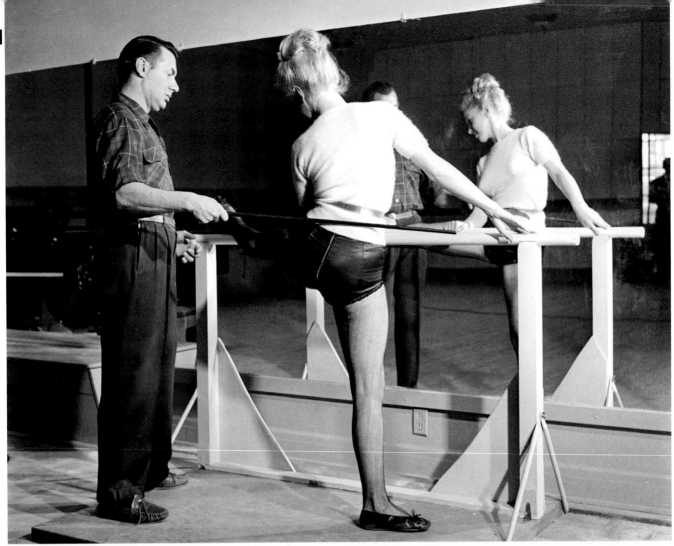

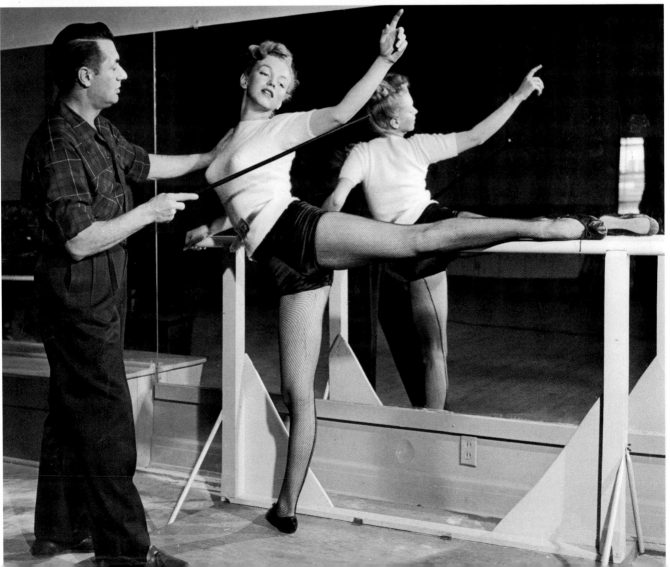

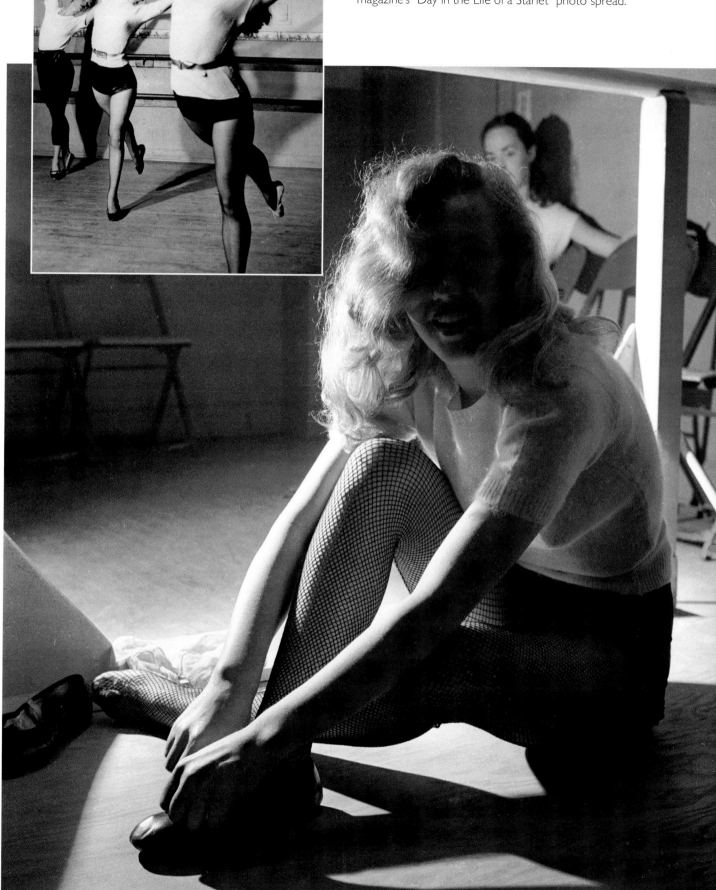

At the Barre

Columbia sent Marilyn for dancing lessons with Greek-born dance instructor Nico Charisse—husband of the famous Cyd Charisse—as photographed by J.R. Eyerman for *Life* magazine's "Day in the Life of a Starlet" photo spread.

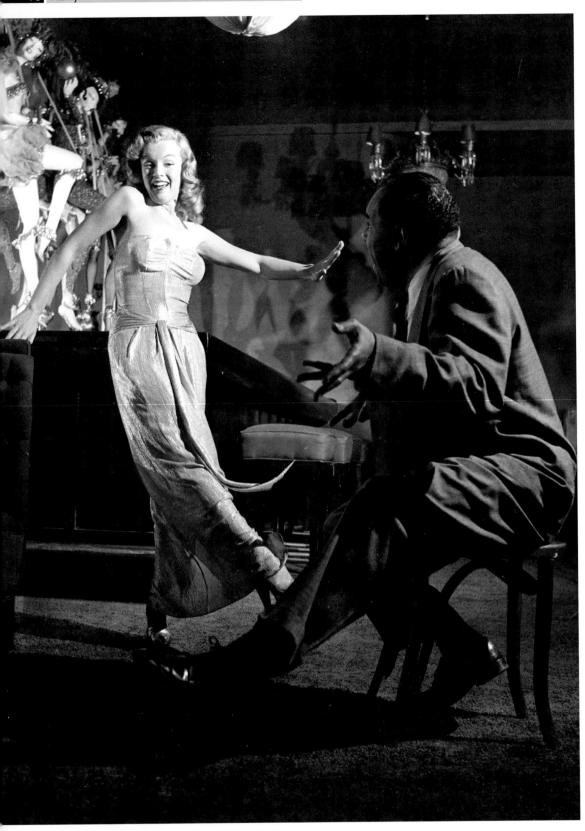

Singing Lessons

Next step in "Day in the Life of a Starlet" is singing and voice lessons
with jazz musician and bandleader Phil Moore at the Mocambo
nightclub, West Hollywood, CA. Marilyn also took vocal lessons
with Fred Karger, a vocal coach at Columbia, and had a passionate
affair that did not last long—although she did move into the house
he shared with his mother Ann. Ann and Fred's sister Mary became
lifelong friends of Marilyn, as is attested by their presence at her
funeral when many others were not invited.

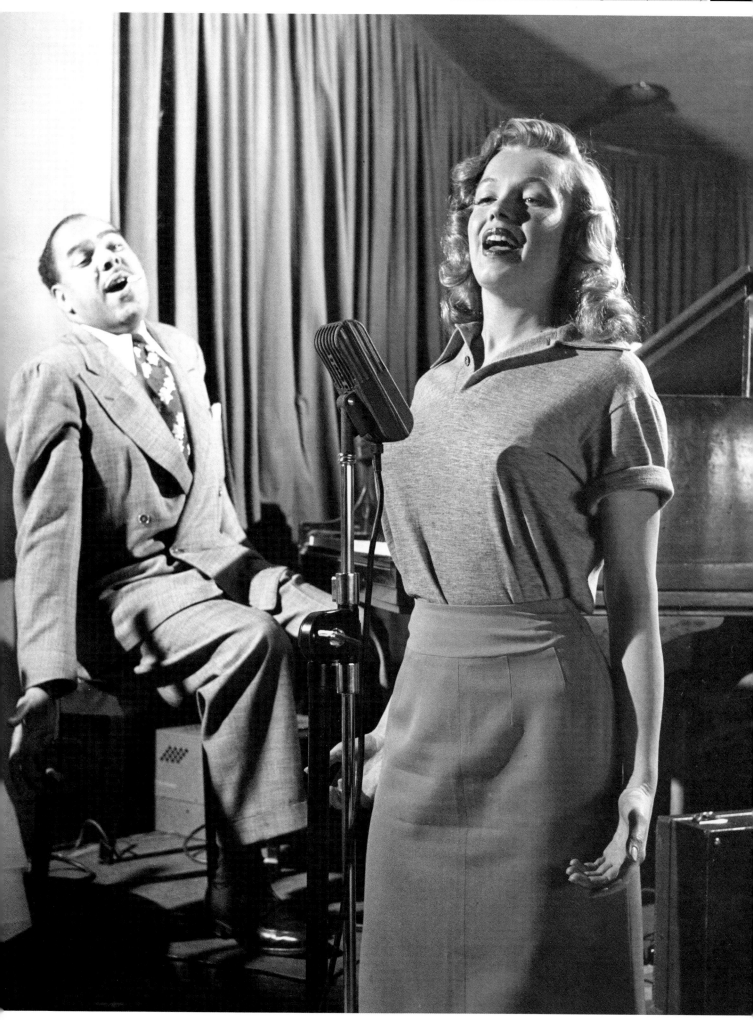

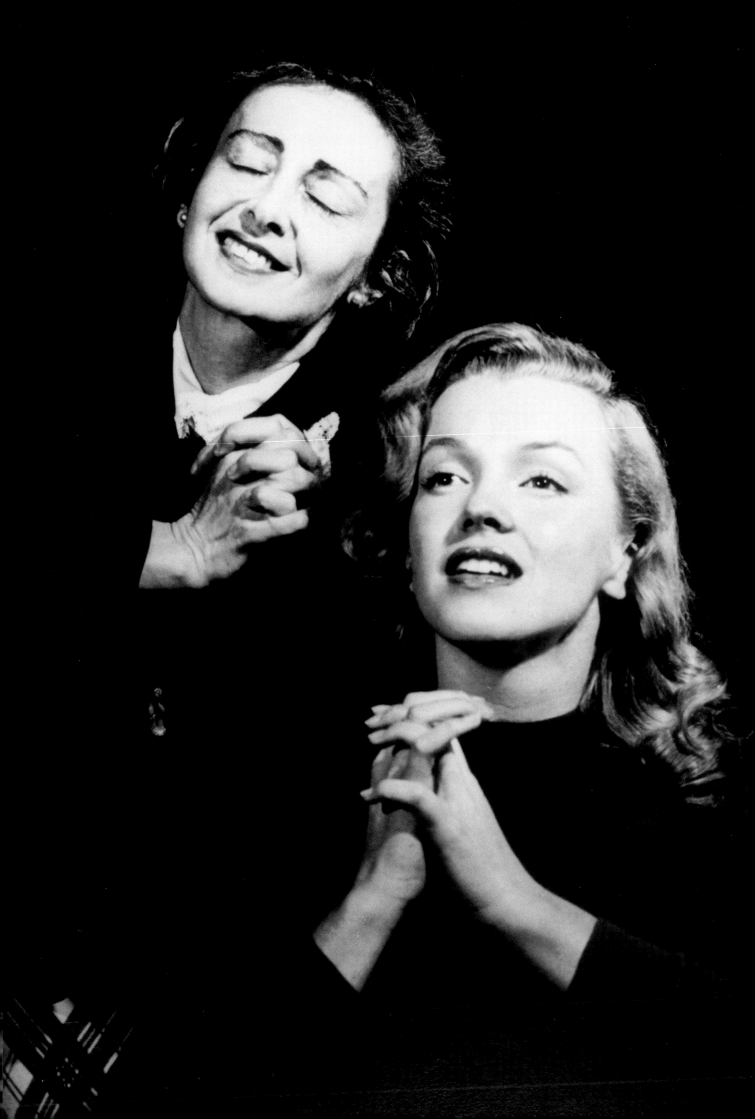

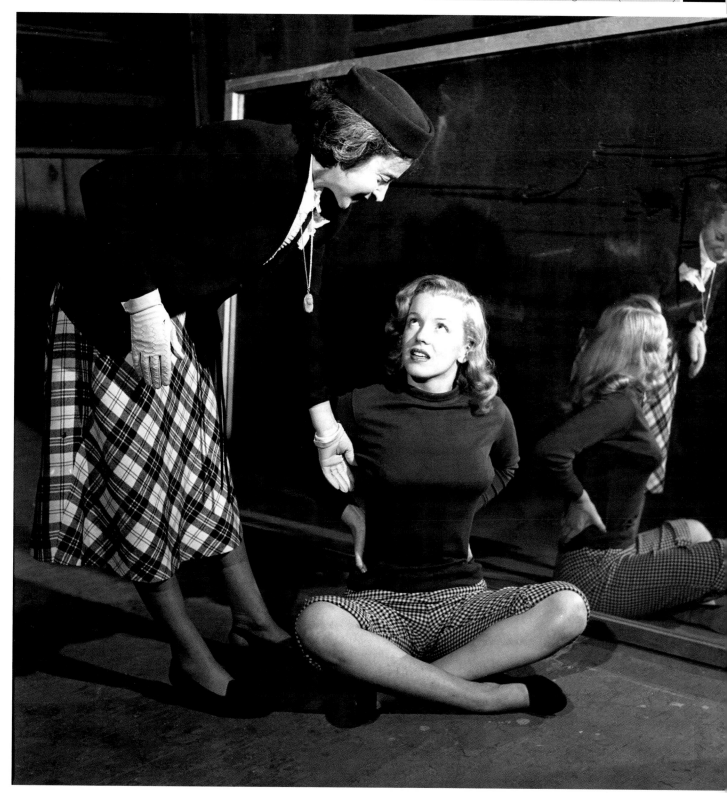

Natasha Lytess

Marilyn met acting coach Natasha Lytess when she moved to Columbia and they hit it off; Natasha would become a close friend and later her personal drama coach, accompanying her and helping her until she moved to New York in 1955. Marilyn lived in Lytess's apartment at 1309 North Harper Avenue in late 1949/early 1950. After losing her job at Columbia, she continued to take lessons with Lytess, probably financed by her sponsor, John Carroll. These photos (here and overleaf) were also part of *Life* magazine's "Day in the Life of a Starlet" photo shoot.

"Dreaming about being an actress is more exciting than being one."

MARILYN

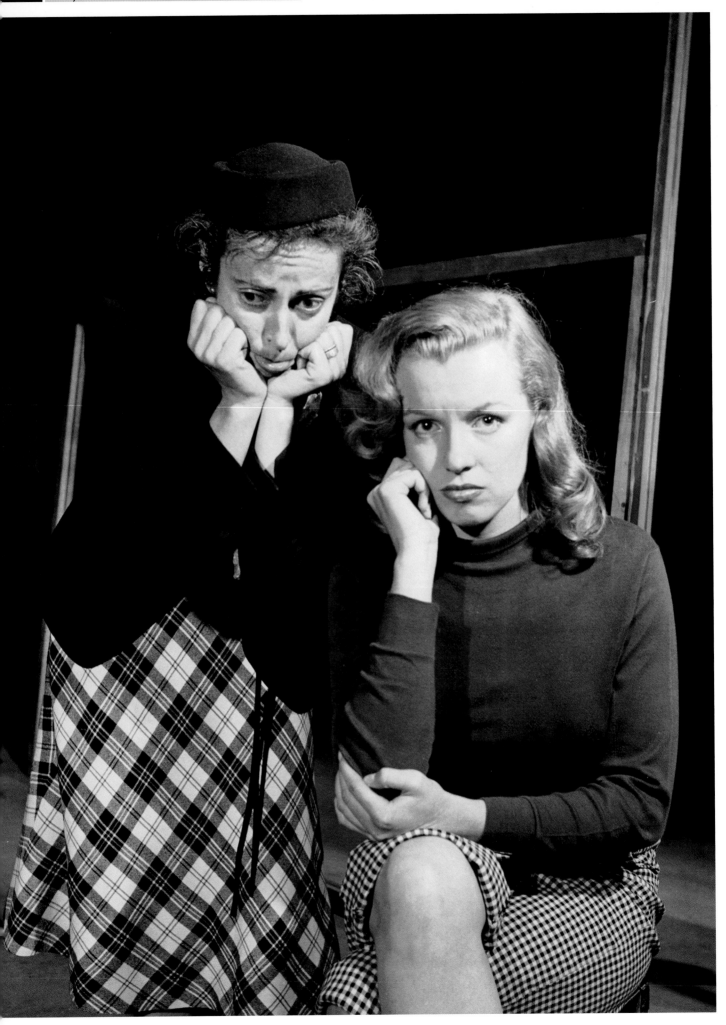

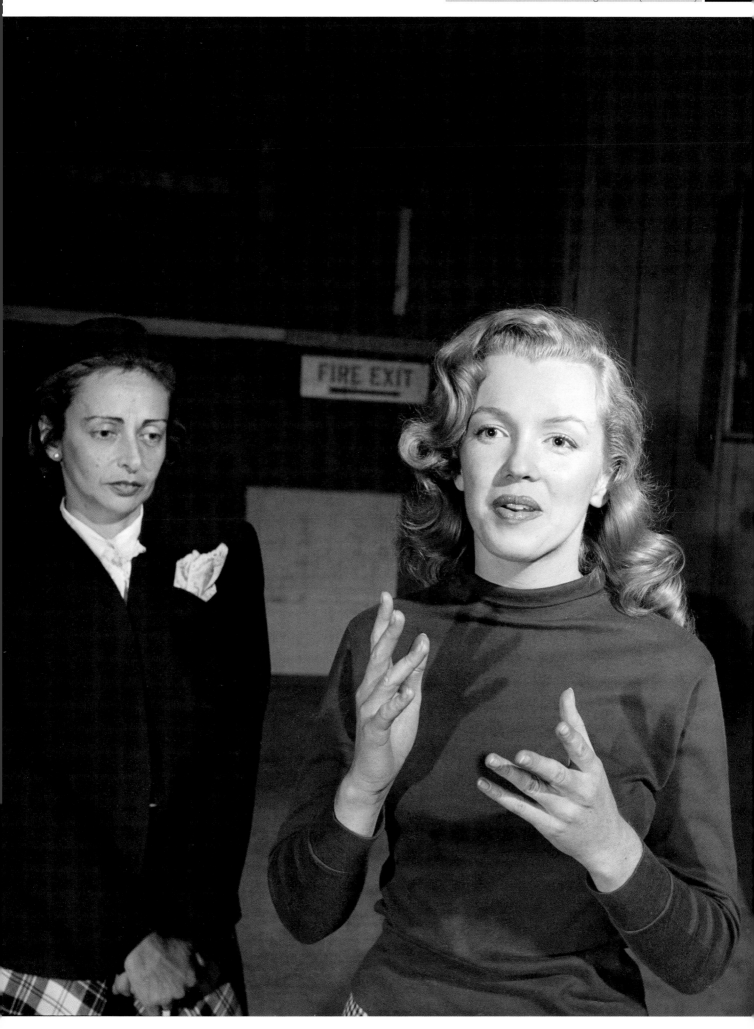

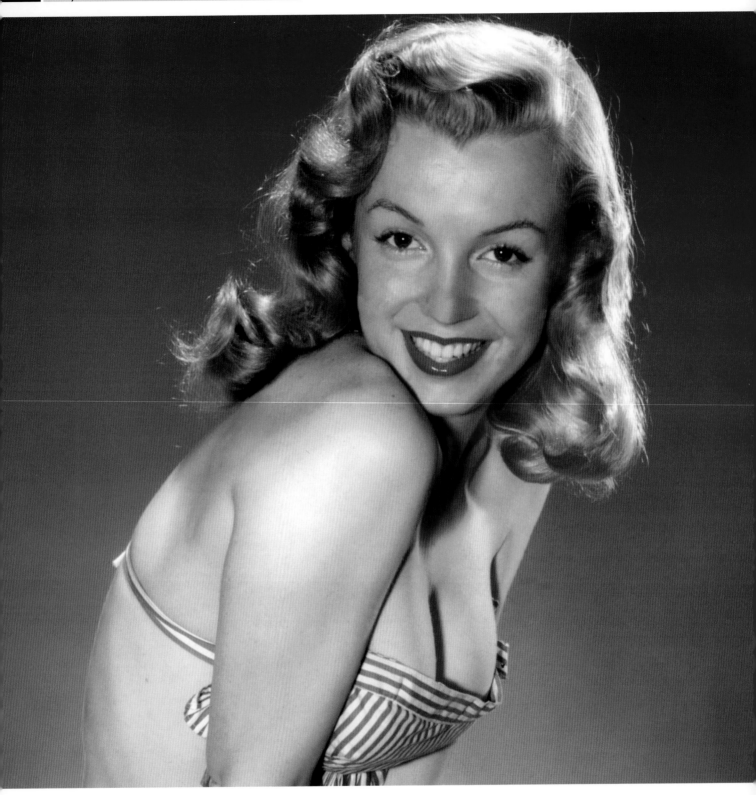

Laszlo Willinger

The acerbic Hungarian-born photographer Laszlo Willinger said this of Marilyn. He photographed her a number of times in her early career and took these 1948 images of her.

"She had a talent to make people feel sorry for her, and she exploited it to the best of her ability—even people who had been around and knew models fell for this 'Help Me' pose."

LASZLO WILLINGER

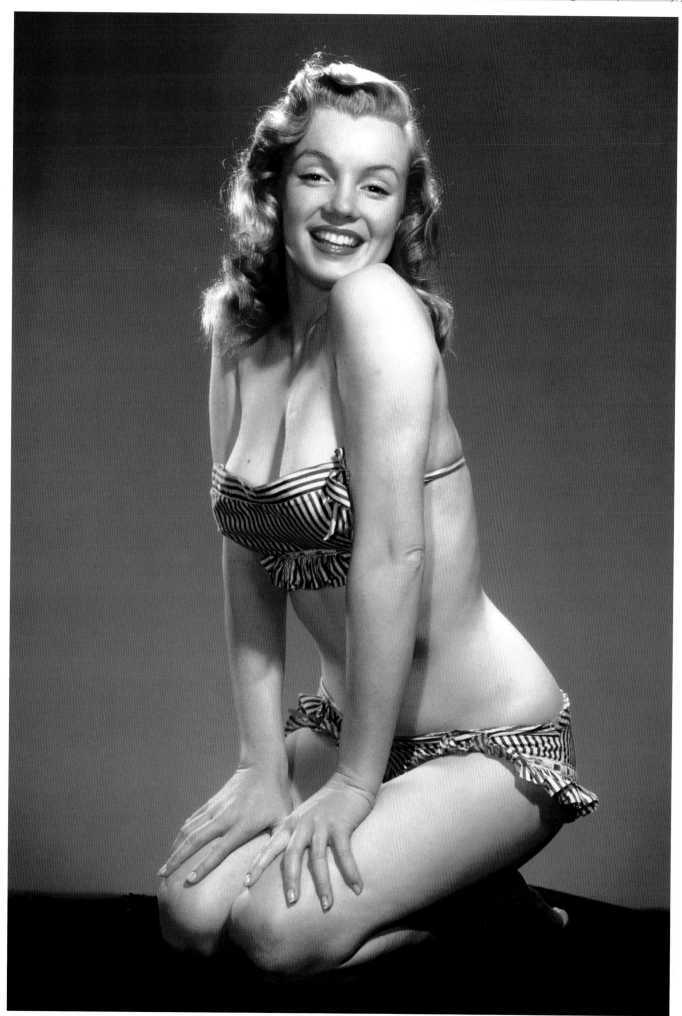

Ladies of the Chorus

Marilyn's first significant role in movies was in her only Columbia movie: *Ladies of the Chorus*, which premiered in San Francisco in fall 1948. Although she was noticed by the reviewer of *Motion Picture Herald* it was not enough for Columbia to renew her contract … although it's said the real reason for this is that she refused a weekend on Harry Cohn's yacht. Her singing lessons had obviously helped: she sang two numbers, "Every Baby Needs a Da Da Daddy" by Alan Roberts and Lester Lee and "Anyone Can See I Love You" by Irene Cara and Bruce Roberts.

Cast & Credits

Adele Jergens—Mae Martin
Marilyn Monroe—Peggy Martin
Rand Brooks—Randy Carroll
Eddie Garr—Billy Mackay
Nana Bryant—Mrs Adelle Carroll

Director: Phil Karlson
Producer: Harry A. Romm
Writer: Harry Sauber's story; screenplay by Joseph Carole and Harry Sauber
Music: Mischa Bakaleinikoff
Cinematography: Frank Redman
Studio: Columbia Pictures
General release date: February 10, 1949

"One of the bright spots is Miss Monroe's singing. She is pretty and, with her pleasing voice and style, she shows promise."

MOTION PICTURE HERALD

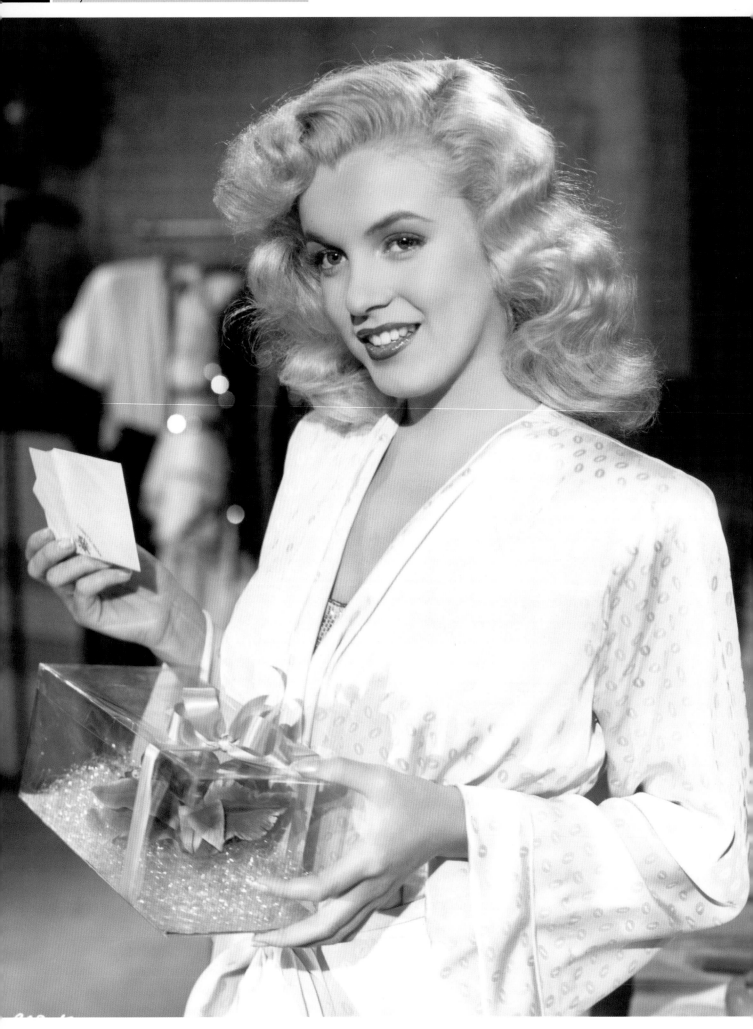

LEFT: Marilyn Monroe holds a corsage in a box, in a scene from *Ladies of the Chorus*.

RIGHT: Marilyn in a publicity shot for *Ladies of the Chorus*.

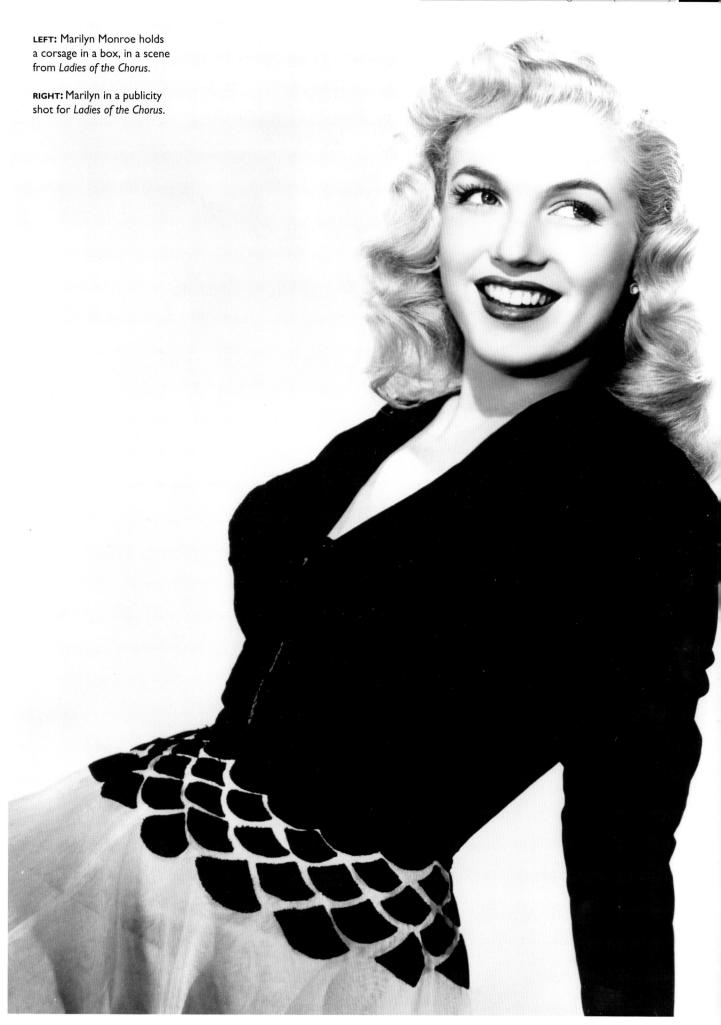

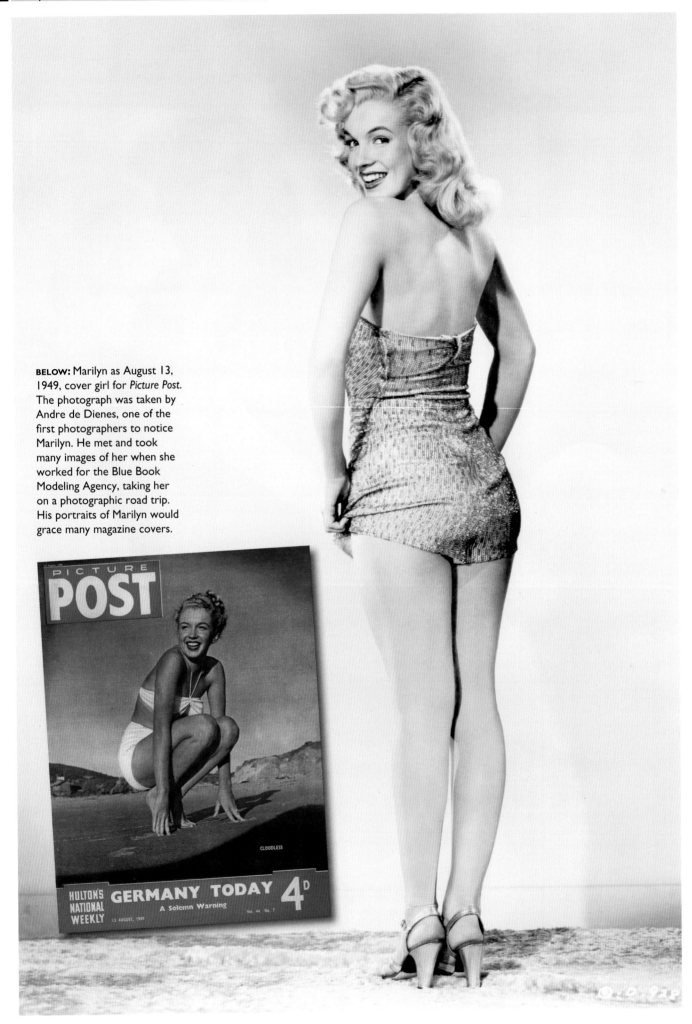

BELOW: Marilyn as August 13, 1949, cover girl for *Picture Post*. The photograph was taken by Andre de Dienes, one of the first photographers to notice Marilyn. He met and took many images of her when she worked for the Blue Book Modeling Agency, taking her on a photographic road trip. His portraits of Marilyn would grace many magazine covers.

Waiting for a Break

ABOVE: Marilyn poses for a portrait around 1949.

After being dropped by Columbia, Marilyn went through a difficult few months, although her friends did what they could. By this time she had a circle of friends who believed in her future: her agent Harry Lipton; the Carrolls—actor John and his wife Lucille Ryman, a talent scout at MGM, who helped finance her; boyfriend Fred Karger; and acting coach Natasha Lytess. Nevertheless, she was short of money, so much so she posed for risqué photos on a number of occasions, including for Earl Moran in November 1948 and in May 1949 for Tom Kelley, a set of images that caused some notoriety in the future.

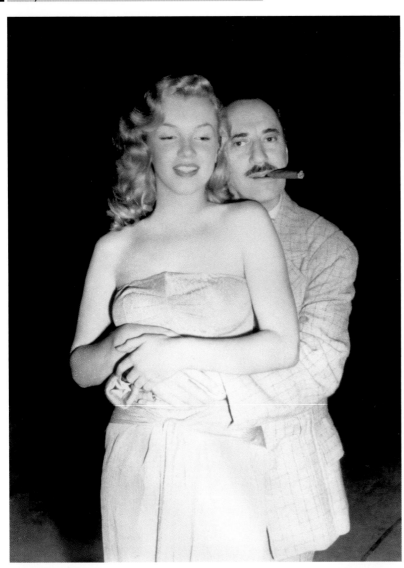

Love Happy

Marilyn was only on screen for a short time—some thirty-nine seconds, but it got her noticed. It is said that she got the part after contacting Lester Cowan: "I hear you're looking for a sexy blonde to play with the Marx Brothers. Would you like to see me? I'm blonde and I'm sexy." Its more likely that the audition was set up by Harry Lipton or Johnny Hyde (see page 97). "I want you to help me ... Some men are following me." Marilyn says, slinking up to Groucho, who leers at her as only he can and replies, "Really? I can't understand why!"

Cast & Credits

Harpo Marx—Harpo
Chico Marx—Faustino
Groucho Marx—Detective Sam Grunion
Ilona Massey—Madame Egelichi
Marilyn Monroe—Grunion's Client

Director: David Miller
Producer: Mary Pickford & David Miller
Writer: Harpo Marx; screenplay by Frank Tashlin, Mac Benoff & Harpo Marx
Music: Ann Ronell
Cinematography: William Mellor
Studio: United Artists
General release date: February 10, 1949

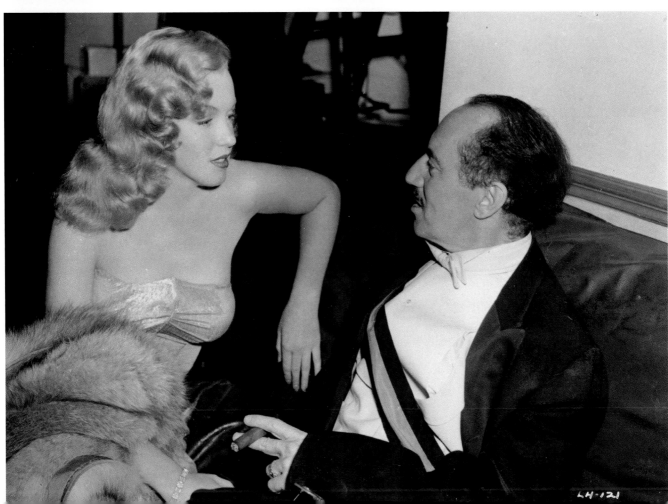

LH-121

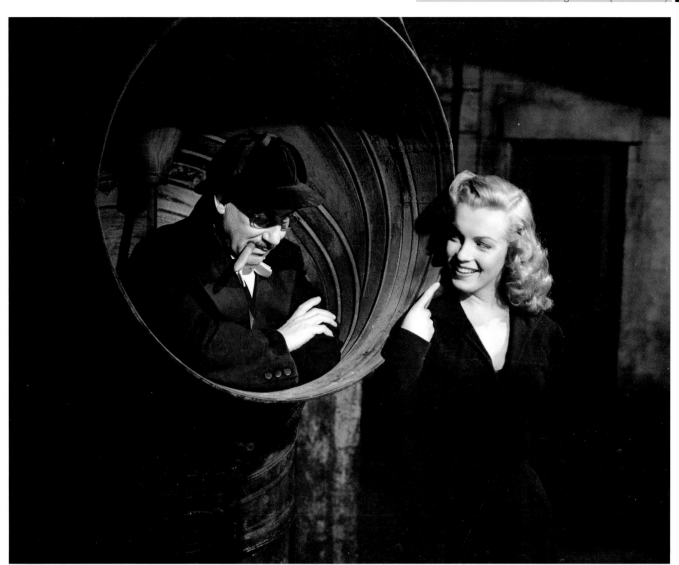

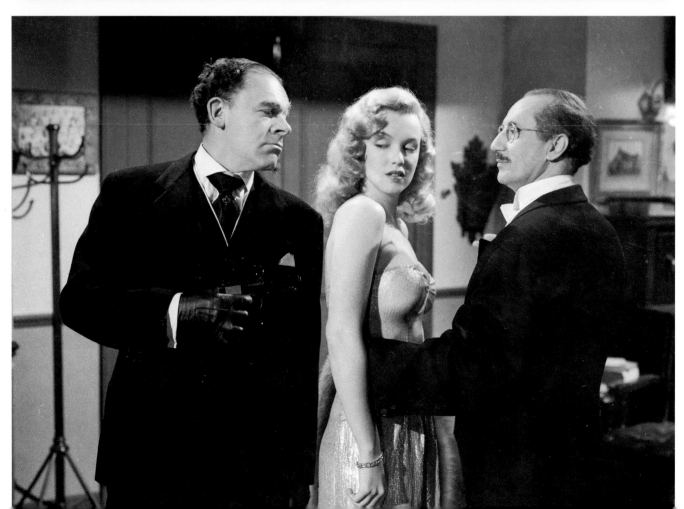

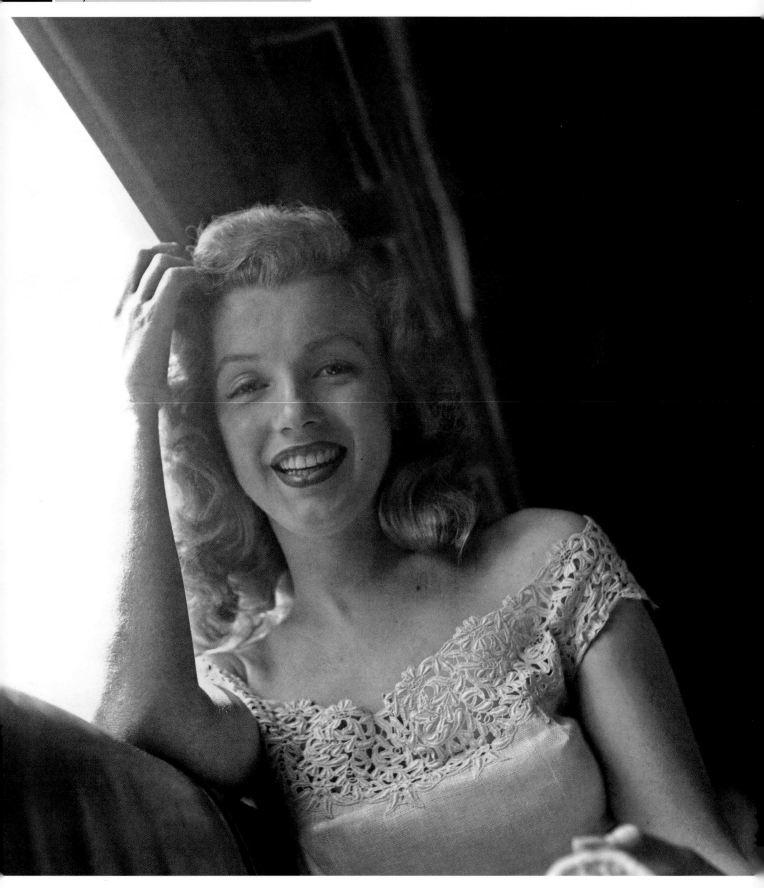

Marilyn was chosen to help promote *Love Happy*,
traveling to New York in June 1949 with Lester
Cowan. While there, one of the publicity stunts was
to present *Photoplay* magazine's "Dream House"
contest winner with the keys to their new home
in Warrenburg, New York. Her companion is Lon
McCallister, who was in *Scudda Hoo! Scudda Hay!*, one
of her first acting roles, although her scenes were cut.

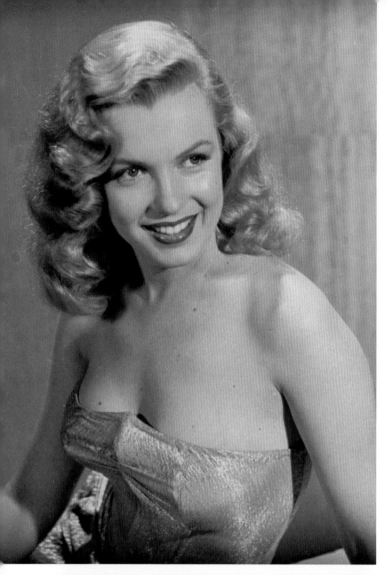

Johnny Hyde

At some stage in 1949 Marilyn met Johnny Hyde, vice president of William Morris, one of the top agencies in Hollywood. Hyde fell head over heels in love, and left his wife and four sons for her. He bought Lipton out of his agenting agreement and concentrated on Marilyn's career full time. This photo, by photographer and friend Bruno Bernard, shows Marilyn on the diving board of the Palm Springs Racquet Club where she is said to have met Hyde.

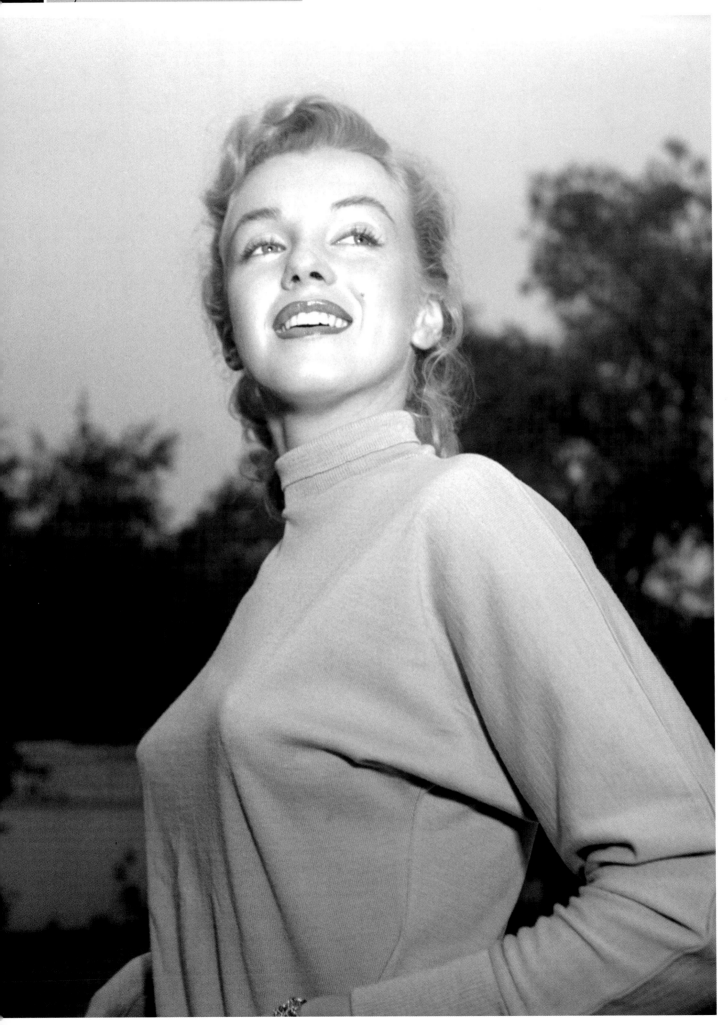

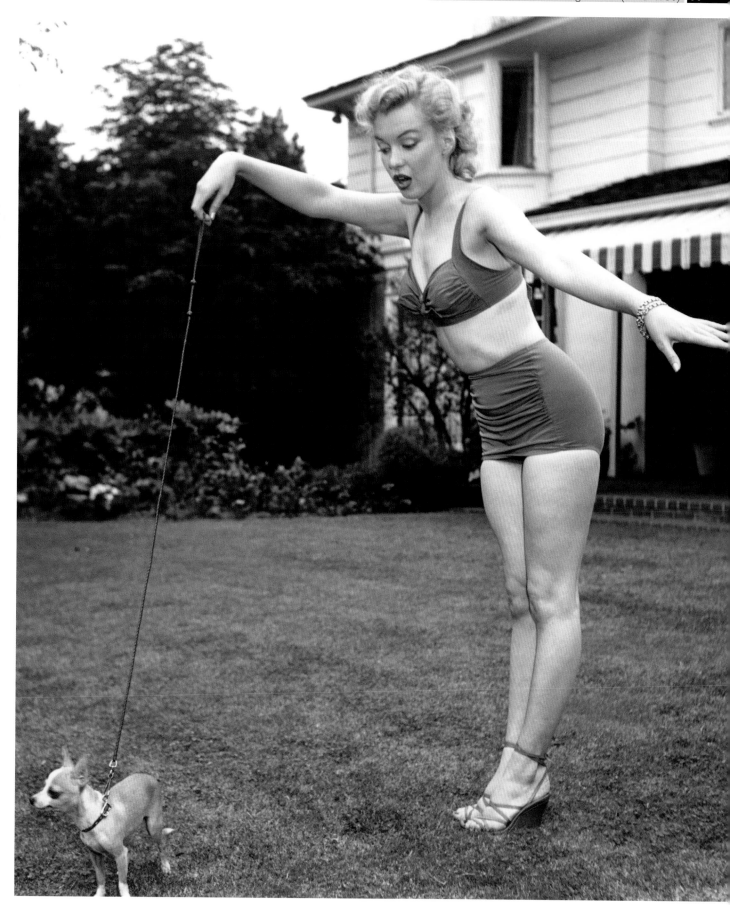

After leaving his family, Johnny Hyde moved into 718 North Palm Drive
in Beverly Hills, and Marilyn moved in with him, although she kept an
apartment for the sake of propriety. He repeatedly proposed to her but
she refused. She would later say, "He said he loved me … I knew it was
true … I wished with all my heart that I could love him too." These photos
(and overleaf) were taken in the backyard of 718 North Palm Drive.

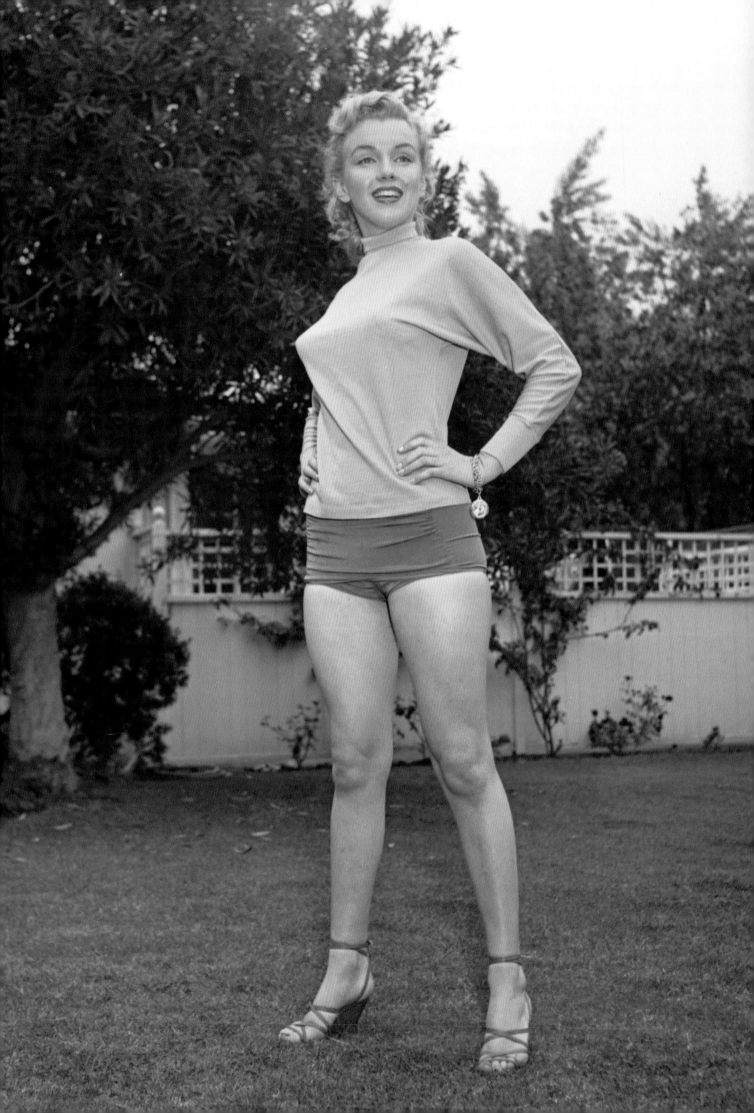

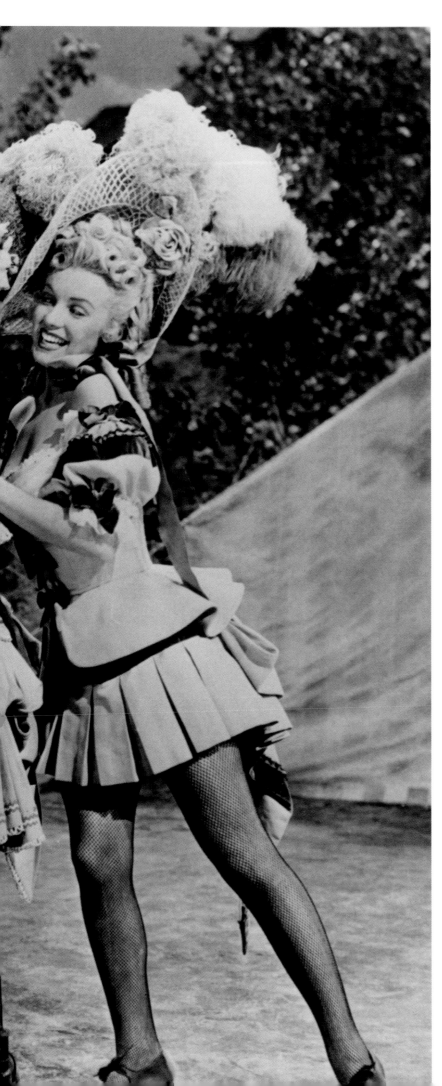

A Ticket to Tomahawk

Johnny Hyde pushed Marilyn into a number of screen tests and she landed a role in a musical western. She was cast as a showgirl and sang "Oh, What A Forward Young Man You Are." The movie was shot on location in Durango, CO, in August 1949, premiering in Denver on April 18, 1950. Here (left) she is one of the girls surrounding Dan Dailey.

Cast & Credits

Dan Dailey—Johnny Behind-the-Deuces
Anne Baxter—Kit Dodge Jr.
Walter Brennan—Terrance Sweeny
Marilyn Monroe—Clara

Director: Richard Sale
Producer: Robert Bassler
Writer: Mary Loos & Richard Sale
Music: Cyril J. Mockridge
Cinematography: Harry Jackson
Studio: Twentieth Century-Fox
General release date: May 19, 1950

"A struggle with shyness is in every actor more than anyone can imagine ... I'm one of the world's most self-conscious people. I really have to struggle."
MARILYN

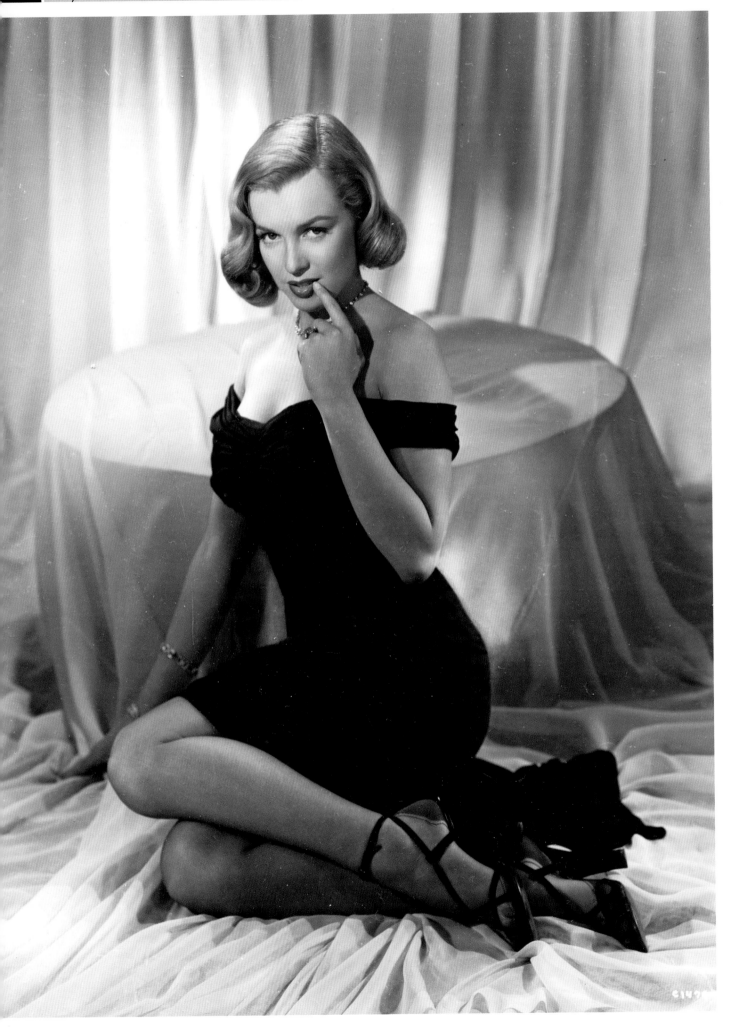

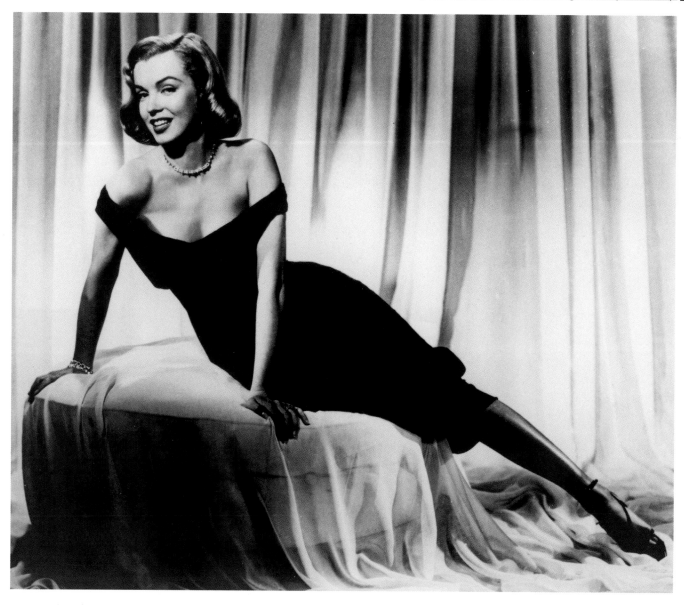

The Asphalt Jungle

Marilyn's big break came when John Carroll and his wife strong-armed John Huston into casting Marilyn in this stylish film noir thriller. She hadn't impressed at the audition, but she performed brilliantly, as *Photoplay* said: "There's a beautiful blonde too, name of Marilyn Monroe, who plays Calhern's girlfriend, and makes the most of her footage."

Cast & Credits

Sterling Hayden—Dix Handley
Louis Calhern—Alonzo D. Emmerich
Jean Hagen—Doll Conovan
James Whitmore—Gus Ninissi
Sam Jaffe—Doc Riedenschneider
Marilyn Monroe—Angela Phinlay

Director: John Huston
Producer: Arthur Hornblow Jr.
Writer: Screenplay by Ben Maddow and
John Huston of a novel by W.R. Burnett
Music: Miklos Rozsa
Cinematography: Harold Rosson
Studio: MGM
General release date: June 8, 1950

> *"Make a note of Marilyn Monroe as the crooked lawyer's girl friend. She's got personality plus."*
>
> **THE DAILY MIRROR**

1479-

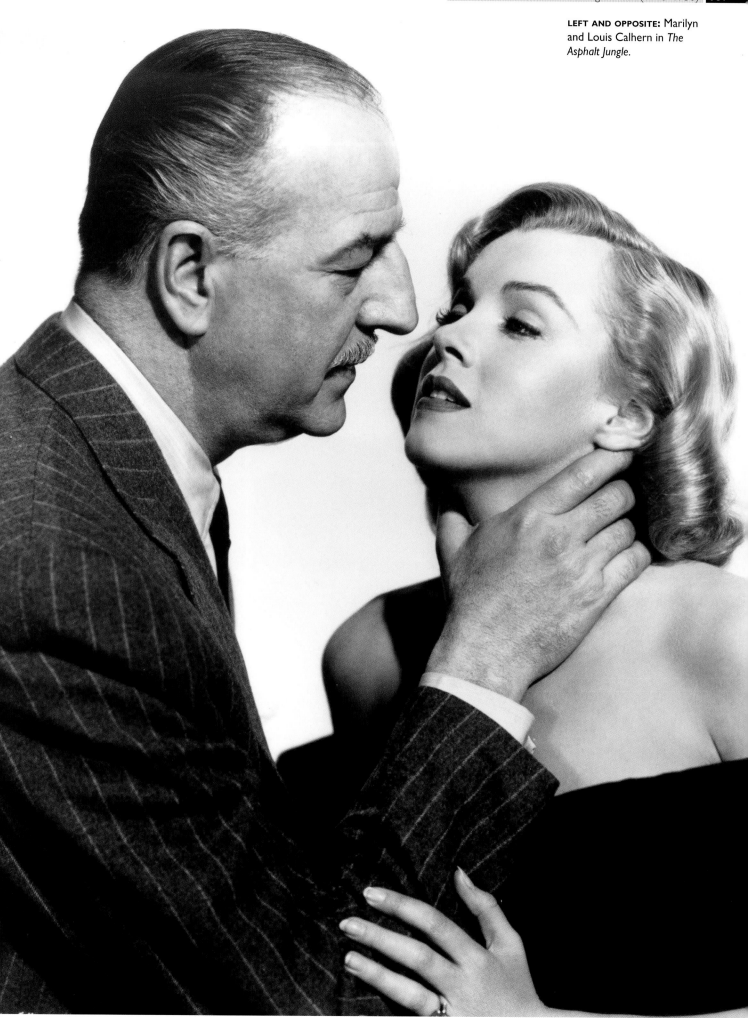

Right Cross

In early 1950 Marilyn had small parts in two movies, the lesser being *Right Cross*, a boxing drama starring Dick Powell (seen here). It premiered on October 6, the day before *The Fireball*.

The Fireball

Shot in January 1950, this roller-skating vehicle for Mickey Rooney premiered the day after *Right Cross*. The actor between Mickey Rooney and Marilyn in the photo above is James Brown, better known as Lt. Rip Masters in TV's *Adventures of Rin Tin Tin*.

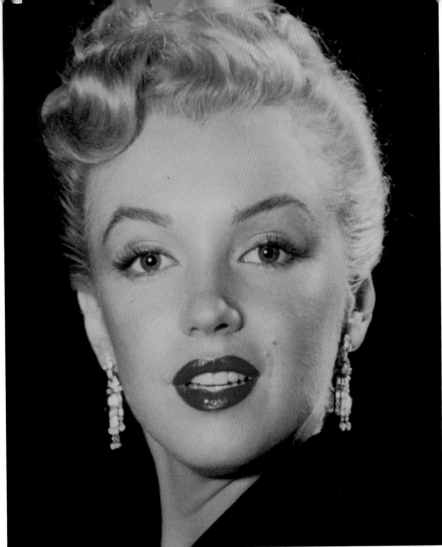

Almost Unknown

Ed Clark recalled his first session with Marilyn in August 1950. He continued, "Three months before this shoot, she appeared as a crooked lawyer's girlfriend in *The Asphalt Jungle*; two months later, she had a small role as an aspiring starlet in *All About Eve*." The shoot was between the two movies and shows a young woman—she had just turned 24—flowering into a real beauty, wearing a fur and dangling rhinestone earrings.

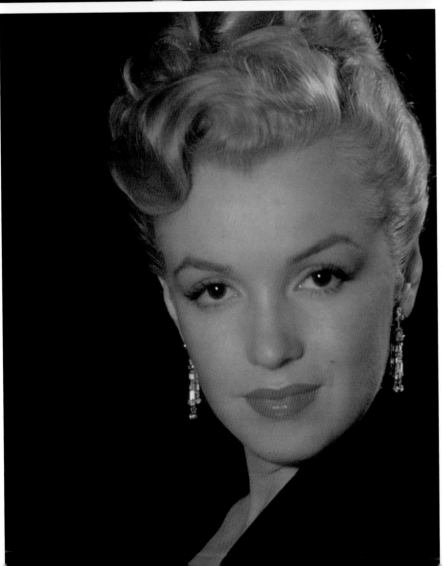

"She was almost unknown then, so I was able to spend a lot of time shooting her."

ED CLARK

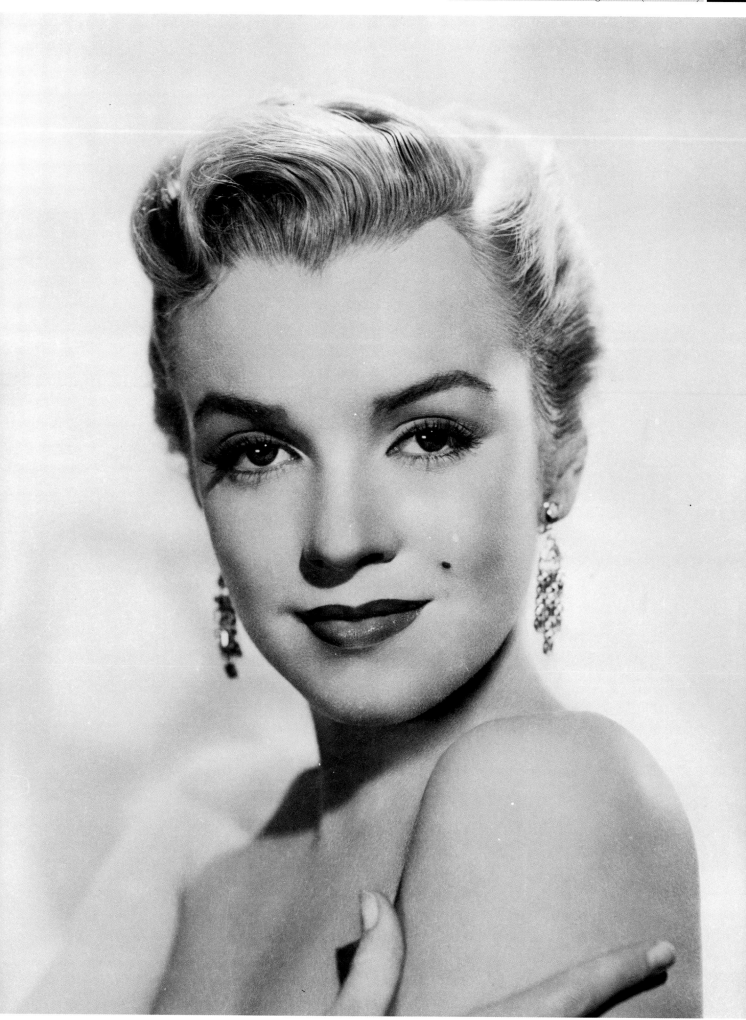

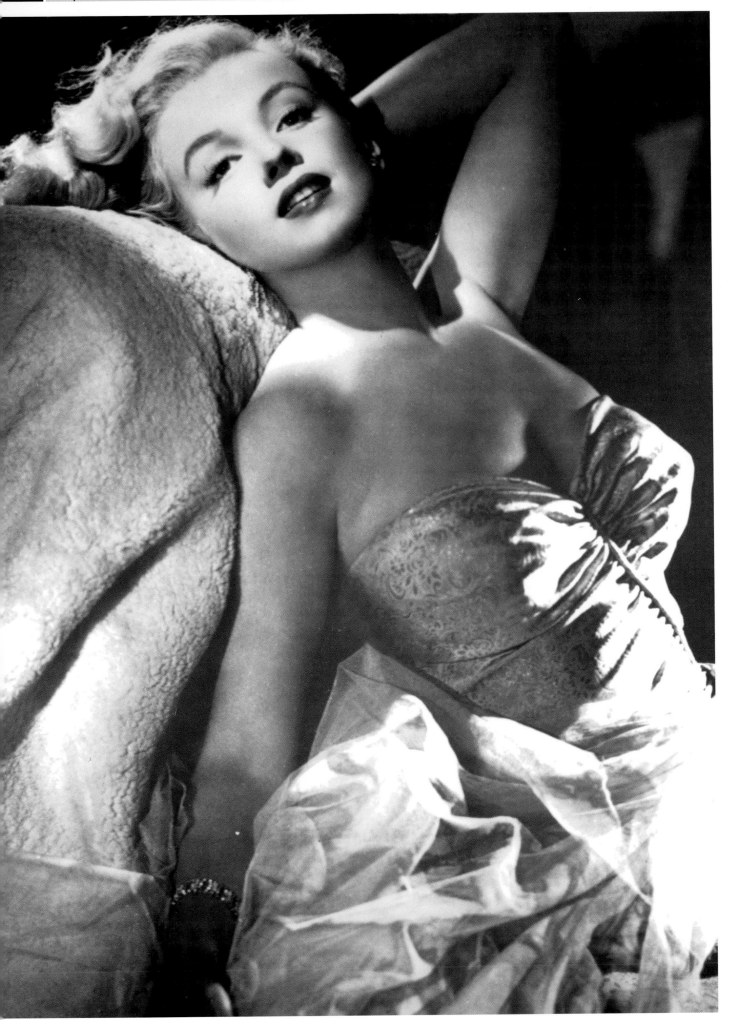

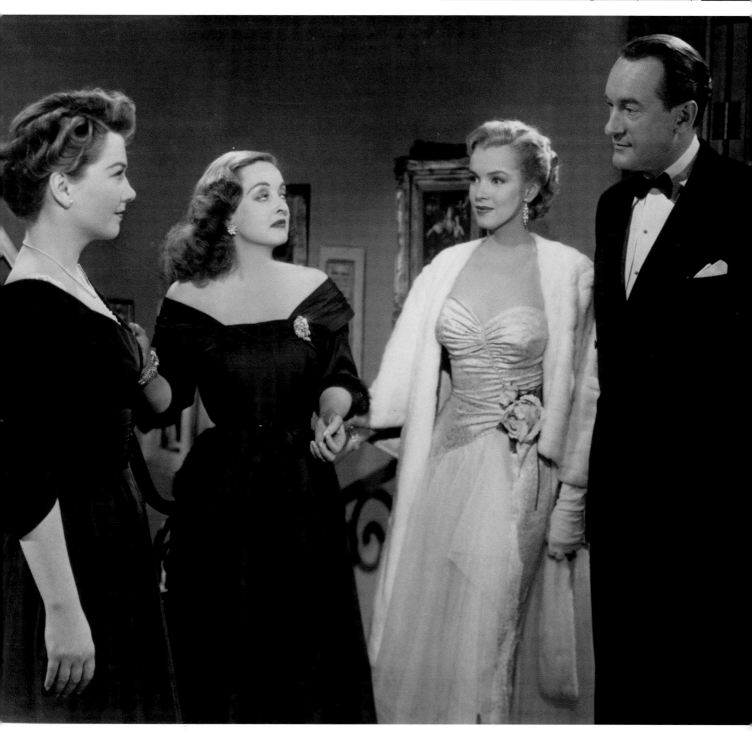

All About Eve

Hyde managed to get Marilyn a contract from Fox for a role in *All About Eve* that shot in New York in May and June 1950. Marilyn was in awe of the star of the movie, Bette Davis (see in photo above: L–R Anne Baxter, Bette Davis, Marilyn, and George Sanders), and needed multiple takes to complete one particular scene, even having to leave the set to be sick. While her role didn't amount to much, it was good to be associated with a success. Nominated for 14 Academy Awards including a record four female acting nominations (not for Marilyn), in 1990 *All About Eve* was one of the first fifty films to be registered by the Library of Congress for preservation.

Cast & Credits

Bette Davis—Margo Channing
Anne Baxter—Eve Harrington
George Sanders—Addison DeWitt
Celeste Holm—Karen Richards
Gary Merrill—Bill Sampson
Marilyn Monroe—Miss Casswell

Director: Joseph L. Mankiewicz
Producer: Darryl F. Zanuck
Writer: Screenplay by Joseph L. Mankiewicz based on Mary Orr's 1946 short story "The Wisdom of Eve."
Music: Alfred Newman
Cinematography: Milton R. Krasner
Studio: Twentieth Century-Fox
General release date: November 9, 1950

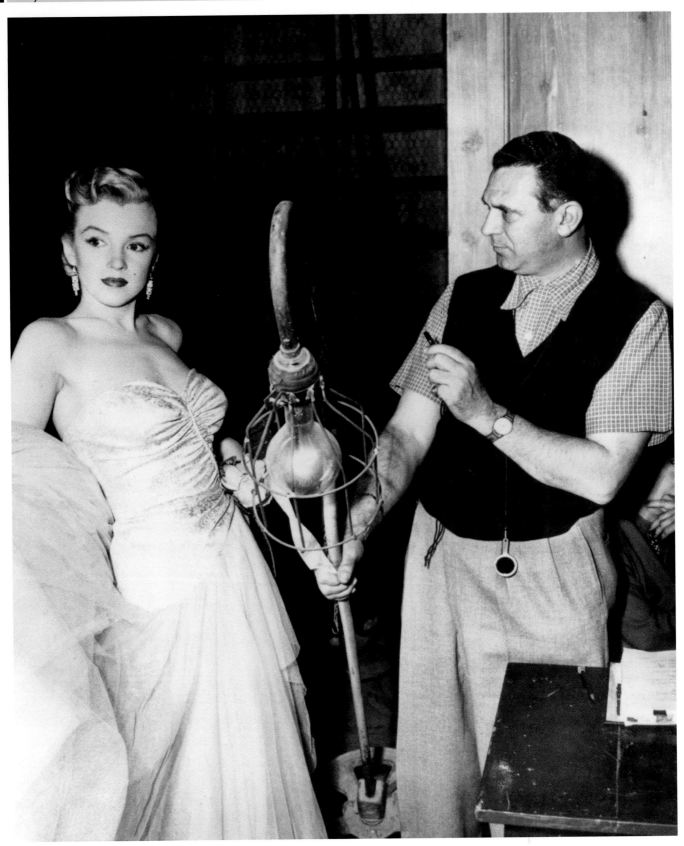

"Johnny Hyde was
wonderful . . . but he was
not my Svengali."

MARILYN

ABOVE: A technician checks the lighting for Marilyn during a rehearsal for *All About Eve*.

RIGHT: Marilyn got a part that had been considered for Angela Lansbury and performed well enough for Twentieth Century-Fox's Darryl F. Zanuck to agree to another screen test. Zanuck saw the results in December 1950 and immediately ordered a six-month contract. Johnny Hyde sorted out the details and a few days later, on December 18, died of his longstanding heart problems. Marilyn was devastated.

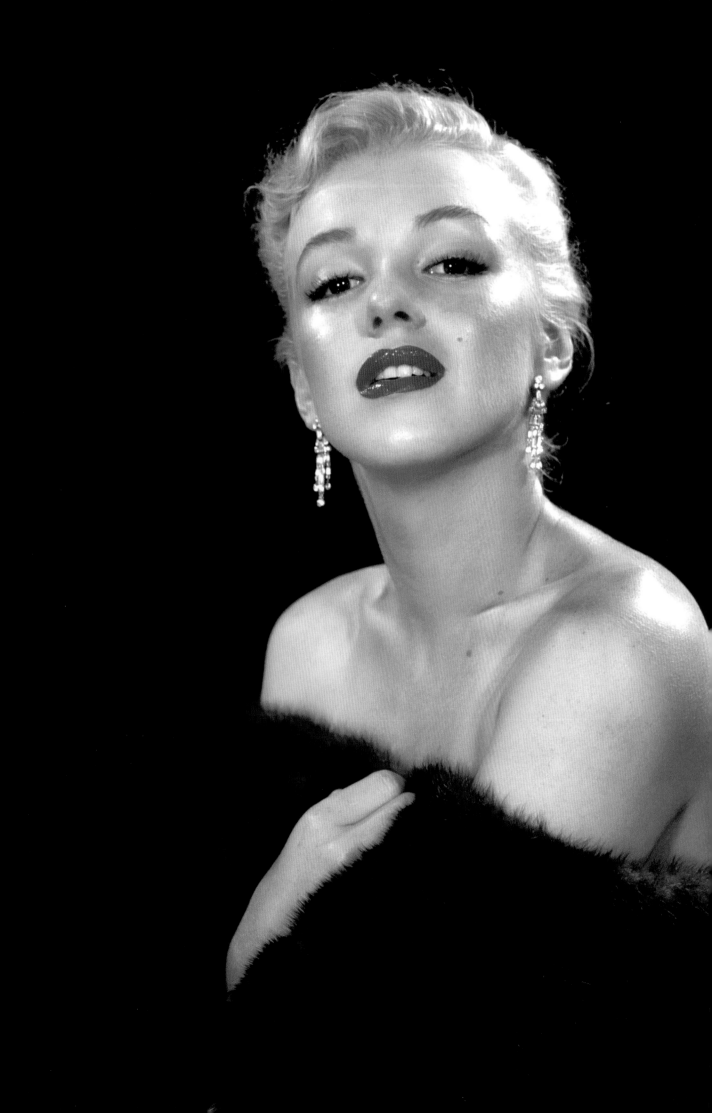

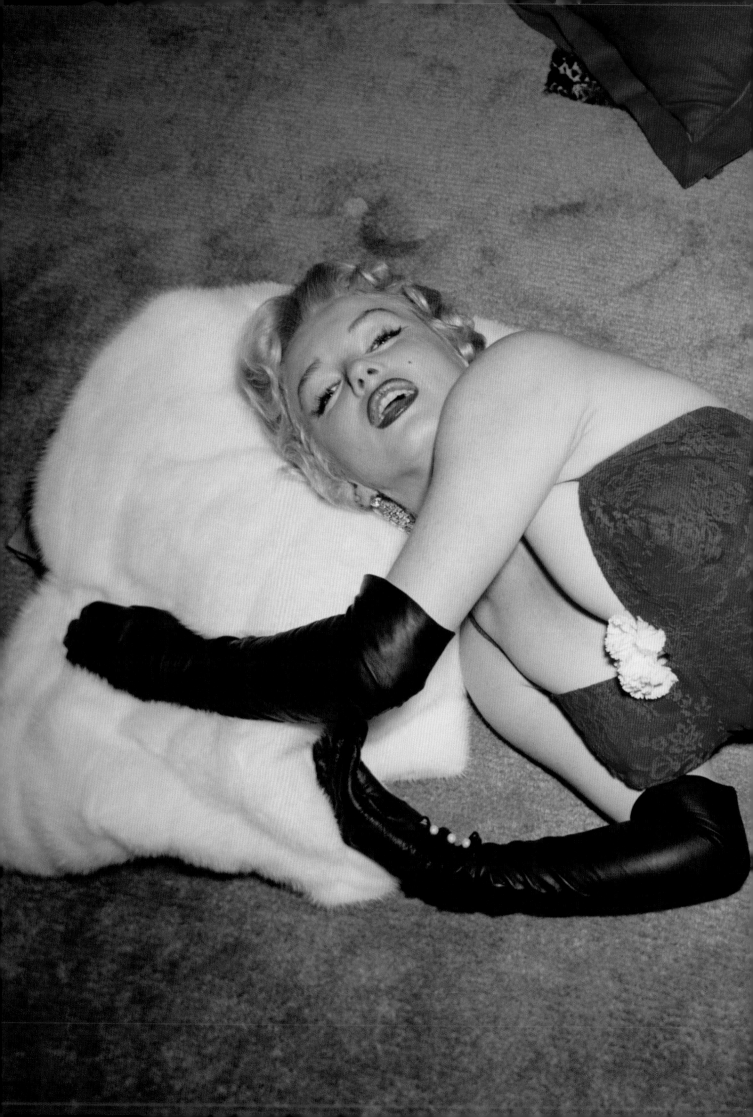

CHAPTER 3

The Talk of Hollywood (1951–1955)

Cast in larger roles with better directors, Marilyn made numerous movies in the first two years of the fifties, but her first breakthrough role came in 1953 with *Gentlemen Prefer Blondes*, a role that cemented her "blonde bombshell" persona and propelled her into Hollywood's A list.

For a while, it looked like all Marilyn's dreams might come true. She was a bona fide movie star and, in January 1954, married baseball hero Joe DiMaggio before further endearing herself to the nation by performing for servicemen in Korea. Sadly, her second husband was never happy with her sexy image and the marriage ended only nine months later (though he would remain a close friend for the rest of her life).

Disillusioned with Hollywood and particularly with her studio—again, Twentieth Century-Fox—Marilyn ended the year by forming her own production company and moving her base to New York. In her new home, she joined Lee Strasberg's Actors Studio and became involved with the married playwright Arthur Miller.

LEFT: Gene Lester took this fabulous image of Marilyn in March 1956 in her house on North Beverly Glen Boulevard where she was staying during the shooting of *Bus Stop*.

Timeline 1951—1955

1951

March 29 At the 23rd Academy Awards ceremony, Marilyn presents Thomas Moulton with the Oscar for Best Recording for his work on *All About Eve*.

May 11 Marilyn's short-term contract with Twentieth Century-Fox is extended to a new seven-year contract.

May 18 *Home Town Story* premieres. Marilyn plays a secretary. in a low budget movie about a local newspaper.

August 2 *As Young as You Feel* premieres. In another beautiful secretary role, Marilyn gets a good review in *The New York Times*.

September 8 First major national story on Marilyn, Robert Cahn's "Hollywood's 1951 Model Blonde" appears in *Collier's* magazine.

October 10 *Love Nest* premieres; Marilyn plays an ex-WAC.

October 31 *Let's Make it Legal* premieres.

Fall Marilyn enrolls to study acting with coach Michael Chekhov.

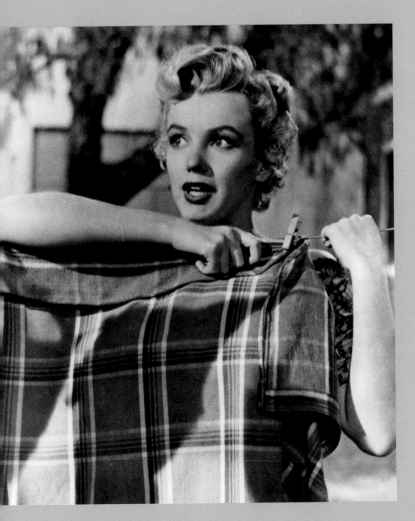

1952

March 8 DiMaggio and Marilyn meet at Villa Nova, an Italian restaurant on Sunset Boulevard.

March 13 Marilyn's nude photo shoot is exposed in the newspapers.

March 15 Marilyn wins *Look* magazine's "The Most Promising Female Newcomer" award.

April 7 Marilyn's first *Life* cover is photographed by Phillipe Halsman.

June 16 *Clash By Night* premieres in Los Angeles.

LEFT: Marilyn in *Clash By Night*.

RIGHT: Marilyn costume session for *Niagara*.

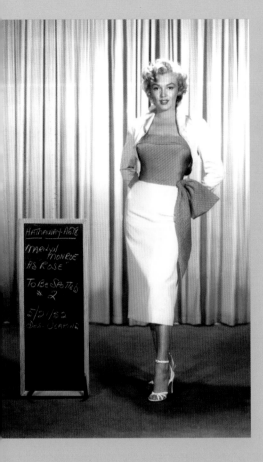

July 18 *Don't Bother to Knock* premieres in New York. Marilyn plays a disturbed, murderous babysitter.

July 23 *We're Not Married!* premieres in Los Angeles. Marilyn stars in one section of a six–part romantic comedy.

August 7 O. Henry's *Full House* premieres in Greensboro, NC. Another anthology movie, Marilyn plays a streetwalker in her section.

September 2 Marilyn is Grand Marshall for the Miss America Pageant parade in Atlantic City, NJ. The same day *Monkey Business* is premiered.

1953

January 21 Release of *Niagara* in New York. Marilyn takes the headlines in this film noir. "Here is the greatest star since Jean Harlow," says the *Los Angeles Examiner*.

March 9 Marilyn receives the "Best Young Box Office Personality" from *Redbook* magazine.

May 23 Marilyn and Jane Russell appear on the cover of *Life* magazine in a still from *Gentlemen Prefer Blondes*.

June 26 Marilyn and Jane Russell impress their hands in wet cement
at Grauman's Chinese Theatre.

June 30 Marilyn, Betty Grable, and Lauren Bacall—the stars of *How to Marry a Millionaire*—appear on the cover of *Look* magazine.

July 1 *Gentlemen Prefer Blondes* premieres in Atlantic City, NJ. "As usual," says the review in *New York Herald Tribune*, "Miss Monroe looks as though she would glow in the dark, and her version of the baby-faced blonde whose eyes open for diamonds and close for kisses is always amusing as well as alluring."

Timeline 1951-1955

September 13 Marilyn makes her live television debut on Jack Benny's CBS-TV show.

September 28 Marilyn's one-time guardian, Grace McKee, is found dead of a barbiturate overdose.

November 4 *How to Marry a Millionaire* premieres in Los Angeles.

December First issue of *Playboy*: Marilyn is on the cover.

December 31 Joe DiMaggio proposes to Marilyn.

1954

January 4 Fox suspends Marilyn for failing to appear for filming *Girl in the Pink Tights*.

January 14 Marilyn and Joe DiMaggio marry at a civil ceremony at San Francisco City Hall.

January 22 Marilyn wins the Henrietta Award for World Film Favorite Female at the Golden Globes.

February 2–23 Marilyn and Joe go to Japan. Marilyn undertakes a ten-venue tour of Korea to entertain the troops.

March 8 Marilyn receives the Best Actress Award from *Photoplay* magazine for *Gentlemen Prefer Blondes* and *How to Marry a Millionaire*.

April 30 Premiere of *River of No Return*.

September 15 Infamous skirt-blowing scene for *The Seven Year Itch* is shot at Lexington Avenue and 52nd Street. Joe is insanely jealous.

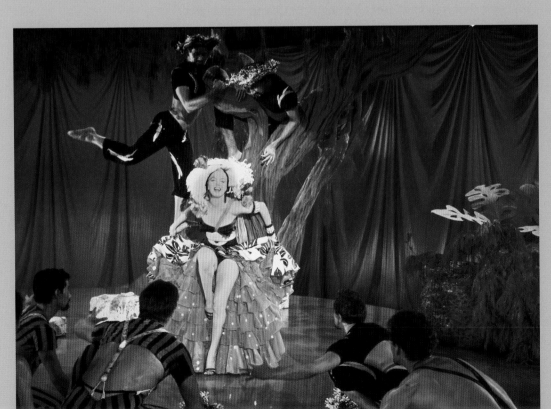

LEFT: Marilyn on the set of the musical *There's No Business Like Show Business*.

ABOVE: Marilyn while she donated her services as an usherette at the premiere of *East of Eden* at the Astor Theatre.

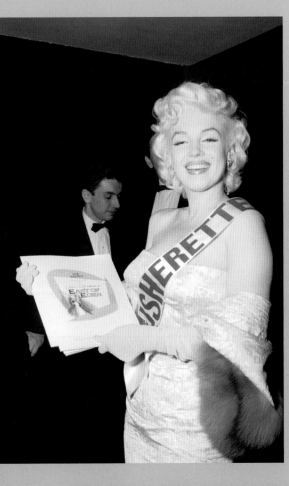

September 16 Marilyn and Joe return to Los Angeles. Two weeks later, Marilyn files for divorce.

December 16 *There's No Business Like Show Business* premieres.

1955

January 7 Marilyn and Milton Greene hold a press conference at which they announce the creation of Marilyn Monroe productions.

January 15 Marilyn moves to the East Coast and is once again suspended by Fox.

February Lee Strasberg, leader of the prestige Actors Studio acting school, agrees to take Marilyn on.

March 9 At the premiere of *East of Eden* in New York City, Marilyn acts as an usherette in aid of the Actors Studio. She renews her acquaintance with Arthur Miller.

March 30 Marilyn appears riding a pink elephant at Madison Square Garden for the New York Arthritis & Rheumantism Foundation.

June 1 *The Seven Year Itch* premieres on Marilyn's birthday.

September 29 Marilyn attends the opening of Arthur Miller's *A View From the Bridge*.

October 5 Miller is thrown out of his house after his wife finds out about his affair with Marilyn.

October 31 Final divorce decree ends Marilyn and Joe DiMaggio's marriage ... but Joe will always be there for her. On the same day, lawyers for Twentieth Century-Fox and Marilyn Monroe Productions agree a new contract.

December 12 Marilyn and Marlon Brando are photographed together and an affair is alleged.

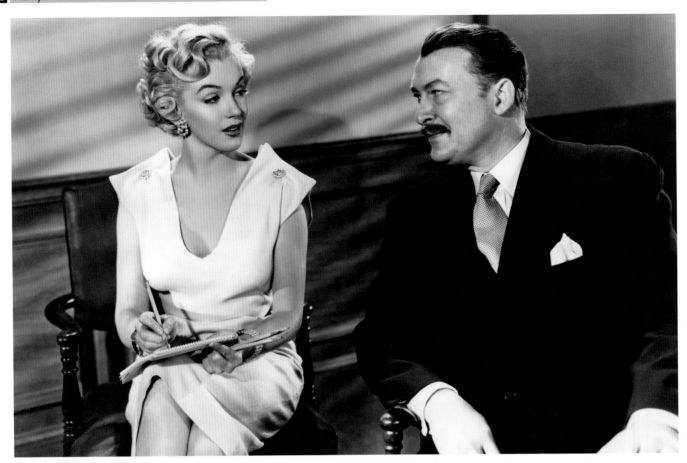

As Young as You Feel

Playing a secretary—a regular role in the early days—Marilyn impressed *The New York Times*: "There is so much that is pleasant about this gay, shrewd and unaffected film, tossed off with a wink and chuckle, that you should try not to let it slip by." Shot in January 1951, *As Young as You Feel* went on general release on August 2. Still shocked by the death of Johnny Hyde, Marilyn's spirits were revived during the shooting of the movie by a love affair with co-founder of the Actors Studio, Elia Kazan. It was through Kazan that she met Arthur Miller for the first time. Here (above), Marilyn in a scene with Albert Dekker.

Cast & Credits

Monty Woolley—John R. Hodges
Thelma Ritter—Della Hodges
David Wayne—Joe Elliott
Jean Peters—Alice Hodges
Constance Bennett—Lucille McKinley
Marilyn Monroe: Harriet

Directed: Harmon Jones
Produced: Lamar Trotti
Writer: Screenplay Lamar Trotti from a story by
Paddy Chayefsky
Music: Cyril J. Mockridge
Cinematography: Joseph MacDonald
Studio: Twentieth Century-Fox
General release date: August 2, 1951

LEFT: Anthony Beauchamp was a successful English portrait photographer who met Marilyn in 1950 and first photographed her at Charles Laughton's home. In 1951, over two weeks in spring, he took a series of informal photos of Marilyn capering on Santa Monica beach. A picture from the session made the March 1953 cover of *Focus* magazine.

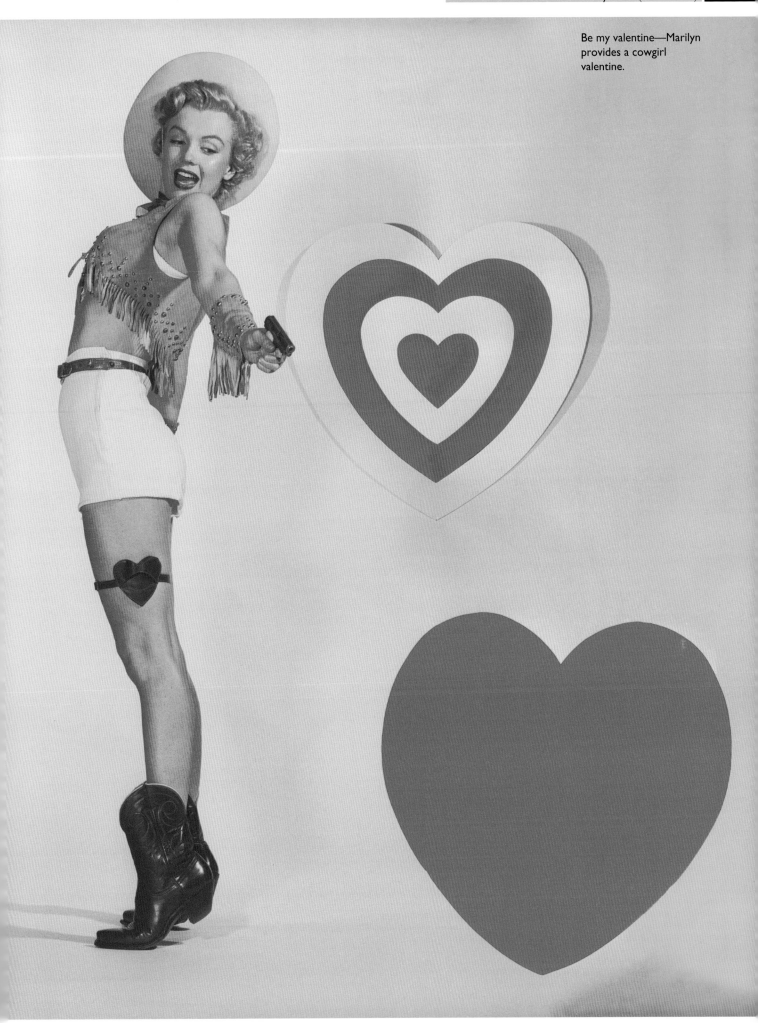

Be my valentine—Marilyn provides a cowgirl valentine.

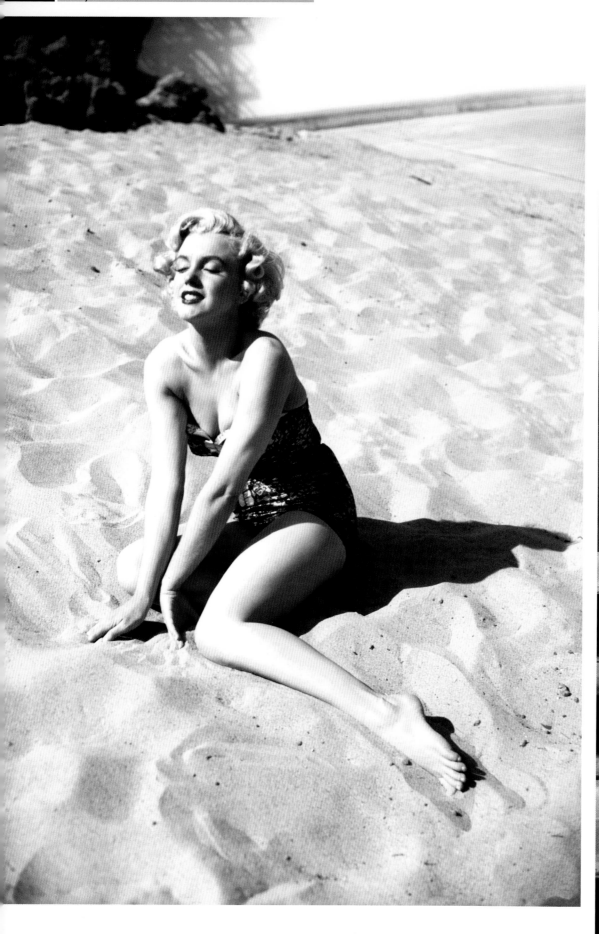

ABOVE AND RIGHT: A classic Earl Theisen publicity shoot of Fox's rising star: Marilyn poses on the Twentieth Century-Fox backlot. Contract negotiations finally saw her sign a seven-year agreement on May 11. As part of the deal, her acting coach, Natasha Lytess, went onto the Fox payroll.

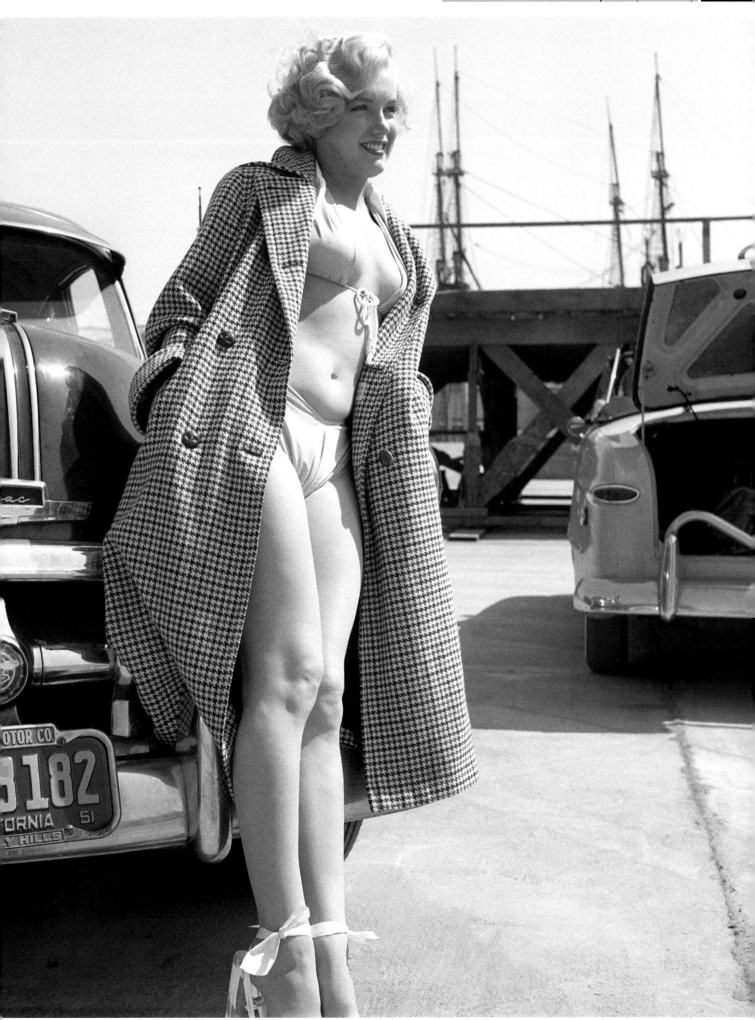

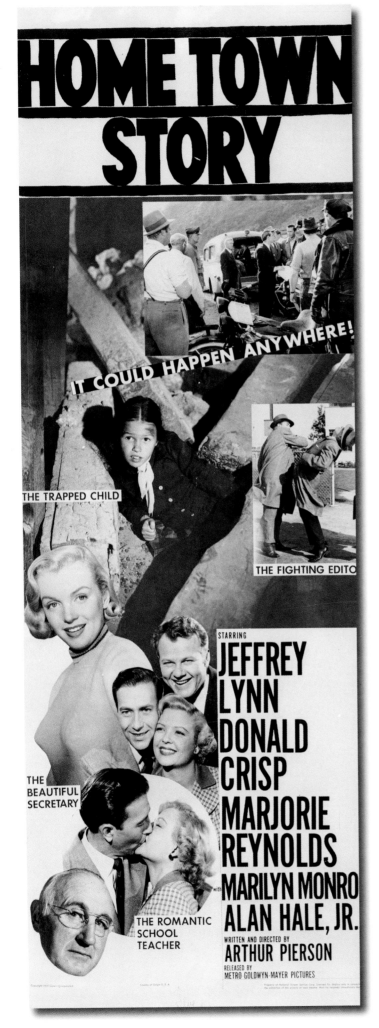

Home Town Story

In the last movie Marilyn did for MGM, the political drama *Home Town Story* written and directed by Arthur Pierson, she played another secretary. It went on general release on May 18, 1951. The movie was backed by General Motors and James D. Ivers of the *Motion Picture Herald* noted: "In short and simple terms, at times almost too simple, this hour-long offering attempts with no subtlety whatsoever a blanket defense of business." Undoubtedly, *Home Town Story* would have been consigned to the dustbin of history had it not been for Marilyn's involvement, which was low key and far removed from the dressier, glamorous roles she would play in 1952.

Cast & Credits
Cast at left on poster.
Director: Arthur Pierson
Producer: Arthur Pierson
Writer: Arthur Pierson
Music: Louis Forbes
Cinematography: Lucien Andriot
Studio: MGM
General release date: May 18, 1951

Let's Make It Legal

During July 1951 Marilyn filmed *Let's Make It Legal*, a light comedy that premiered on October 31 in Los Angeles and went on general release on November 6 of the same year. While filming was taken place, Marilyn posed for a portrait on a staircase in front of a dramatic purple bougainvillea (right). The photograph was taken by Don Ornitz who was one of the "Hollywood Ten" during the McCarthy era.

Cast & Credits
Claudette Colbert—Miriam Halsworth
Macdonald Carey—Hugh Halsworth
Zachary Scott—Victor Macfarland
Barbara Bates—Barbara Denham
Robert Wagner—Jerry Denham
Marilyn Monroe—Joyce Mannering

Director: Richard Sale
Producer: Robert Bassler
Writer: Screenplay by I.A.L. Diamond and F. Hugh Herbert from a story by Mortimer Braus
Music: Cyril J Mockridge
Cinematography: Lucien Ballard
Studio: Twentieth Century-Fox
General release date: November 6, 1951

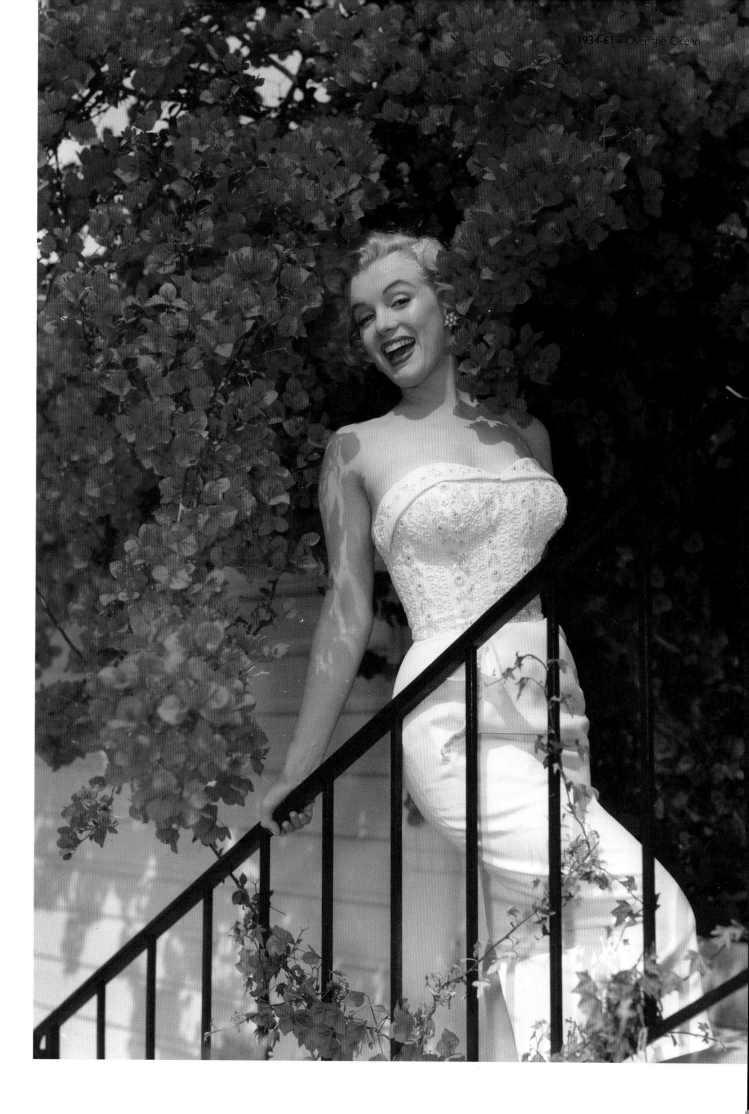

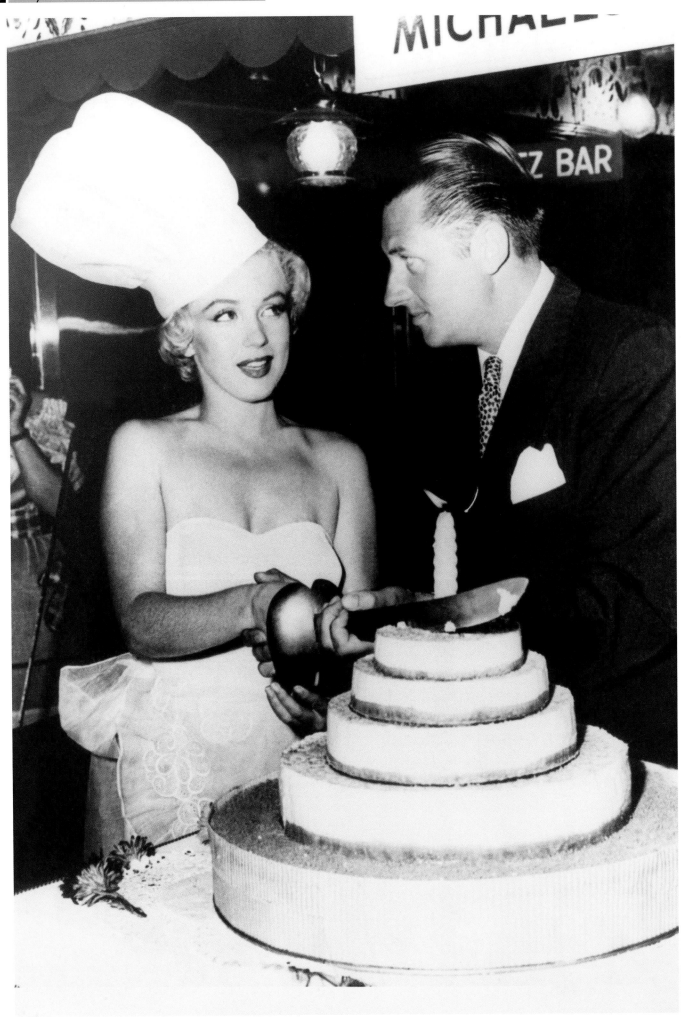

Love Nest

Variety said the movie had, "A rather dated theme ... Marilyn Monroe is tossed in to cause jealousy between the landlords." Darryl F. Zanuck might have typecast her as a sexy secretary—he said of her, "She's a sexpot who wiggles and walks and breathes sex"—but she had bigger dreams. While playing an ex-WAC in this romcom, Marilyn was studying at UCLA, and in the fall would arrange to study acting with Michael Chekhov.

Cast & Credits

June Haver—Connie Scott
William Lundigan—Jim Scott
Frank Fay—Charley Patterson
Marilyn Monroe—Bobbie Stevens
Jack Paar—Ed Forbes

Director: Joseph M. Newman
Producer: Jules Buck
Writer: Screenplay by I.A.L. Diamond from "The Reluctant Landlord" by Scott Corbett
Music: Cyril J. Mockridge
Cinematography: Lloyd Ahern
Studio: Twentieth Century-Fox
General release date: October 10, 1951

ABOVE: Costume fitting for *Love Nest* was on April 12; shooting took place during spring 1951 and the movie was released on October 10, 1951. Here Marilyn wears a satin robe.

LEFT: June Haver, William Lundigan, Jack Paar, and Marilyn having a drink together in a scene from *Love Nest*.

FAR LEFT: Marilyn was elected Miss Cheesecake by the magazine *Stars and Stripes*. On August 4, 1951, she was guest of honor at a party for Michael Gaszynski, a Polish diplomat celebrating his becoming an American citizen. The reception was in Hollywood Farmer's market where she cut a large cheesecake.

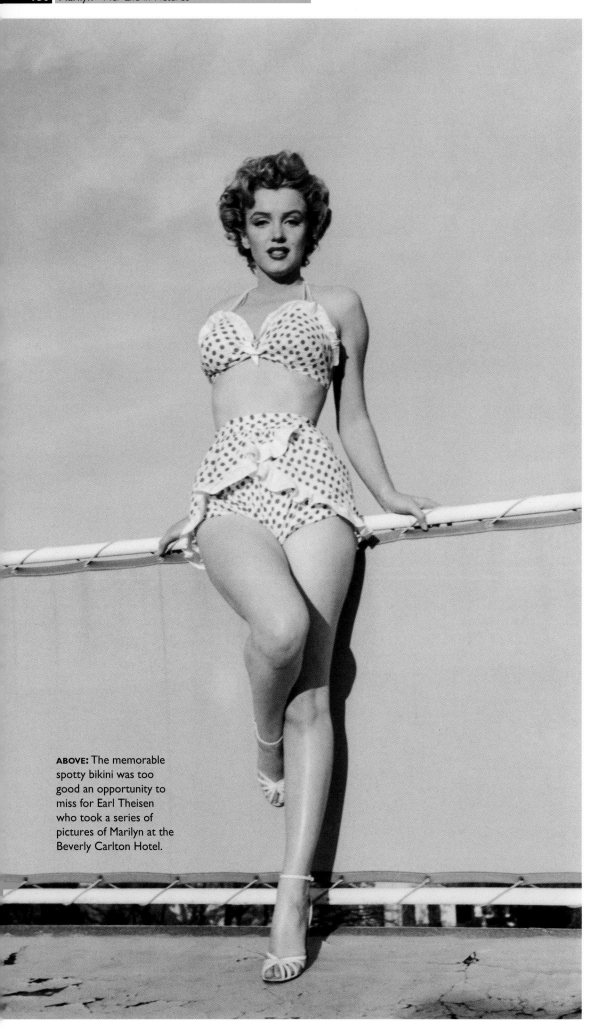

ABOVE: The memorable spotty bikini was too good an opportunity to miss for Earl Theisen who took a series of pictures of Marilyn at the Beverly Carlton Hotel.

ABOVE: Marilyn during a party at Ciro's Restaurant, from a photo shoot for *Modern Screen* magazine.

RIGHT: The spotted two-piece swimsuit Marilyn donned for *Love Nest* left the crew speechless—bikins were still risqué—and the director made it a closed set while she was there. Her role saw her elected Fox's Female Star of the Month.

FAR RIGHT: The things starlets do on the way up! Marilyn poses for an Earl Theisen portrait in a dress made out of an Idaho potato sack. In fact, the idea for the shoot came about after a newspaper called her low-cut dresses vulgar and said that Marilyn would look better in a potato sack. The PR department took up the challenge and this was the result.

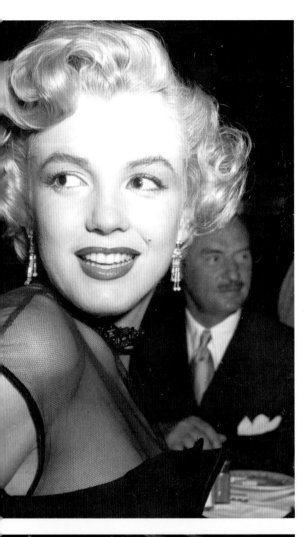

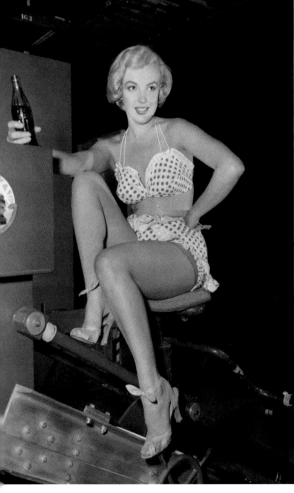

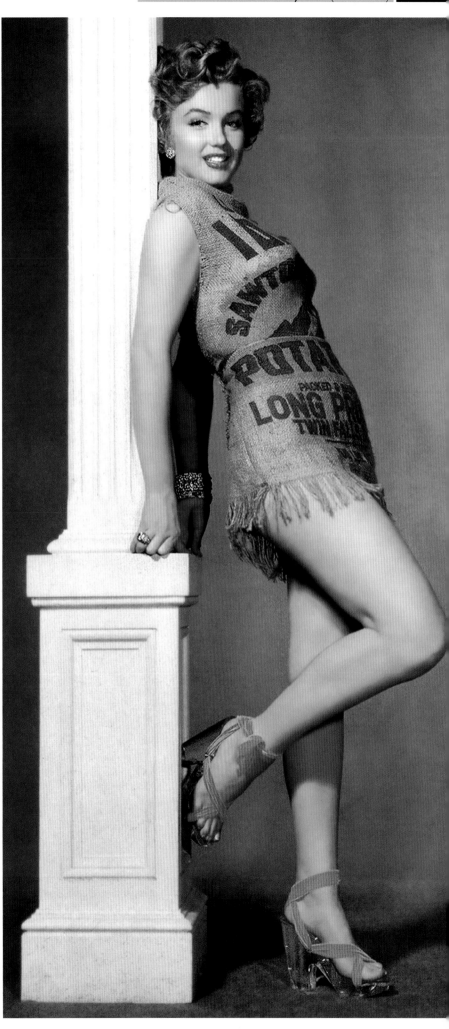

Clash by Night

Marilyn's next movie was more demanding than her recent minor comedies. *Clash by Night* was a drama that shot late summer/ fall 1951, whose release would be caught up in the furore caused by the discovery of the Tom Kelley 1949 nude calendar shoot. On loan to RKO from Fox, the shooting was marred by what would become a perennial problem for Marilyn: lateness and her insistence on having Natasha Lytess on set. She was, apparently, terrified of director Fritz Lang. His biographer, Patrick McGilligan, writes about her vomiting before almost every scene. She was lucky to find Barbara Stanwyck a sympathetic and friendly workmate, although the great star's performance would overshadow her role. *Variety* deemed the movie "a rather aimless drama of lust and passion," although it was successful at the box office.

Cast & Credits

Barbara Stanwyck—Mae Doyle D'Amato
Paul Douglas—Jerry D'Amato
Robert Ryan—Earl Pfeiffer
Keith Andes—Joe Doyle
Marilyn Monroe—Peggy

Director: Fritz Lang
Producer: Jerry Wald and Norman Krasna
Writer: Alfred Hayes's screenplay of Clifford Odets's play
Music: Roy Webb
Cinematography: Nicholas Musuraca
Studio: RKO Pictures
General release date: June 18, 1952
.

ABOVE LEFT: Robert Ryan and Marilyn. Ryan had played Joe Doyle on stage but captured the role of misogynist Earl Pfeiffer on film.

LEFT AND RIGHT: Marilyn with Keith Andes, who played her fiance.

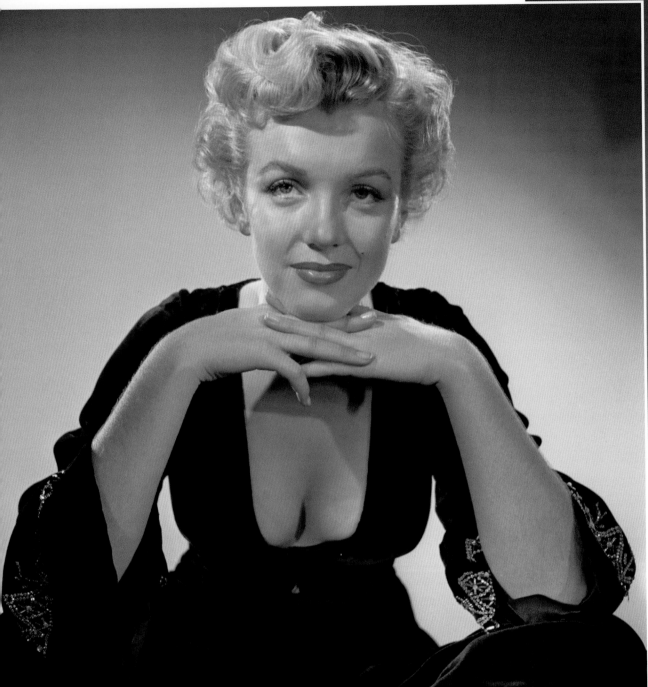

The New Jean Harlow

Marilyn sits for Earl Theisen for *Quick* magazine's November 19, 1951, cover story "Marilyn Monroe: The New Jean Harlow," in which she reprised famous Harlow poses. This was typical of Press reaction to Marilyn in the early Fifties. After seeing *Niagara*, Erskine Johnson in the *New York World Telegram & Sun*, wrote: "Hollywood took 14 years, three-score screen tests and a couple of million dollars to find a successor to Jean Harlow ..."

"Marilyn Inherits Harlow's Mantle"

ERSKINE JOHNSON (NEW YORK WORLD TELEGRAM & SON)

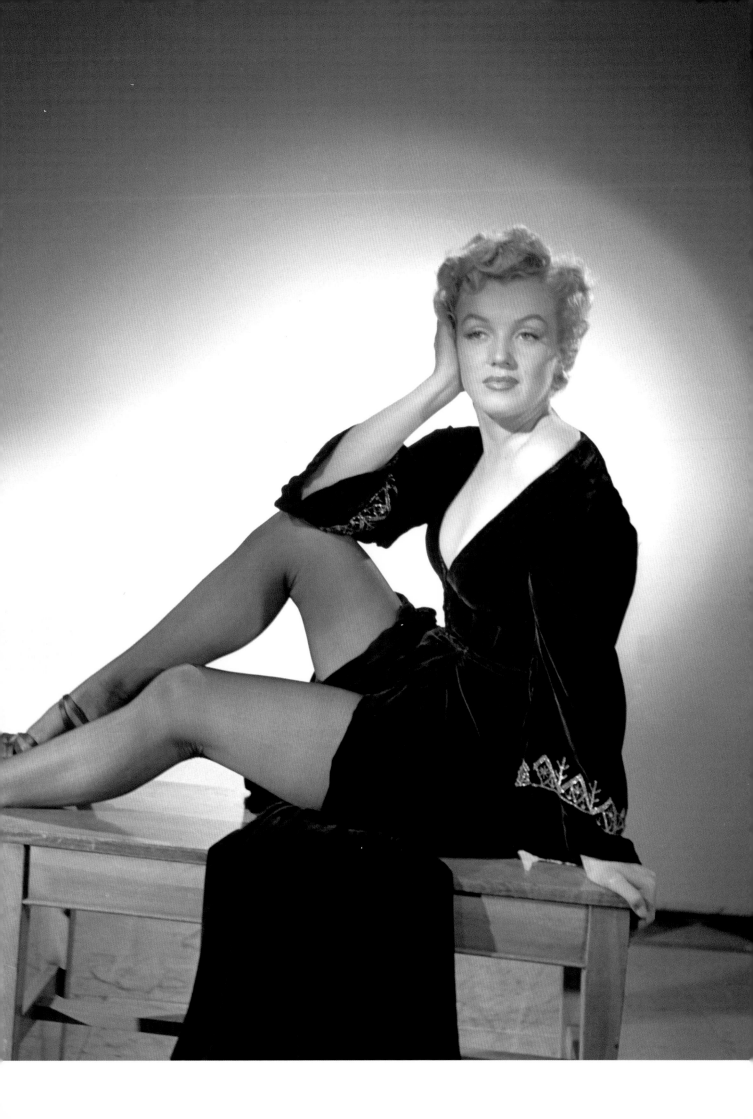

Star of Tomorrow

Marilyn was voted the Best Young Box Office Personality by the Hollywood Foreign Press Association and received her Henrietta at the Club Del Mar, Santa Monica, CA, on January 26, 1952. Photographer Loomis Dean of *Life* magazine was there to record the event, but the black and white photographs do no justice to her spectacular Oleg Cassini red velvet sheath gown that captivated her fellow guests. *Today's* online article that accompanies the images from that night over half a century ago talks about how Marilyn's life changed in 1952— meeting Joe DiMaggio and their whirlwind romance; starring in *Niagara, Gentlemen Prefer Blondes, and How to Marry a Millionaire*—and how this moment in January 1952 catapulted her to fame.

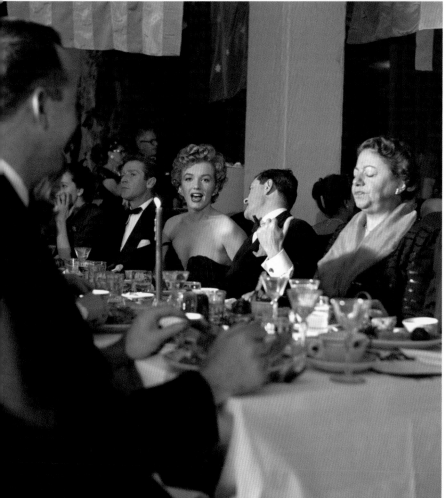

"*It's a scene straight out of a movie— but in this case, it's nothing less than a pivotal moment in a real-life Hollywood legend's life.*"

LIFE MAGAZINE

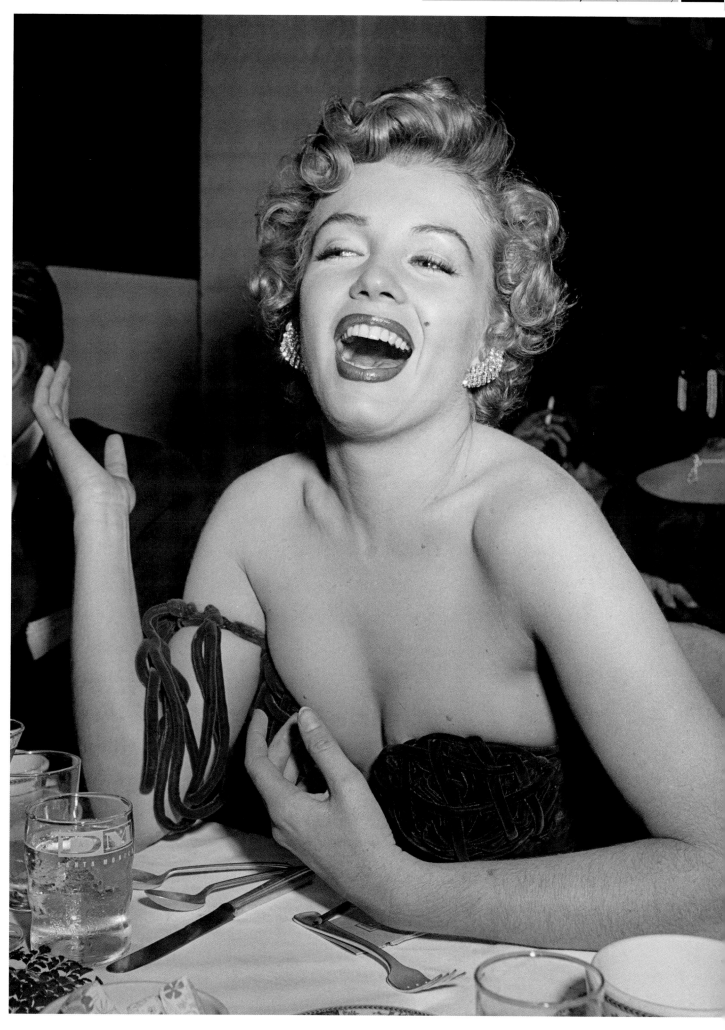

Don't Bother to Knock

Marilyn's successful handling of a dramatic role in *Clash by Night* led to another; as a disturbed babysitter in Fox's thriller *Don't Bother to Knock*. Costume fitting took place in December 1951, and the movie was shot immediately in four weeks through mid-January 1952. Following release, the critics were less kind about her than Anne Bancroft, whose first movie this was, who said, "She moved me so that tears came into my eyes."

Cast & Credits

Richard Widmark— Jed Towers
Marilyn Monroe—Nell Forbes
Anne Bancroft—Lyn Lesley
Donna Corcoran—Bunny Jones
Jeanne Cagney—Rochelle

Director: Roy Ward Baker
Producer: Julian Blaustein
Writer: Daniel Taradash's screenplay of *Mischief* by Charlotte Armstrong published in 1951.
Music: Lionel Newman
Cinematography: Lucien Ballard
Studio: Twentieth Century-Fox
General release date: July 30, 1952

LEFT: Richard Widmark and Marilyn.

A dramatic moment—Widmark and
Corcoran, playing Bunny, the girl
is babysitting.

ABOVE: Marilyn watching
Widmark and Jim Backus.

Monkey Business

It was back to the light comedies in January 1952 as Marilyn played another beautiful secretary leading principal man Cary Grant astray. It's silly but infectious—a cut above some of her 1951 comedies thanks to the involvement of Grant and Rogers.

Cast & Credits

Cary Grant—Dr. Barnaby Fulton
Ginger Rogers—Edwina Fulton
Marilyn Monroe—Lois Laurel
Charles Coburn—Oliver Oxley
Hugh Marlowe—Hank Entwhistle

Director: Howard Hawks
Producer: Sol C. Siegel
Writer: Screenplay by Ben Hecht, Charles Lederer, and I.A.L. Diamond from a story by Harry Segall
Music: Leigh Harline
Cinematography: Milton R. Krasner
Studio: Twentieth Century-Fox
General release date: September 5, 1952

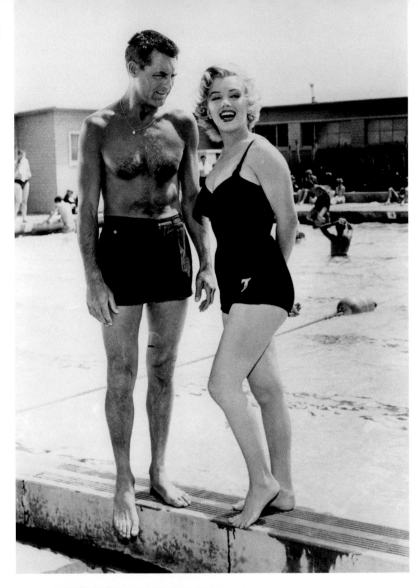

ABOVE: Marilyn and Cary Grant made a sparkling couple.

LEFT: Barnaby and Edwina Fulton (Cary Grant and Ginger Rogers) bicker in *Monkey Business*. Barnaby's secretary Lois Laurel (Marilyn) watches on.

RIGHT: Now that's a sexy secretary!

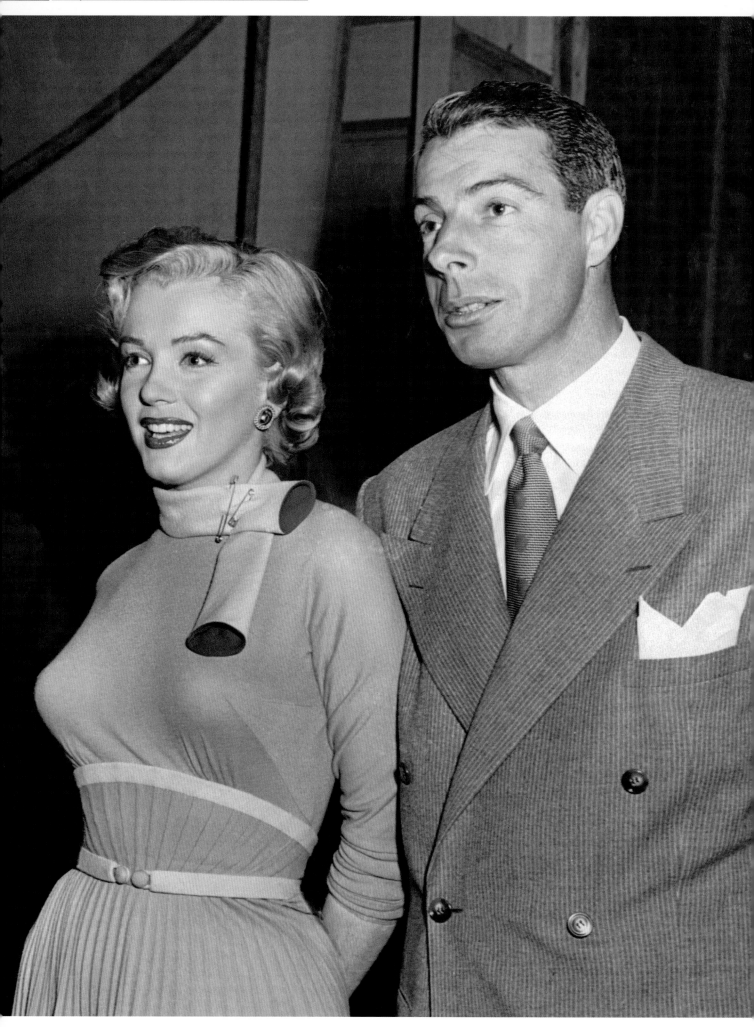

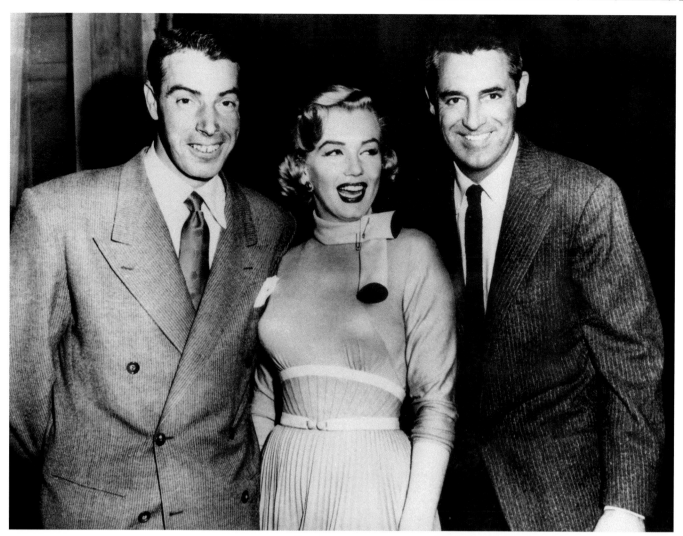

LEFT AND ABOVE: Joe DiMaggio visited the set of *Monkey Business* on the last day of shooting in April. Marilyn and he had been dating for some weeks and he was obviously very taken with her.

RIGHT: They had met on a blind date at the Villa Nova (in this photo renamed Rainbow Bar and Grill), in February 1952.

"If I hadn't been told he was some sort of ballplayer, I would have guessed he was either a steel magnate or a congressman."

MARILYN

RIGHT: Joe DiMaggio was a genuine legend. Playing his entire career (1936–1951 with a wartime break) for New York Yankees, as late as baseball's centennial in 1969 he was voted baseball's greatest living player. Here he poses for a portrait prior to a 1937 game. His number 5 was retired in 1952 with him.

OPPOSITE: Joe DiMaggio slams one out of the park. The 1951 world championship saw the Yankees' third straight title, letting Joe retire on a high point.

Joe DiMaggio

With his 56-game hitting steak, Joltin' Joe, the Yankee Clipper, was a New York idol. It's said he saw a photo of Marilyn with Chicago White Sox players Joe Dobson and Gus Zernial, and liked what he saw. He finally got to meet her on a blind date and she was surprised to find not a sports jock but a gentleman. Joe really liked what he saw and pursued Marilyn in spite of the 12-year age difference. He won his girl, but their differences led to a short marriage of less than a year. First, he didn't get on with Marilyn's acting coach and confidante Natasha Lytess.

Second, he didn't like the Press attention: 1952–1954 were the years that Marilyn moved from being up and coming to bona fide star. And then there was that billowing skirt scene …

In fact, although the marriage didn't last, Joe was always there for Marilyn, and by the time of her death there was serious talk of a remarriage. It was Joe who organized her funeral. He died in 1999. He had not remarried and he had never talked about her publicly since her death.

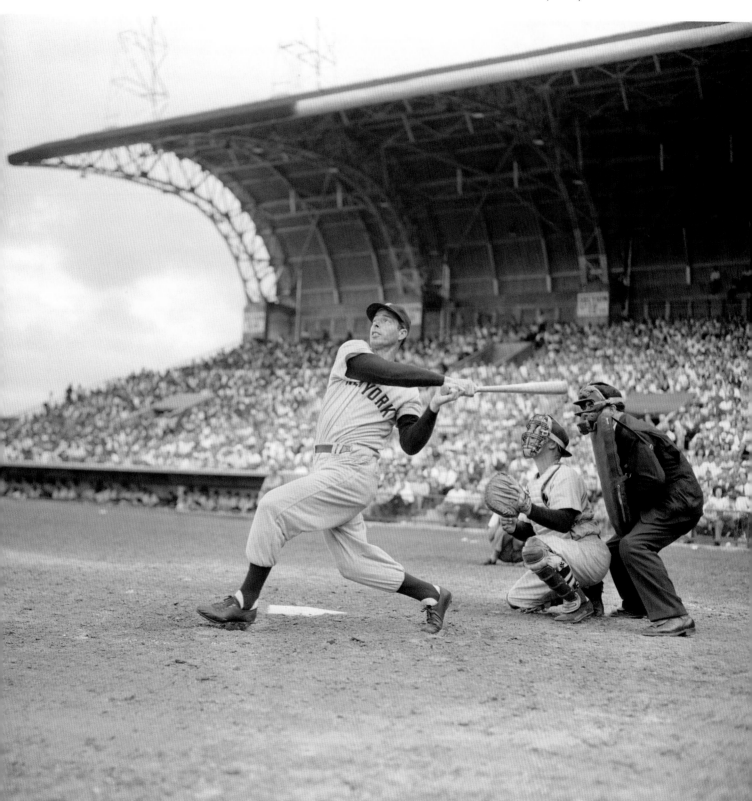

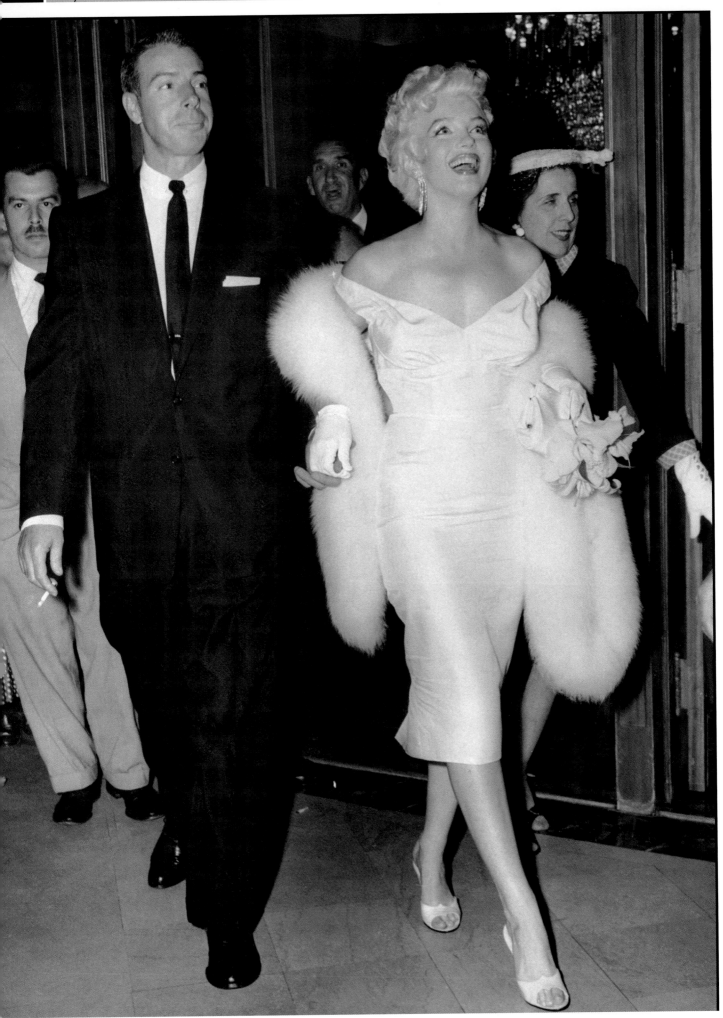

> ## "I didn't want to give up my career, and that's what Joe wanted me to do most of all."
>
> *MARILYN*

LEFT: Marilyn and Joe made a handsome couple sought after by Press and paparazzi—although that nomenclature didn't start being used until the 1960s.

RIGHT: Some years after their marriage ended, Marilyn and Joe started to see each other again. Here they attend a 1961 game at Yankee Stadium. It was Joe who Marilyn called in February 1961 after she had been placed in a psychiatric ward of the Payne-Whitney Clinic in New York.

BELOW: A recent view of the Beverly Hills house Marilyn and Joe shared for five months.

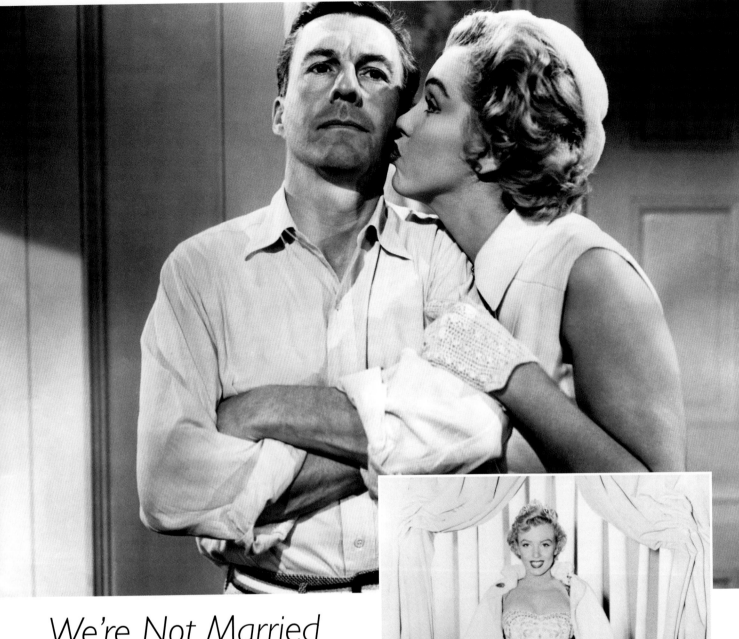

We're Not Married

This 1952 anthology comedy is about five couples who discover that due to a judicial error that they are not legally married. Costume fitting had taken place in January; the movie was shot in May and released quickly, premiering in New York City on July 11, shortly before *Don't Bother To Knock*.

Cast & Credits

Ginger Rogers—Ramona Gladwyn
Fred Allen—Steve Gladwyn
Victor Moore—Justice of the Peace Melvin Bush
Marilyn Monroe—Annabel Jones Norris
David Wayne—Jeff Norris

Director: Edmund Goulding
Producer: Nunnally Johnson
Writer: Nunnally Johnson's screenplay of Gina Kaus's and Jay Dratler's unpublished work "If I Could Remarry."
Cinematography: Leo Tover
Studio: Twentieth Century-Fox
General release date: July 23, 1952

ABOVE LEFT: Annabel Norris attempts to melt husband Jeff Norris (David Wayne), who's having none of it.

LEFT: Promotional still for *We're Not Married*.

ABOVE: Art Adams took the opportunity to take a range of publicity shots of Marilyn in her *We're Not Married* bathing suit.

Niagara

Marilyn's huge public esteem won her the part of Rose in *Niagara* … aided by the fact she was younger and cheaper than Darryl Zanuck's first choice, Betty Grable. Choosing Marilyn proved to be a good move. She grabbed the headlines. "Here is the greatest star since Jean Harlow. She has more intelligence than Harlow. She out-lures Lana. She makes any other glamour-girl you care to name look house-wifely." (*Los Angeles Examiner*) Costume fitting took place in May, 1952, and the movie was shot on location in June. It would prove enormously successful and push Marilyn into stardom.

Cast & Credits

Marilyn Monroe—Rose Loomis
Joseph Cotten—George Loomis
Jean Peters—Polly Cutler
Casey Adams—Ray Cutler
Richard Allan—Patrick

Director: Henry Hathaway
Producer: Charles Brackett
Screenplay: Charles Brackett, Walter Reisch, and Richard Breen
Music: Sol Kaplan
Cinematography: Joseph MacDonald
Studio: Twentieth Century-Fox
General release date: February 1953

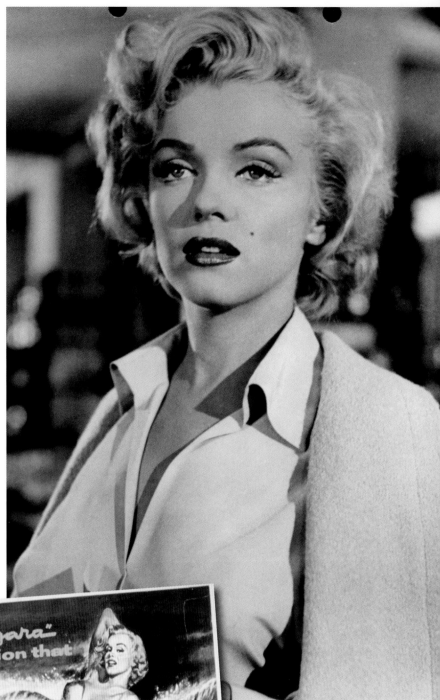

ABOVE: Rose was a scheming manipulator who used her looks to suborn men. Marilyn was magnetic in the role.

RIGHT: Marilyn with the Falls behind her.

PAGES 152–153: Marilyn shows off two of her form-fitting costumes for *Niagara*. The movie grossed $6 million and proved she was box office dynamite.

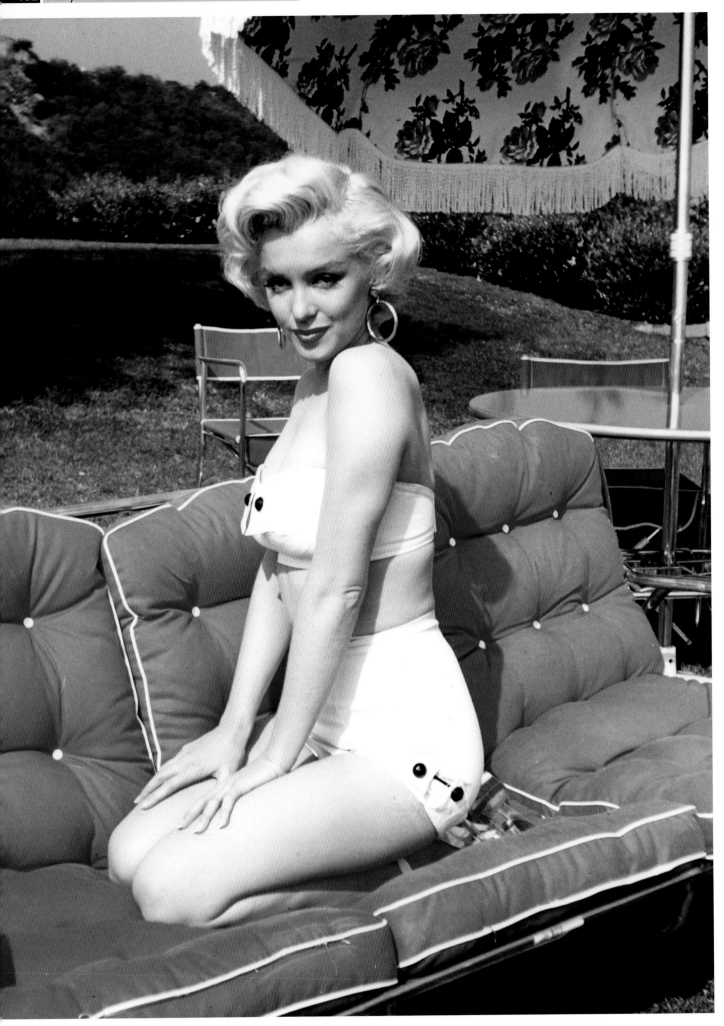

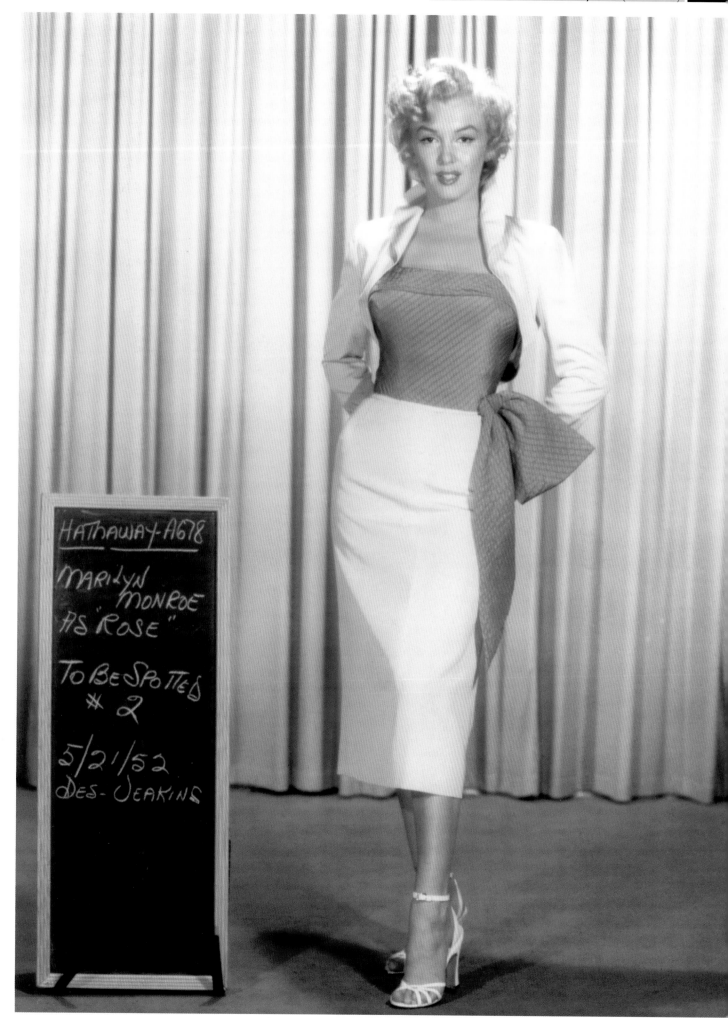

The text on the chalkboard reads:

HATHAWAY-A678

MARILYN MONROE
AS "ROSE"

TO BE SPOTTED
2

5/21/52
DES- JEAKINS

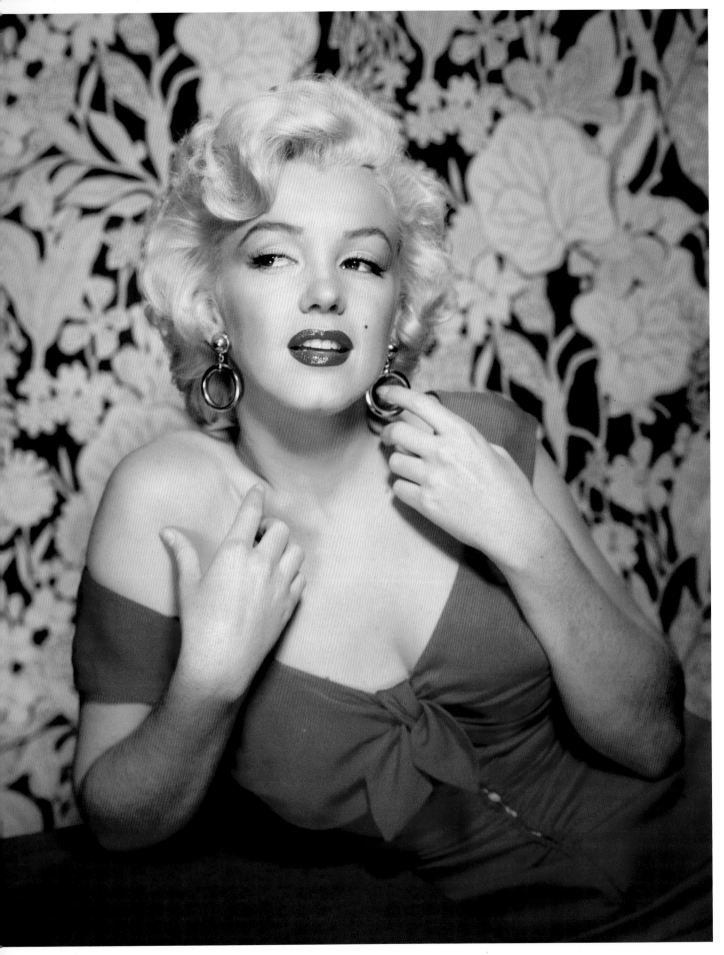

ABOVE: Nickolas Muray photographed Marilyn in the red dress she wore for *Niagara*: "Get out the fire hose!" said Casey Adams: it's as true today as it was then.

RIGHT: Another photograph by Nickolas Muray, an eminent photographer best known, perhaps, for his relationship with Frida Kahlo.

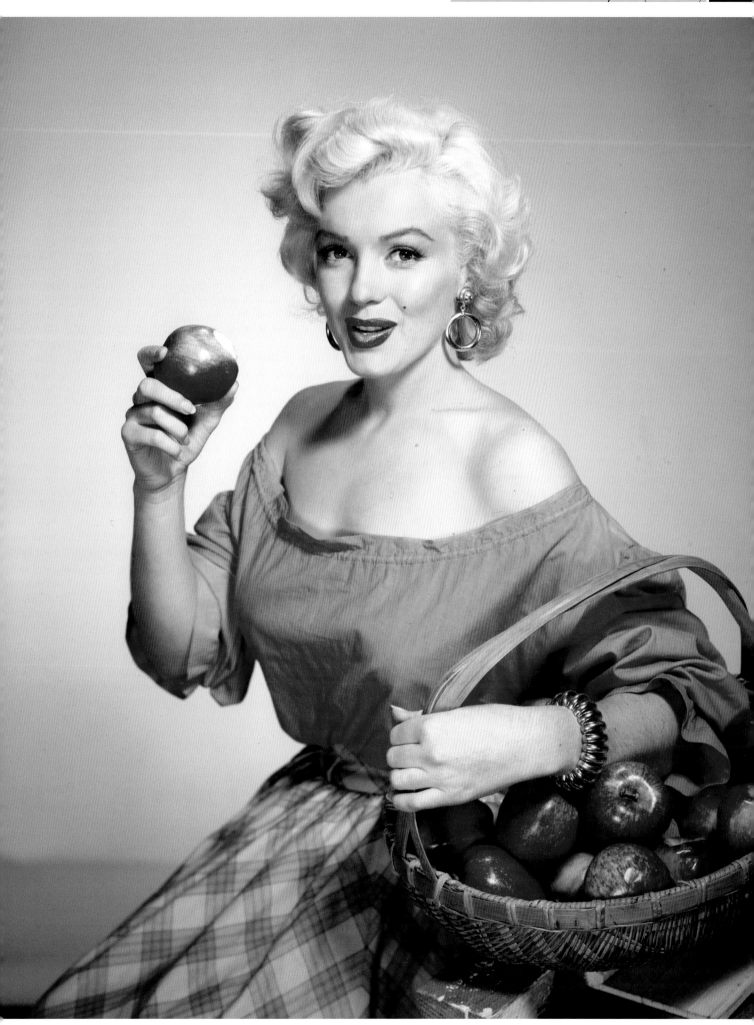

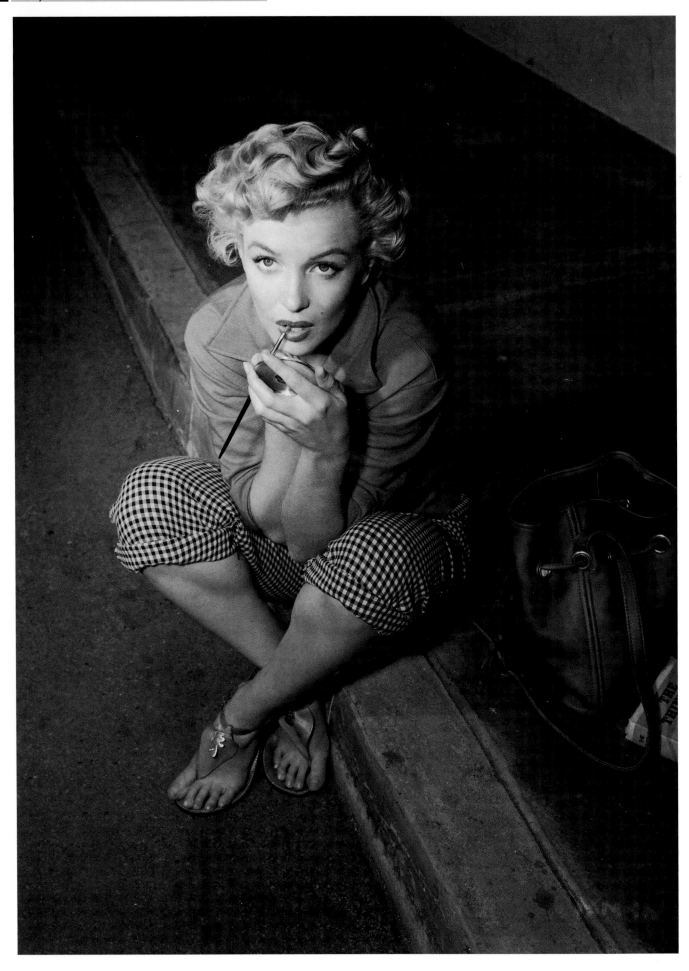

ABOVE: Ernest Bachrach catches Marilyn Monroe sitting on a curb and applying makeup.

RIGHT: Frank Powolny snapped Marilyn in a black dress and rhinestones in July 1952 … the same outfit she had used in a picture session for J. W. Richardson of *Leatherneck* magazine.

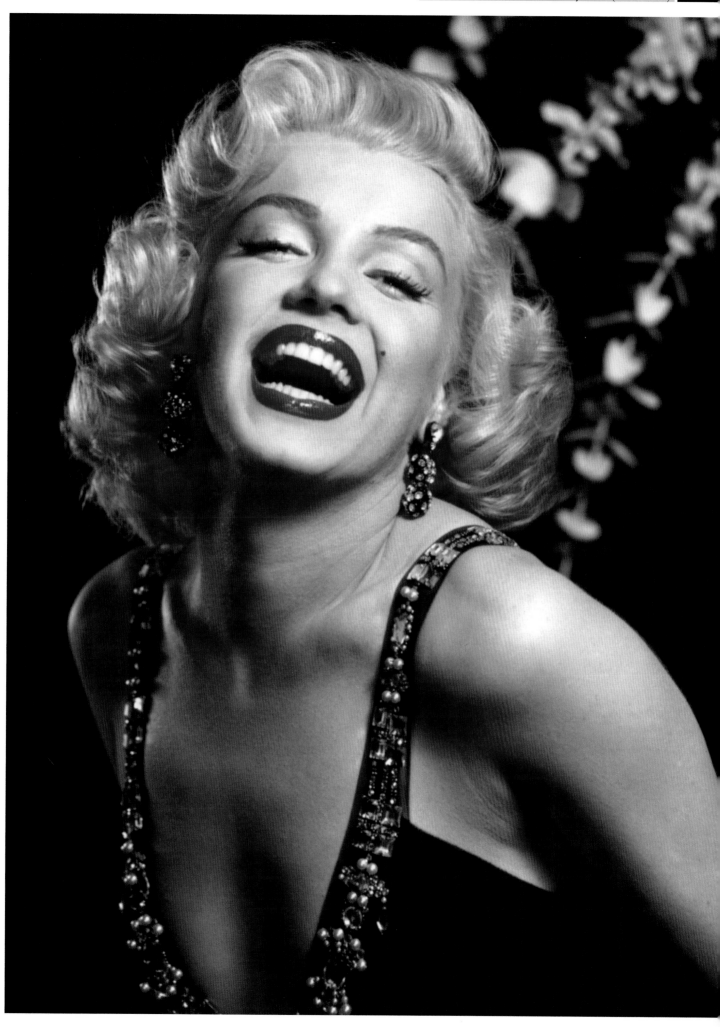

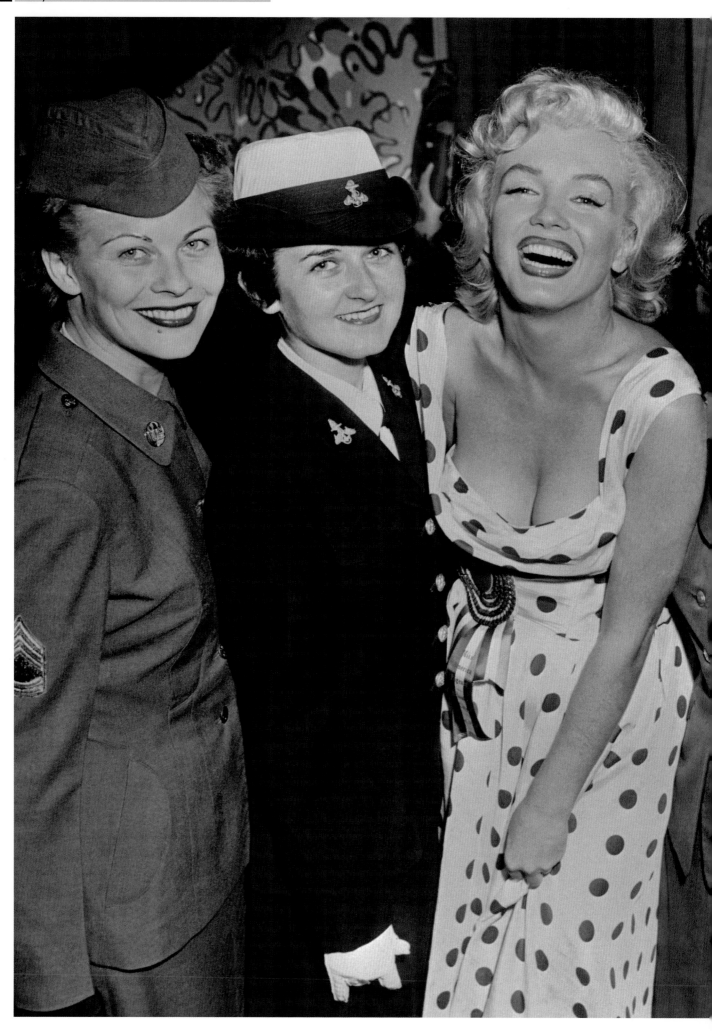

1952 Miss America Pageant

Marilyn was Grand Marshall for the 1952 Miss America pageant held at the Atlantic City Convention Hall. She posed with women from (L–R): the US Army (WAC Sgt. Yvonne Pitt), Navy (WAVE Frances McDonald), Air Force (WAF Sgt. Carol A. James), and Marine Corps (Marine Sgt. Mary M. Jamison)—Marilyn's ample cleavage enhanced by the photographer standing on a chair. It was all part of the publicity drive for *Monkey Business* that premiered in Atlantic City the same day, September 2.

"Your clothes should be tight enough to show you're a woman but loose enough to show you're a lady."

EDITH HEAD

(although the famous Paramount costume designer never, to her regret, dressed Marilyn)

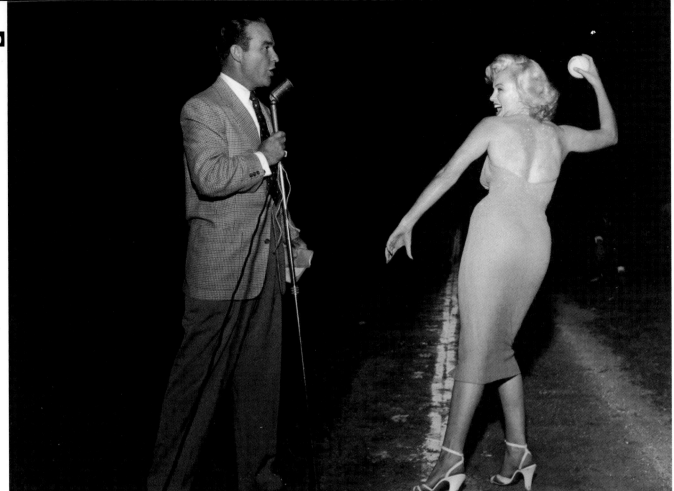

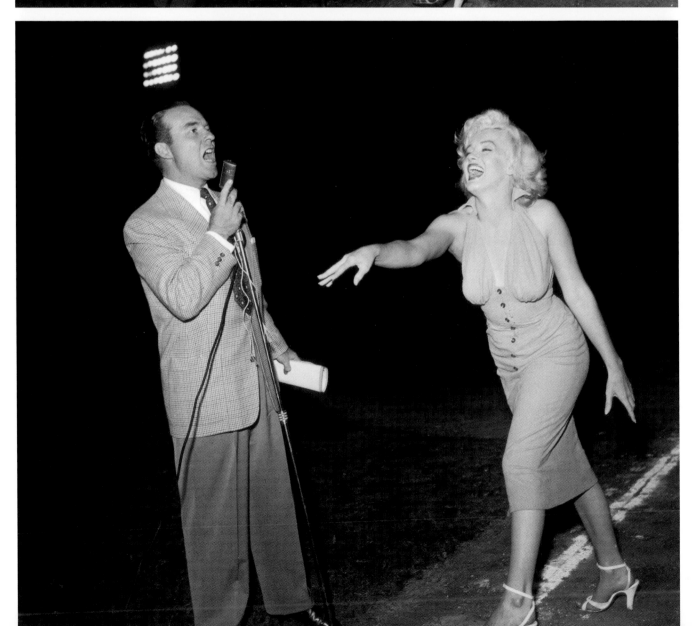

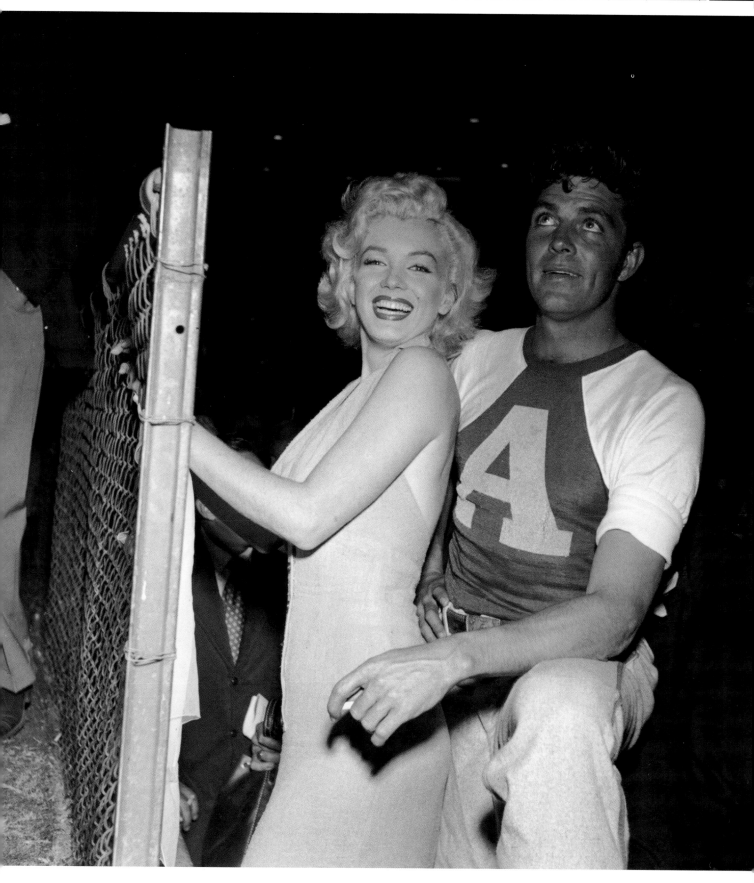

First Pitch

The sixth "Out of This World Series" baseball game took place at Gilmour Field in Los Angeles on September 15, 1952. This charitable enterprise included boxer Art Aragon, actors Mickey Rooney and Dale Robertson, and—to throw the first pitch—Marilyn. Promoting *Niagara* she wore the skin-tight pink dress she had worn on screen, much to the delight of all concerned.

OPPOSITE: With television show host Ralph Edwards as emcee, Marilyn throws the opening pitch.

ABOVE: Marilyn and Dale Robertson in the dugout.

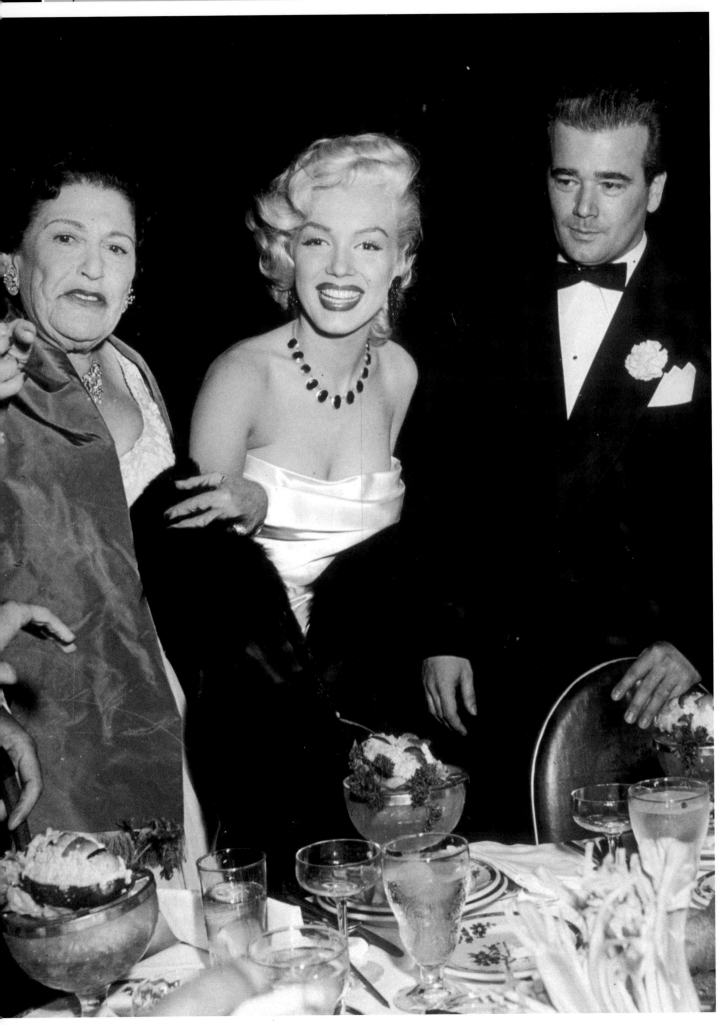

O. Henry's *Full House*

The second of Marilyn's anthology films of 1952 was released on September 19. Marilyn's segment, "The Cop and the Anthem," saw her play a streetwalker opposite Charles Laughton.

Cast & Credits

Charles Laughton—Soapy
Marilyn Monroe—Streetwalker
David Wayne—Horace

Director: Henry Koster
Producer: Andre Hakim
Writer: Screenplay by Lamar Trotti
Music: Alfred Newman
Cinematography: Lloyd Ahern
Studio: Twentieth Century-Fox

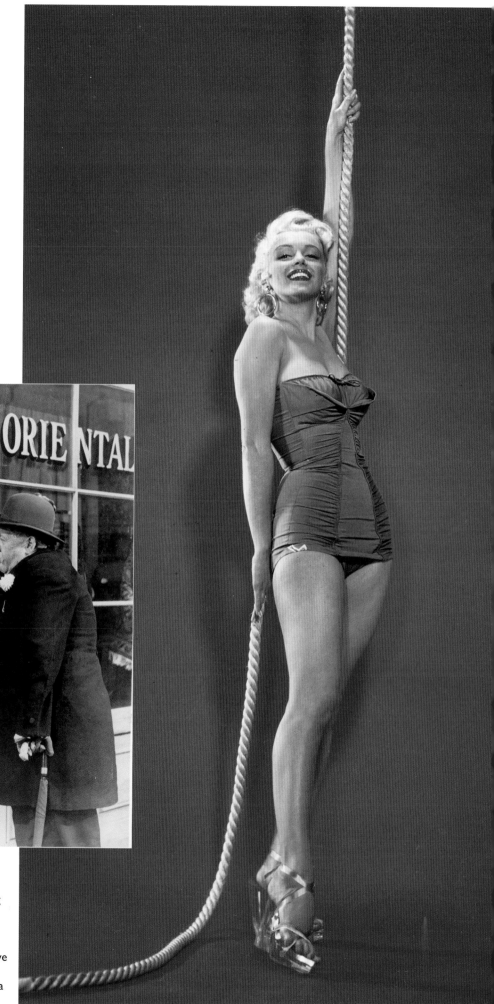

ABOVE: Here she is with Charles Laughton.

RIGHT: Marilyn poses for Bert Reisfield wearing a blue bathing suit and glass high heels.

LEFT: Marilyn attended the 1953 Cinemascope New Year party, at the famous Cocoanut Grove Nightclub of the Los Angeles' Ambassador Hotel. She is seen with gossip columnist Louella Parsons and maitre d' Jack Martin.

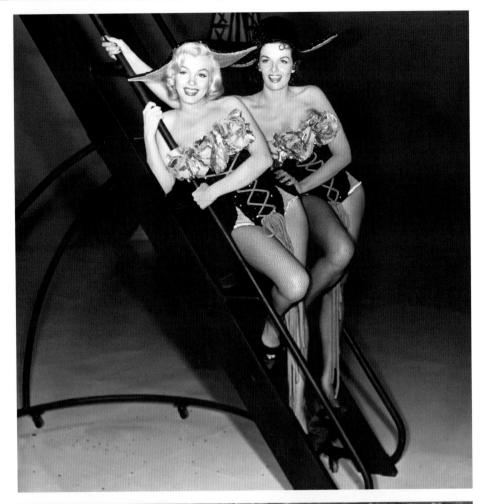

Gentlemen Prefer Blondes

Marilyn's work on one of her most spectacular movies started with costume fittings on October 21, 1952. In November there were more fittings, makeup, and color tests before shooting started. It went on until March 1953 at the end of which Fox had a massive hit. The photos show the "Two Little Girls from Little Rock." They got on well together. Jane Russell said of Marilyn, "Marilyn is a dreamy girl. She's the kind who's liable to show up with one red shoe and one black shoe." As a staffer, Marilyn was a cheaper option than others mentioned for the role—Betty Grable being the front runner—and received considerably less than Jane Russell. She did, however, insist on her own dressing room reportedly saying, "I am the blonde and it is *Gentlemen Prefer Blondes*." That's where she stayed, too, until Howard Hawks allowed back Natasha Lytess, whom he had barred from the set. It was all worth it when the film became the ninth best box office seller for the year.

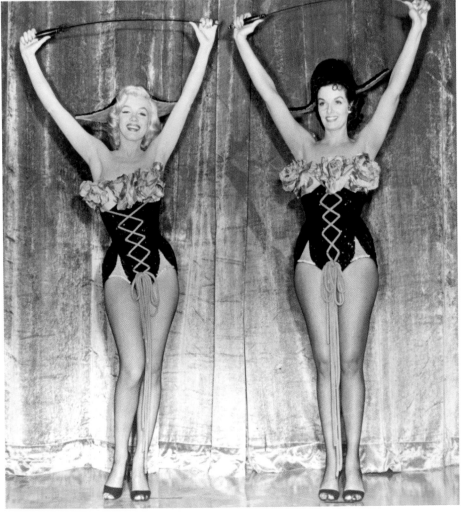

Cast & Credits

Jane Russell—Dorothy Shaw
Marilyn Monroe—Lorelei Lee
Charles Coburn—Sir Francis "Piggy" Beekman
Elliott Reid—Ernie Malone
Tommy Noonan—Gus Esmond
George Winslow—Henry Spofford III

Director: Howard Hawks
Producer: Sol C. Siegel
Writer: Screenplay by Charles Lederer based on the musical comedy by Joseph Fields and Anita Loos, whose novel was the first step
Cinematography: Harry J. Wild
Studio: Twentieth Century-Fox
General release date: New York—July 15, 1953; Los Angeles—July 31, 1953

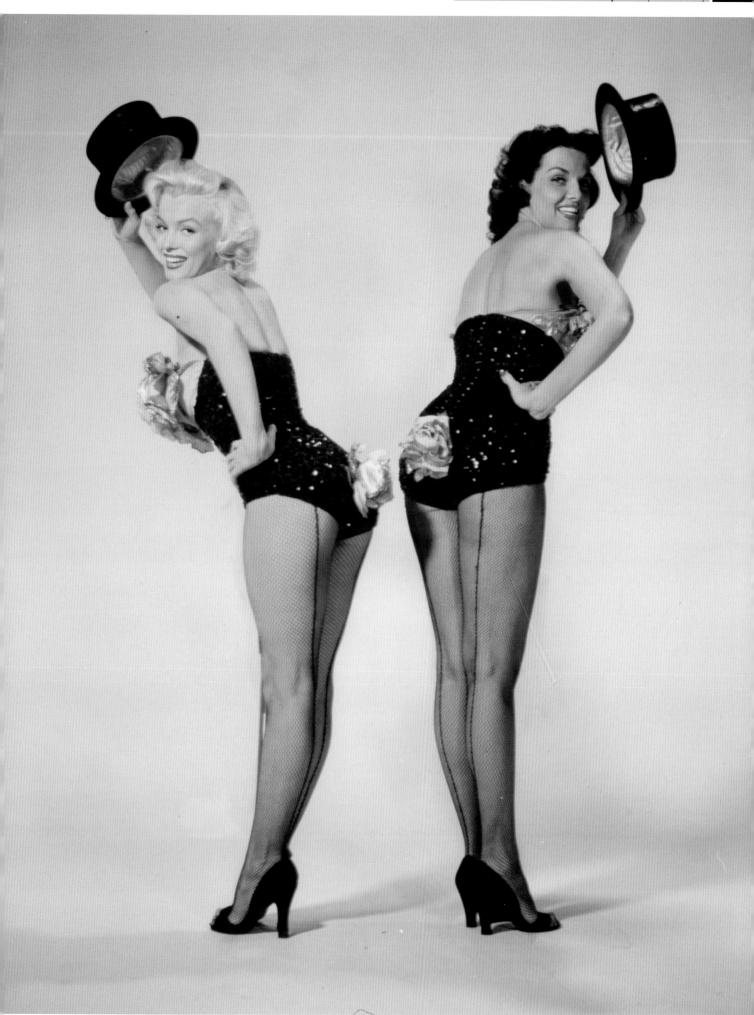

"As usual, Miss Monroe looks as though she would glow in the dark, and her version of the baby-faced blonde whose eyes open for diamonds and close for kisses is always amusing as well as alluring."

NEW YORK HERALD TRIBUNE

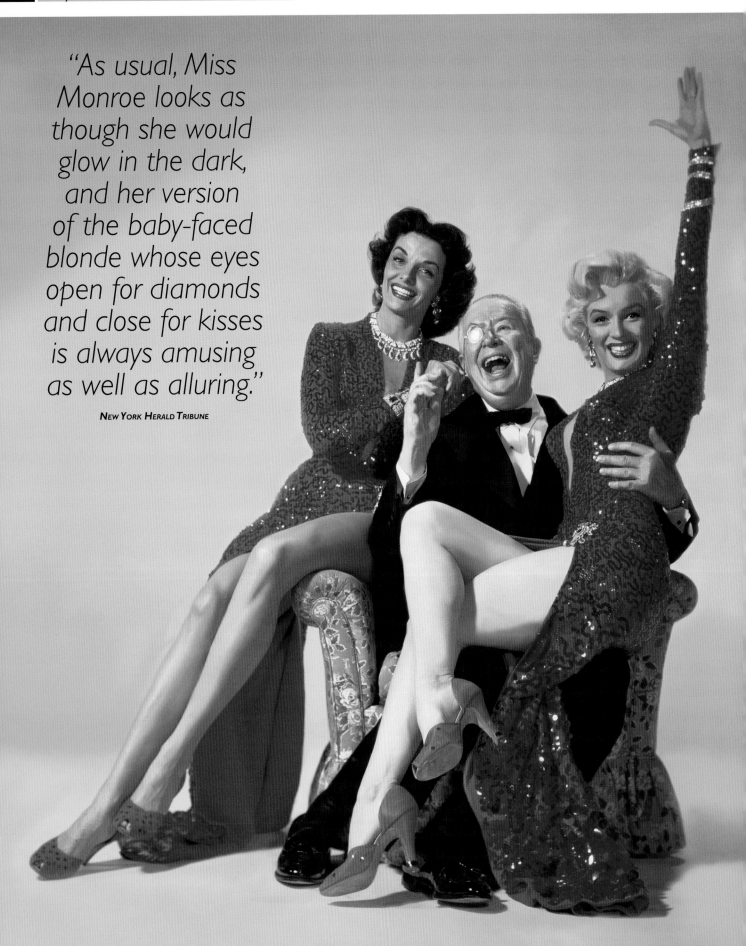

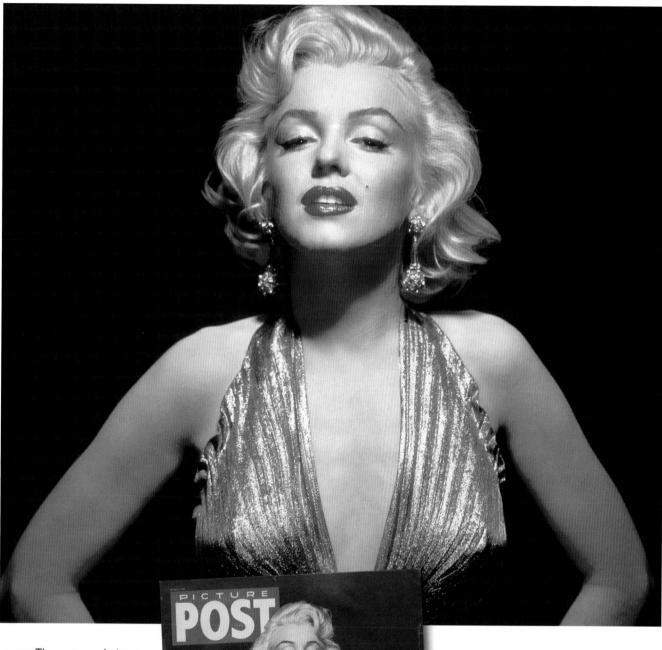

ABOVE: The costume designer for *Gentlemen Prefer Blondes* was Marilyn's friend William "Billy" Travilla. "Billy Dear," she told him, "please dress me forever. I love you, Marilyn." The gold lame dress was pretty special, as was the shocking pink in which she sang "Diamonds Are A Girl's Best Friend."

LEFT: Charles Coburn doesn't look unhappy to be sandwiched between Jane Russell and Marilyn.

RIGHT: The movie's success is reflected in the huge publicity it engendered—such as these covers of *Picture Post* and *Life* magazines.

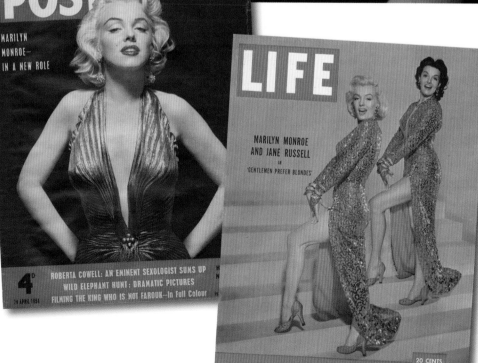

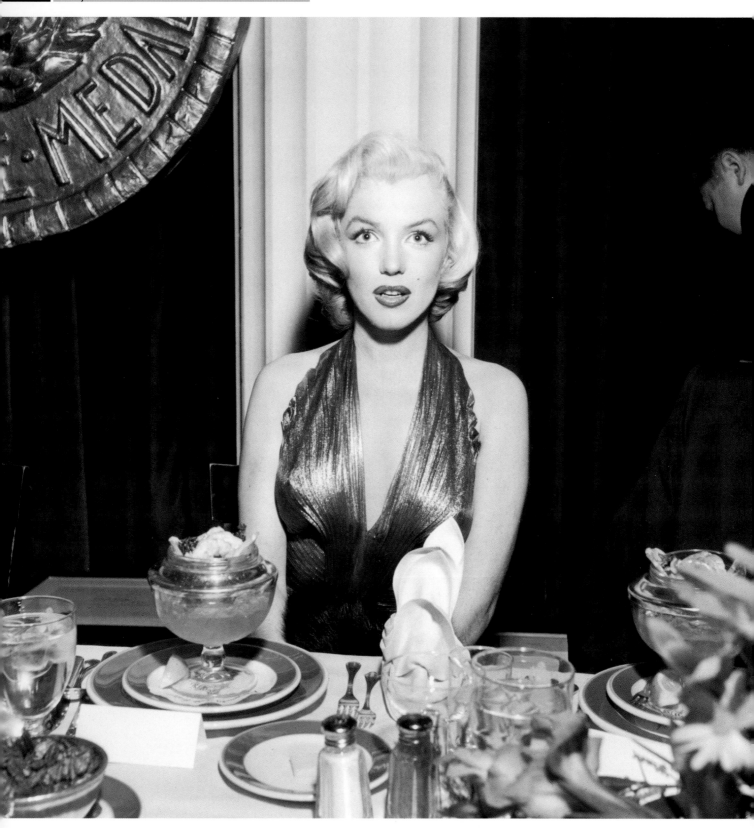

With these words Marilyn accepted *Photoplay* magazine's award for being the "Fastest Rising Star of 1952." The reception took place in the Crystal Room of the Beverly Hills Hotel and Marilyn chose to wear Travilla's gold lame dress with sunray pleats (above). Billy wasn't too happy—he thought it should be kept just for the movie—but Marilyn won him over. She wore it without anything underneath and had to be sewn into it. It caused a sensation.

RIGHT: Marilyn in 1953. Her beauty spot was a flesh-colored mole that she used to hide with makeup before turning it into a beauty spot.

"It's a great thrill and I'm very appreciative to everyone who's made this possible."

MARILYN

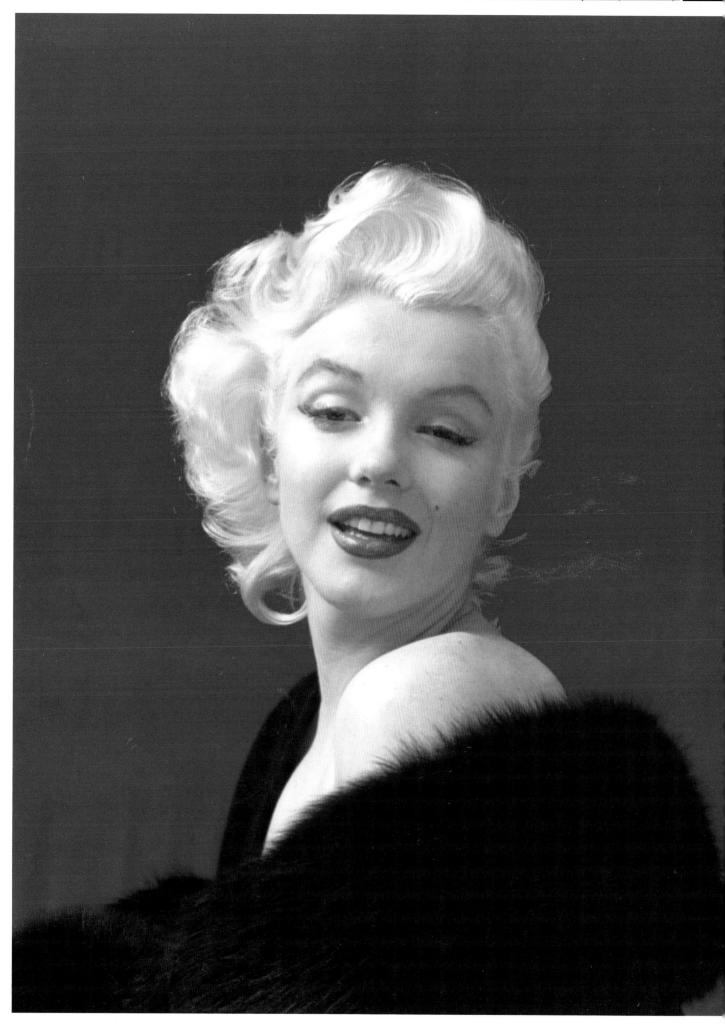

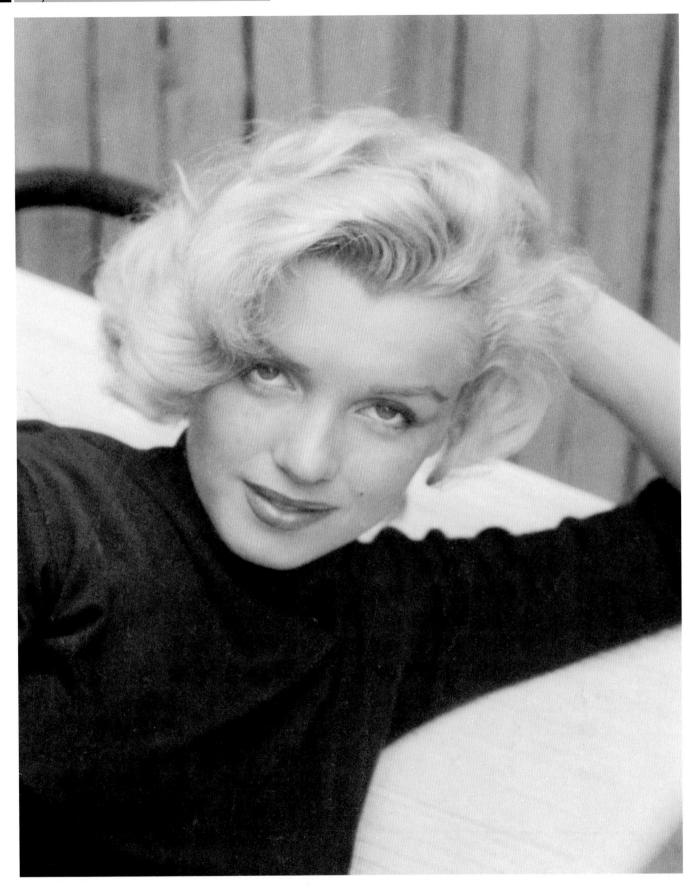

In May 1953 Alfred Eisenstaedt—"Eisie"—took a series of photographs of Marilyn at home for *Life* magazine. They showed a radiant 26-year old star for whom superstardom beckoned. Ben Cosgrove, editor LIFE.com writes about "the great, uniquely empathetic photographer" and the reminder he has left us to the "talented, beautiful, utterly alive young Marilyn who so bewitched the world."

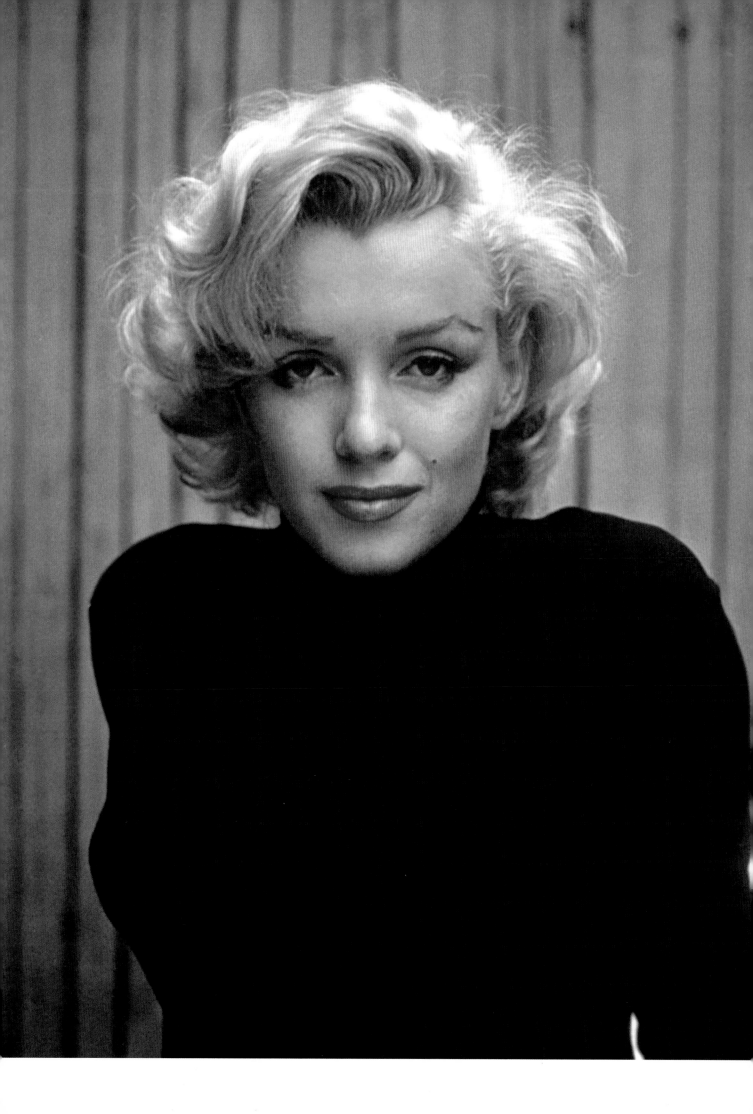

How to Marry a Millionaire

Only a few days after filming of *Gentlemen Prefer Blondes* finished in March 1953, *How To Marry A Millionaire* started. Another blockbuster, it was the first movie to be filmed in CinemaScope. The Press expected sparks to fly between Marilyn and Betty Grable but they were to be disappointed: Grable—as with Jane Russell—took to the shy blonde, although Lauren Bacall found it difficult to cope with Marilyn's lateness and dependence on Natasha Lytess.

Cast & Credits
Betty Grable—Loco Dempsey
Marilyn Monroe—Pola Debevoise
Lauren Bacall—Schatze Page
David Wayne—Freddie Denmark
Rory Calhoun—Eben
Cameron Mitchell—Tom Brookman

Director: Jean Negulesco
Producer: Nunnally Johnson
Writer: Screenplay by Nunnally Johnson from material by Zoe Atkins, Dale Eunson, and Katherine Albert).
Music: Alfred Newman
Cinematography: Joseph MacDonald
Studio: Twentieth Century-Fox
General release date: November 5, 1953

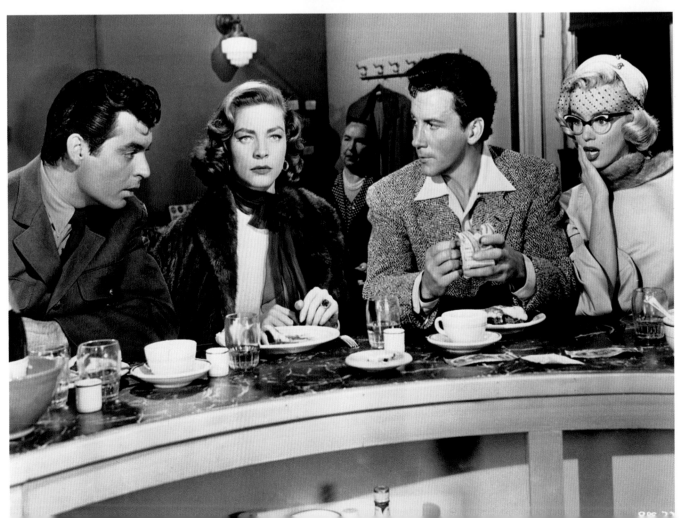

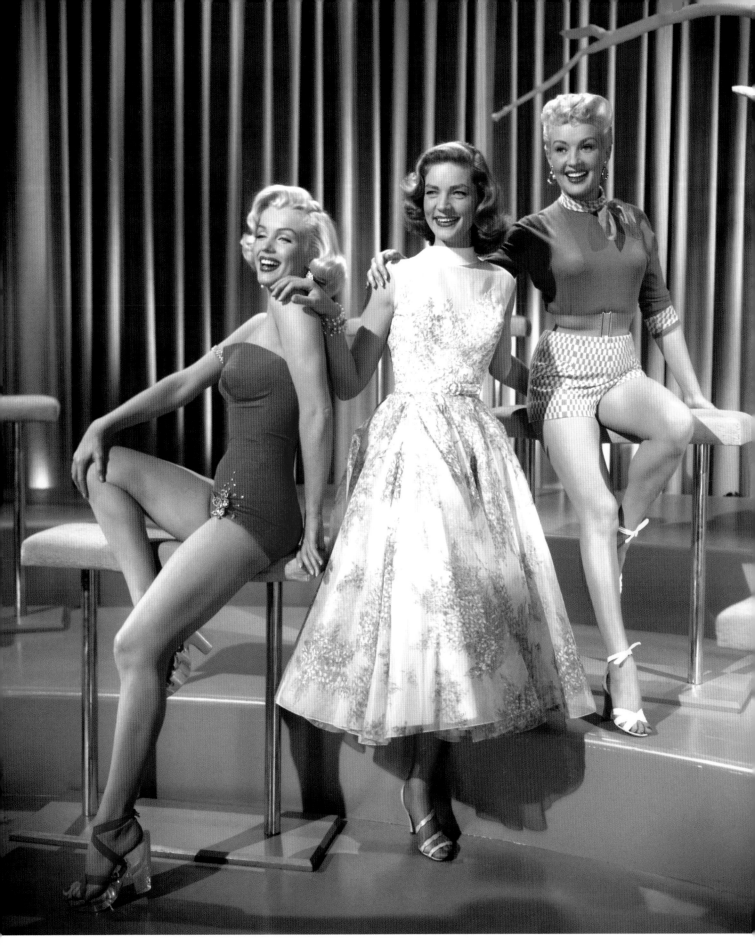

ABOVE LEFT: Marilyn and Betty Grable at the premiere of *How to Marry a Millionaire*. Marilyn is wearing a strapless silk gown with matching long gloves and a fur wrap. Grable is wearing a beaded dress and a fur jacket.

BELOW LEFT: L–R: Rory Calhoun as Eben, Lauren Bacall as Schatze Page, Cameron Mitchell as Tom Brookman, and Marilyn as Pola Debevoise.

ABOVE: Marilyn, Bacall, and Grable photographed by Earl Theisen on the set.

OVERLEAF
LEFT: Betty Grable, Lauren Bacall, and Marilyn pose for another portrait by Earl Theissen on the set.

RIGHT: Diamonds are a girl's best friend!

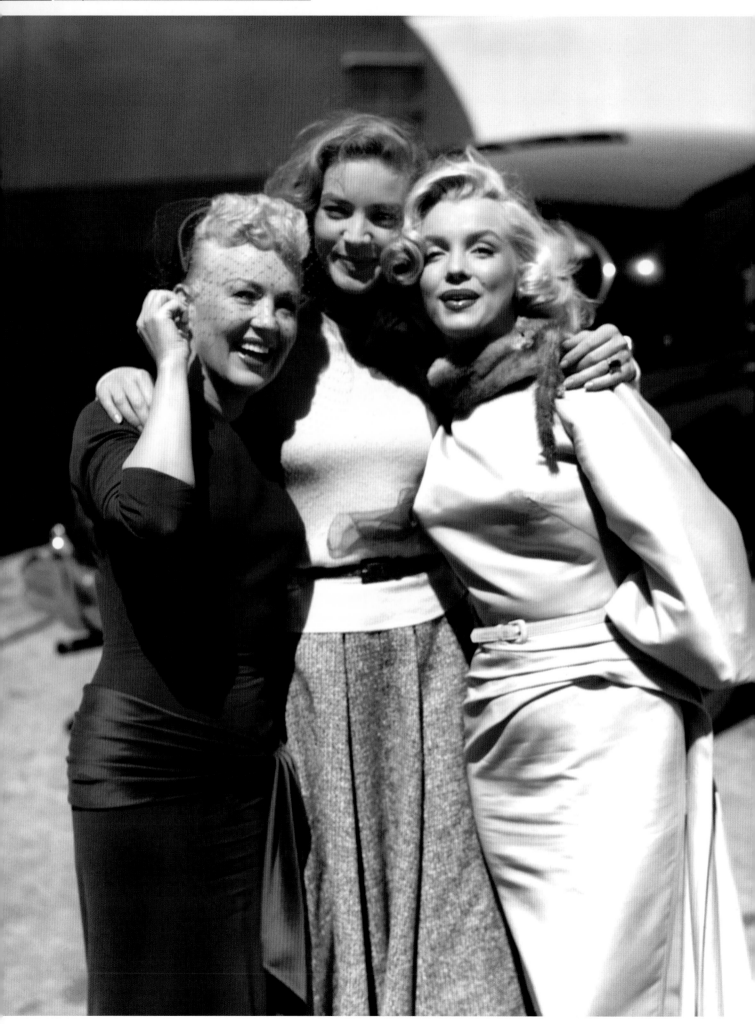

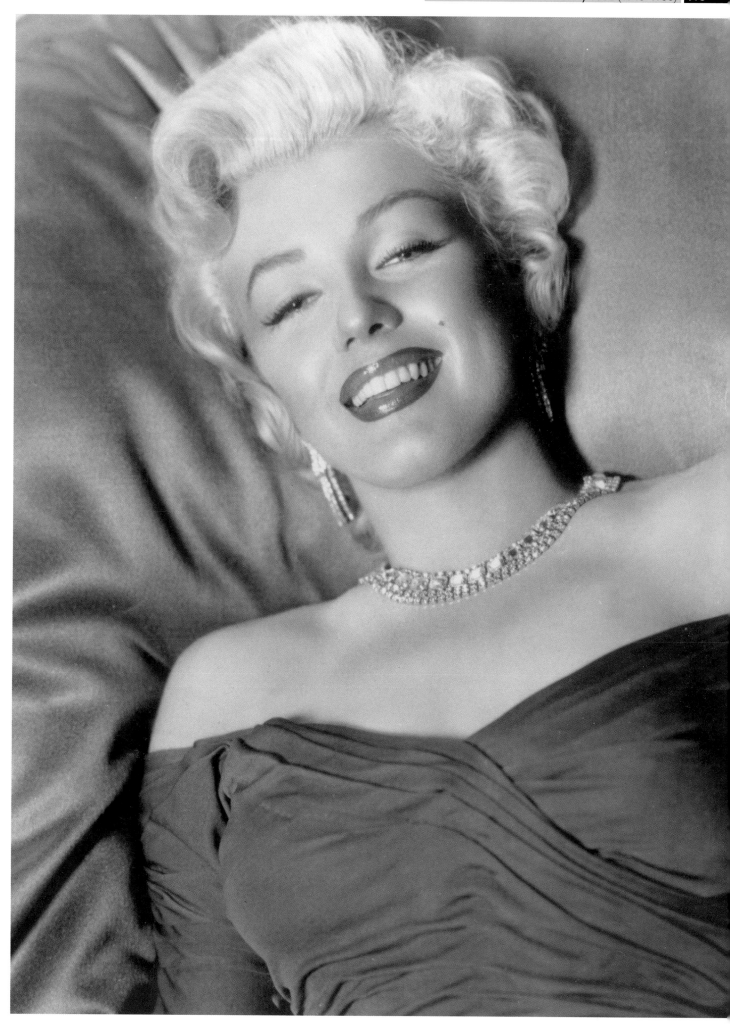

River of No Return

Following *Gentlemen Prefer Blondes*, Marilyn embarked on a Western opposite Robert Mitchum. Costume fitting was in June and shooting started in Canada in August. It was a surprising choice for Fox: the CinemaScope worked brilliantly for the scenery, but the movie was hardly the right vehicle for Marilyn. Unsurprisingly, when it came out in 1954 the critics damned it with faint praise and talked of the fantastic views … of mountains and of Marilyn. The director, Otto Preminger, clashed vociferously with Natasha Lytess, and eventually banished her, although Marilyn had her reinstated by calling Darryl Zanuck.

Cast & Credits

Robert Mitchum—Matt Calder
Marilyn Monroe—Kay Weston
Tommy Rettig—Mark Calder
Rory Calhoun—Harry Weston

Director: Otto Preminger
Producer: Stanley Rubin
Writer: Screenplay by Frank Fenton based on a story by Louis Lantz
Music: Cyril J. Mockridge
Cinematography: Joseph LaShelle
Studio: Twentieth Century-Fox
General release date: April 30, 1954

BELOW: Mitchum had known Marilyn from the 1940s and was a friend of hers. He talked to Roger Ebert about the movie some years later, remembering her fondly. Here they are seen on location.

RIGHT: Marilyn played a saloon singer and sang four numbers including "One Silver Dollar" and the title song "River of No Return."

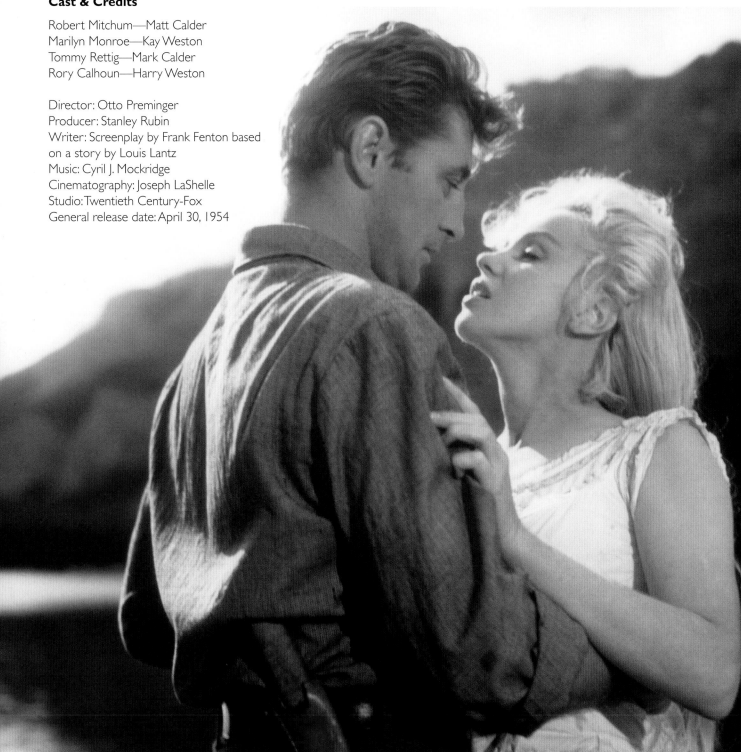

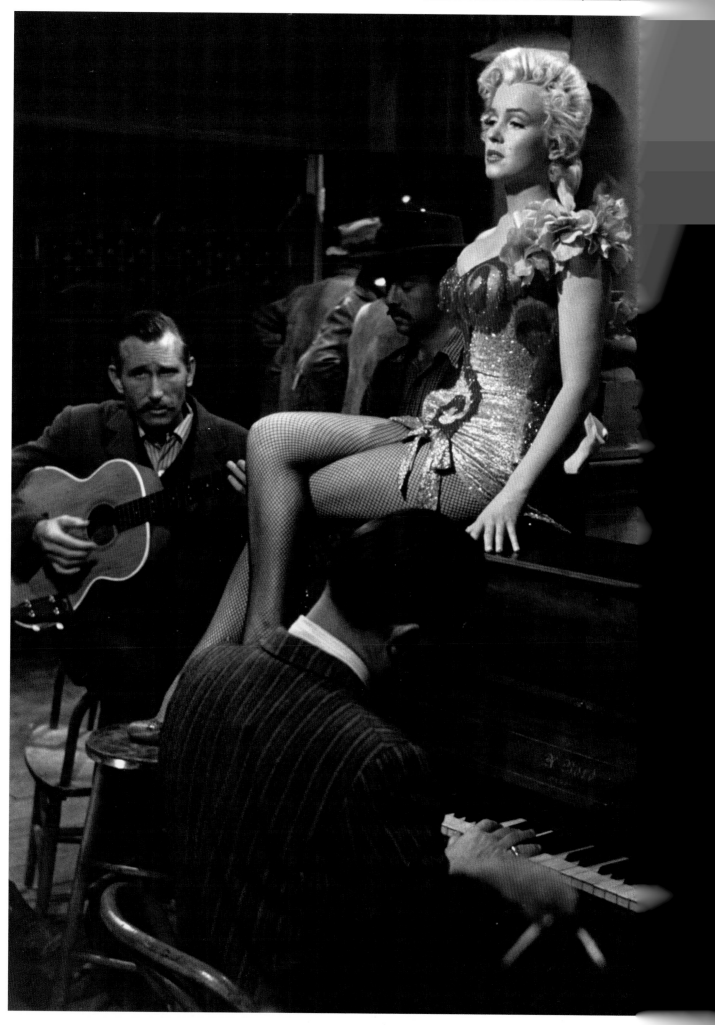

Grauman's Chinese Theatre

Work on *River of No Return* stopped on June 16, when Marilyn and Jane Russell went to Grauman's Chinese Theatre on Hollywood Boulevard to leave their handprints. Other promotion followed preparatory to release of *Gentlemen Prefer Blondes* on July 15.

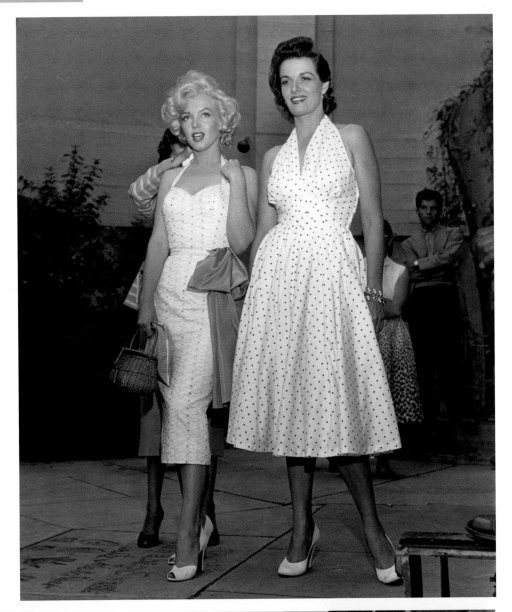

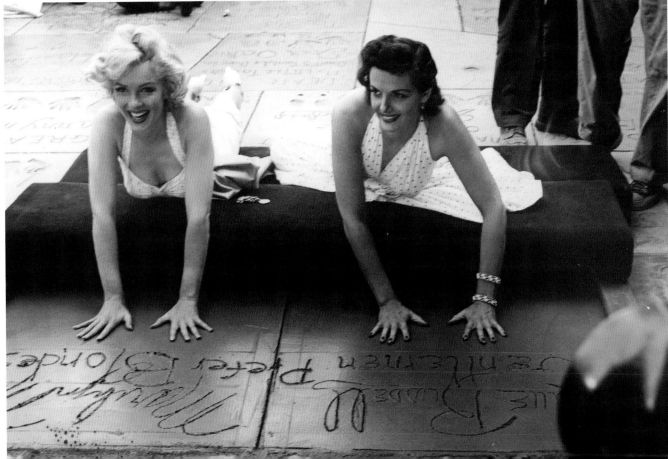

LE SORPRESE
DELLA
BATTAGLIA
ELETTORALE

Un servizio
di Luigi Barzini jr

EPOCA

MARILYN MONROE
BELLISSIMA DI TURN

LIRE 100
100 PAGINE

ABOVE: Marilyn made her official television debut on Jack Benny's 1953 season premiere on September 13.

LEFT: Always the cover queen: the cover of the Italian weekly magazine *Epoca*, dated June 14, was of Marilyn.

Darryl F. Zanuck

Marilyn's relationship with Twentieth Century-Fox, founded in 1935 by Joseph Schenck and Darryl F. Zanuck, was a difficult one, Her first contract was with the studio, who let her go after six months. They took her on again—at Zanuck's insistence—following a December 1950 screentest. Trouble was that Zanuck thought she was simply cheesecake, something only confirmed by the Kelley nude photos: "She's a sex pot who wiggles and walks and breathes sex, and each picture she's in she'll earn her keep but no more dramatic roles!"

In spite of this, Marilyn made it to the top. Movies such as *Gentlemen Prefer Blondes* and *How To Marry a Millionaire* took her to stardom … something not reflected in the size of her pay packet. Joe DiMaggio—who knew all about contract negotiation and the value of success—took issue with what

Fox was paying her and Marilyn, fed up with dizzy blonde roles, put her foot down when she heard of the studio's next role for her—*Pink Tights*. Her agent, Charles Feldman, was instructed to tell Fox that her contract must be renegotiated and that *Pink Tights* wasn't on the agenda.

The end of the year saw her showered with awards, among others, the World Film Favorite award from The International Press of Hollywood and—to add insult to injury—an Award of Achievement for being one of the "Top ten money-making stars of 1953."

Zanuck, in spite of pressure from Spyros Skouras. played hardball. On January 4, she was suspended by Fox for not turning up for work on *Pink Tights*.

Marilyn's response was unequivocal. She married Joe.

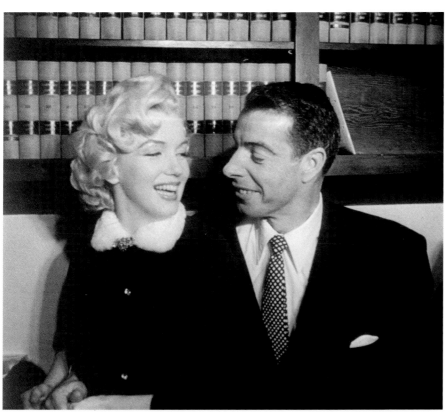

Mr. and Mrs. DiMaggio

On January 14, Marilyn and Joe got married in the office of Municipal Judge Charles Peery in San Francisco City Hall. She wore a dark brown woolen suit with an ermine collar, and held orchids. They hoped it would be private and there were very few guests … but outside there were over 200 reporters and cameramen and about the same number of enthusiastic wellwishers.

LEFT: Sealed with a kiss: Joe kisses his bride in the judge's chambers.

BELOW: As they came out of San Francisco Town Hall they were met by reporters, cameramen, and a good number of fans. They left in Joe's blue Cadillac.

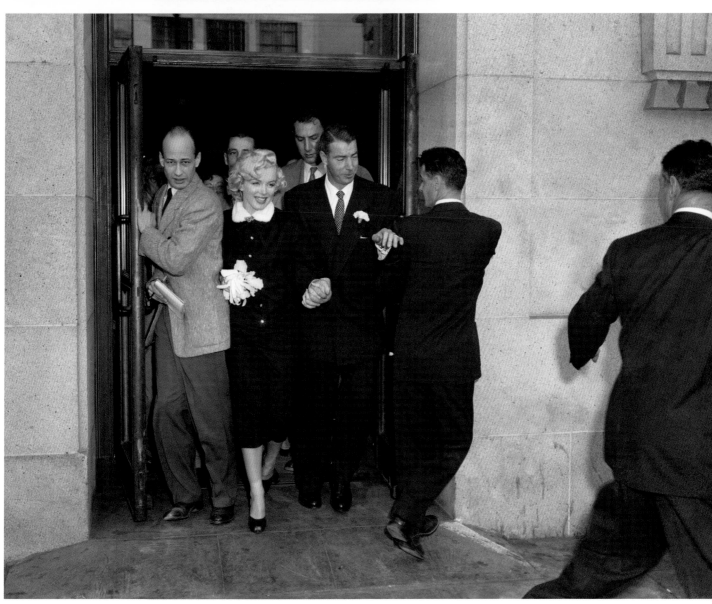

Korea

"I've got to go to Japan on some baseball business and we could make a honeymoon out of our trip," said Joe. So that's what they did, and while they were there Marilyn was invited to entertain the troops in Korea. She went, leaving Joe in Japan. Already moody because most of the interest in his press conferences was about Marilyn, Joe didn't take her absence well.

RIGHT: American soldiers surround Marilyn at Seoul during the Korean tour.

OPPOSITE: Marilyn sang favorites from her movies such as "Diamonds are a Girl's Best Friends" and "Bye, Bye, Baby."

BELOW: On February 23, 1954, nursing a cold, Marilyn and Joe left Tokyo to return to the United States. Joe went to New York at the beginning of March and Marilyn to Los Angeles.

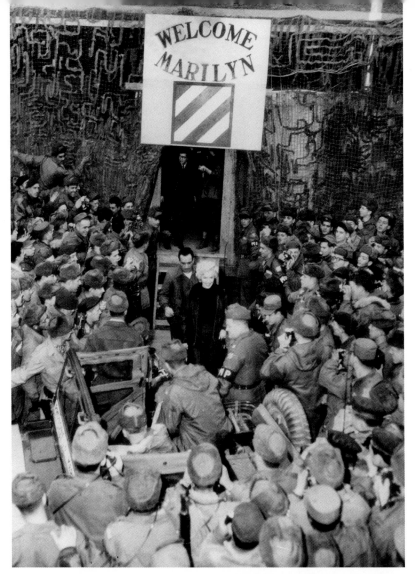

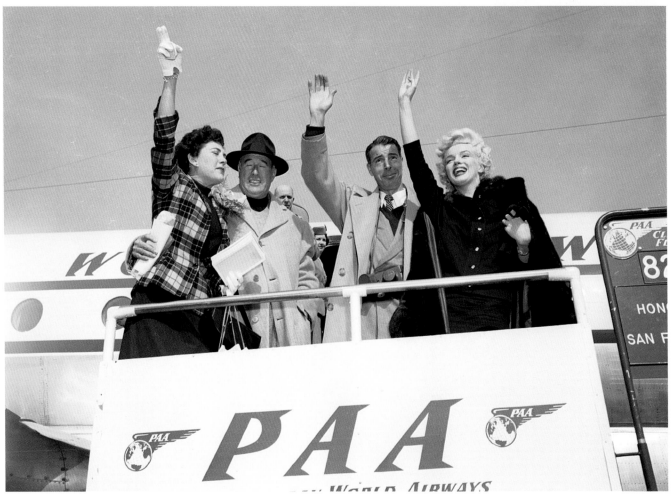

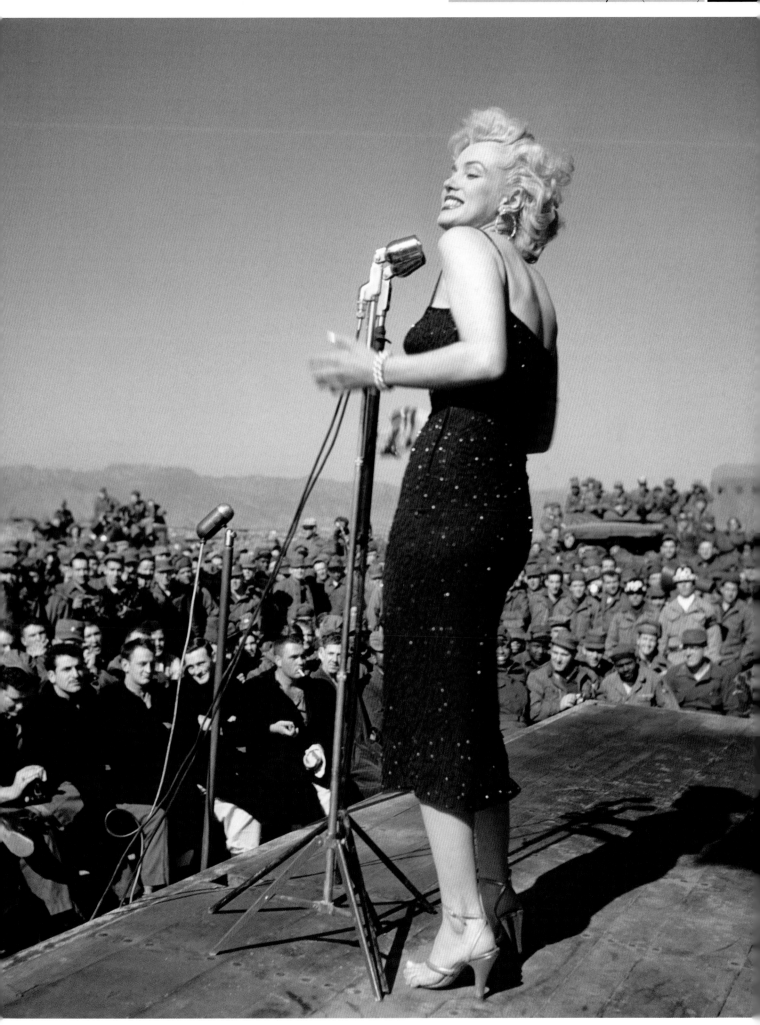

Back from Korea

"Here's the first photo showing blonde screen star Marilyn Monroe back at work after her long tilt with Twentieth Century-Fox over what pictures she would work in"—Marilyn and Johnnie Ray on the set of *There's No Business Like Show Business* (right). When she came back from Korea, Fox caved in. They couldn't afford to lose Marilyn who was fast becoming one of their biggest stars.

BELOW AND OPPOSITE: Marilyn posed for Ted Baron in Palm Springs during summer 1954.

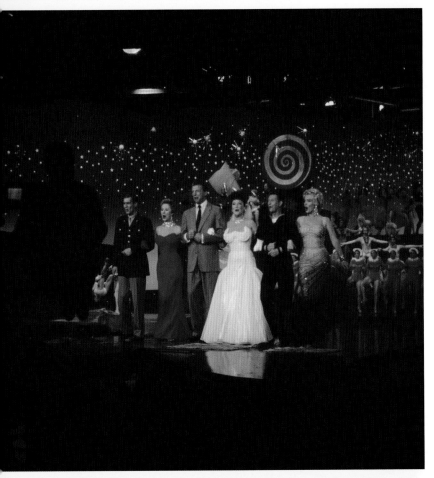

There's No Business Like Show Business

With Charles Feldman and the Famous Artists Agency now in charge officially of her fortunes, Marilyn's contract renegotiation improved her financial position substantially, ended talk of *Pink Tights*, officially allowed her to bring Natasha Lytess, Hal Schaefer (her singing coach), and Jack Cole (her dancing coach) on set, and secured her a leading role in Billy Wilder's screen version of the Broadway hit *The Seven Year Itch*—complete with a $100,000 bonus.

Her suspension over, she started on the musical *There's No Business Like Show Business*. Her Travilla costumes for "Show Business"—and the dance moves she made in them—were controversial, in particular the torrid "Heat Wave" number, performed by Marilyn and a bevy of male dancers. Joe certainly didn't like Marilyn's skimpy costumes, and refused to pose for pictures with her when he visited the set.

Costume fitting took place in June; Shooting (postponed from May because Marilyn had picked up bronchitis in Korea) took place between August and September 1954, after which Marilyn hurried to New York to start work on *The Seven Year Itch*.

Cast & Credits

Ethel Merman—Molly Donahue
Donald O'Connor—Tim Donahue
Marilyn Monroe—Vicky
Dan Dailey—Terence Donahue
Johnnie Ray—Steve Donahue
Mitzi Gaynor—Katy Donahue

Director: Walter Lang
Producer: Sol C. Siegel
Writer: Screenplay by Phoebe and Henry Ephron of a Lamar Trotti story
Music: Songs, Irving Berlin; music by Alfred and Lionel Newman, Earle Hagen, Bernard Mayers, Hal Schaefer and Herbert Spencer
Cinematography: Leon Shamroy
Studio: Twentieth Century-Fox
General release date: December 16, 1954

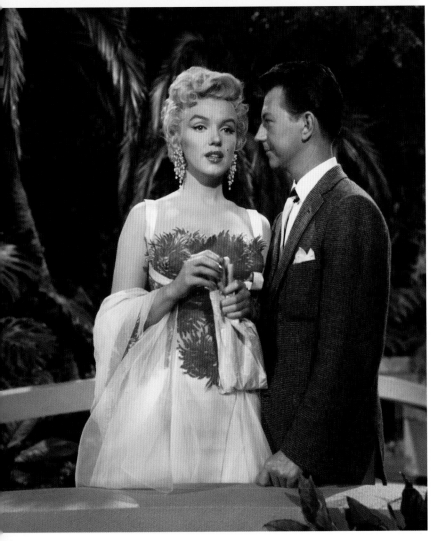

ABOVE LEFT: Johnnie Ray, Mitzi Gaynor, Dan Dailey, Ethel Merman, Donald O'Connor and Marilyn in the grand finale. The largest sound stage at Twentieth Century-Fox was used to depict the stage of the old Hippodrome in New York.

LEFT AND RIGHT: Marilyn with costar Donald O'Connor on the set and (right) wearing the controversial "Heat Wave" outfit.

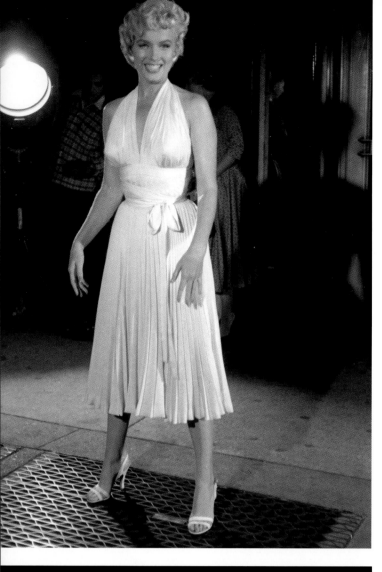
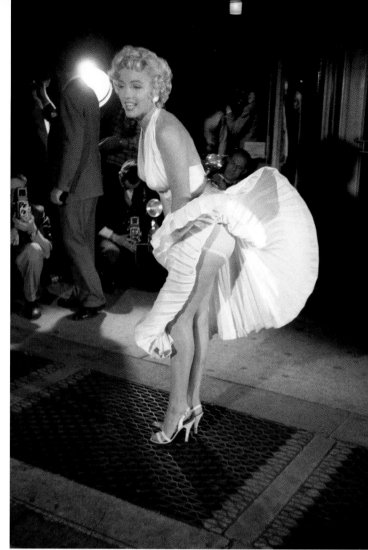
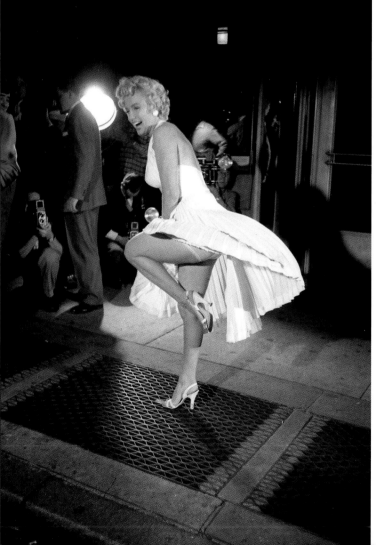
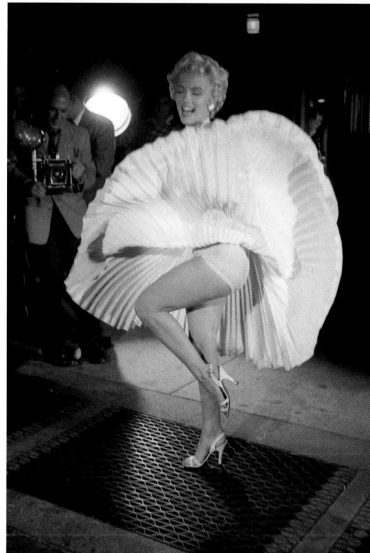

Marilyn and Joe split

On September 15, the famous billowing skirt scene was shot. Joe just couldn't cope seeing his wife in such a pose … particularly as it was shot fifteen times over five hours. When they got back to the hotel an explosive argument ensued, and that, effectively, was that, although the announcement wasn't until early October. The marriage hadn't lasted a year. The Press, as can be imagined, reacted immediately.

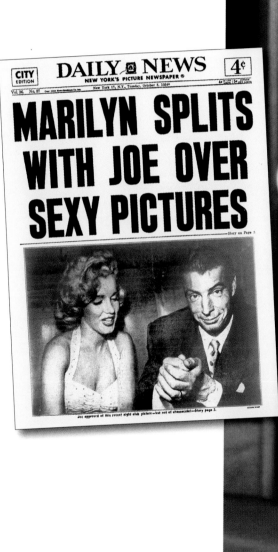

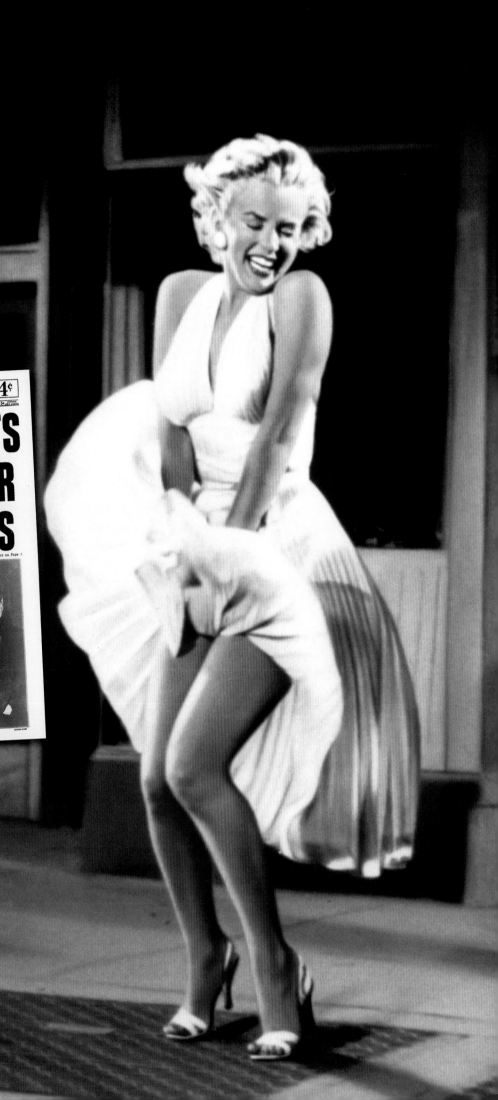

LEFT: Marilyn on location at Lexington Avenue and 52nd Street. The footage, though filmed, was not used in the finished movie and was later reshot in a studio.

RIGHT: The emblematic end result has been used countless times since to identify Marilyn.

In a different role

After the failure of her marriage, Marilyn moved to New York. Determined to become a serious actress, she took acting workshops at the famous Actors Studio in New York City, a non-profit making theatrical collective co-founded and run by Lee Strasberg. Dubbed "the father of Method acting" Strasberg was hugely influential in American theater and movies. Always nervous and unsure of herself, Marilyn was quiet in class until the other actors fully accepted her. In March 1955 Strasberg astonished everyone when he took Marilyn on as a private pupil and in the process became her most important artistic influence—and not always a good one according to many of her co-workers. When he couldn't accompany Marilyn on set, his wife Paula became her guide and drama coach, much to the vast exasperation and fury of many of her directors.

On March 9, 1955, she was an usherette at the premiere of James Dean film East of Eden at the Astor Theater. She and other celebrities donated her services with the proceeds of the $150-a-seat event going to the Actors' Studio. When word got out, crowds of fans filled Times Square for a glimpse of her. At right, she gives Milton Berle a program. On March 30 he would be with Marilyn at a circus at Madison Square Garden, he as ringmaster and Marilyn on an elephant ...

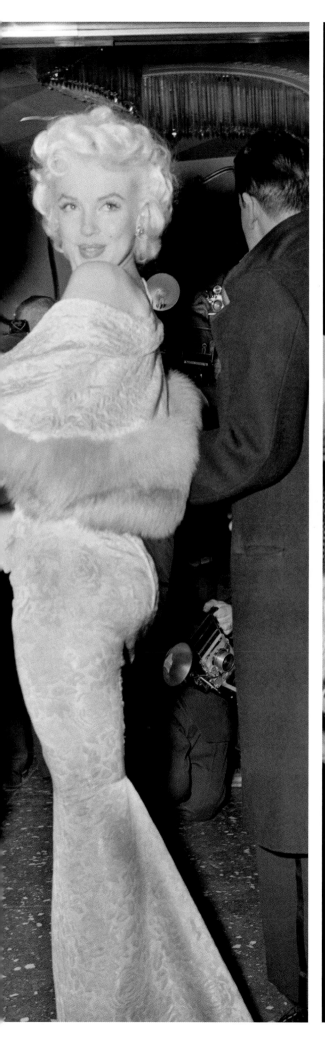

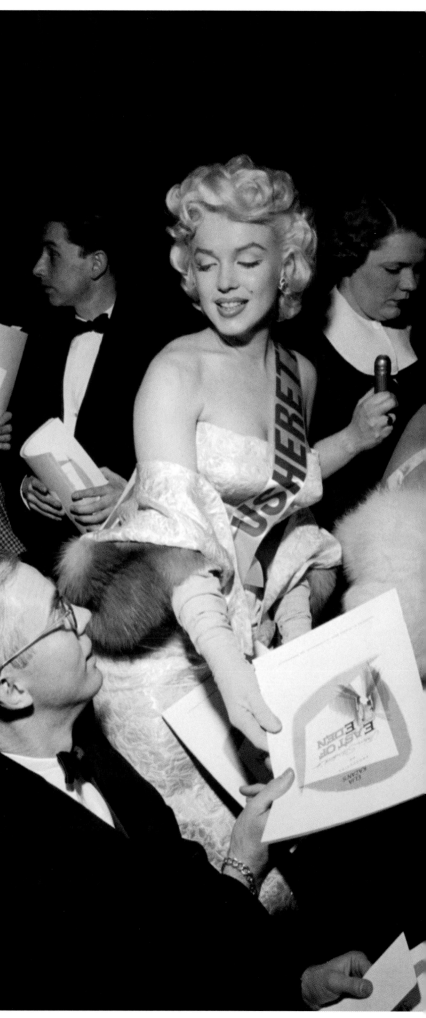

4 Days in New York

While she was living at the Ambassador, Milton Greene—now her partner in Marilyn Monroe Productions—decided her image needed a boost. Photojournalist Ed Feingersh followed her around for a week and produced a remarkable collection of candid shots for *Redbook* magazine, "4 Days in New York." Here she gets ready to go out to see the premiere of *Cat On A Hot Tin Roof* on March 24, 1955, playfully applying her make up and Chanel No. 5 perfume. The aftershow party was at New York's famous El Morocco nightclub.

RIGHT: Marilyn and Truman Capote at the El Morocco. They make a strange pair, the gorgeous blonde and the diminutive—five foot three inches tall—writer. Marilyn was Capote's first choice to play Holly Golightly in *Breakfast at Tiffany's*, although her reputation preceded her and the part went to Audrey Hepburn instead.

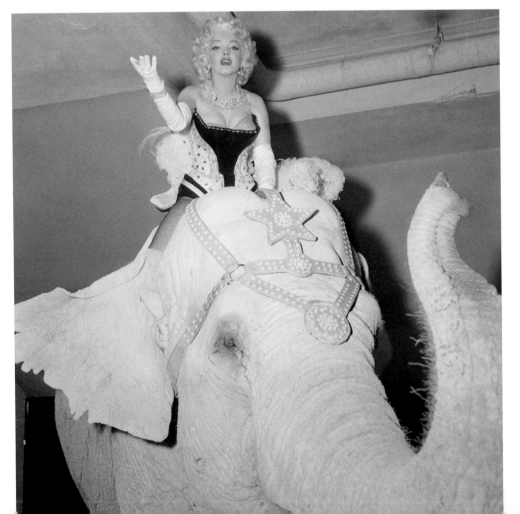

Marilyn and the Elephant

On March 30, Marilyn attended the party organized by Mike Todd and the Ringling Brothers Circus at Madison Square Garden, in favor of the Arthritis and Rheumatic Affections Association. She made a spectacular entrance, dressed as a circus showgirl, riding a pink-painted elephant named Karnaudi, in front of 18,000 people. Milton Berle (Uncle Milti) was the ringmaster.

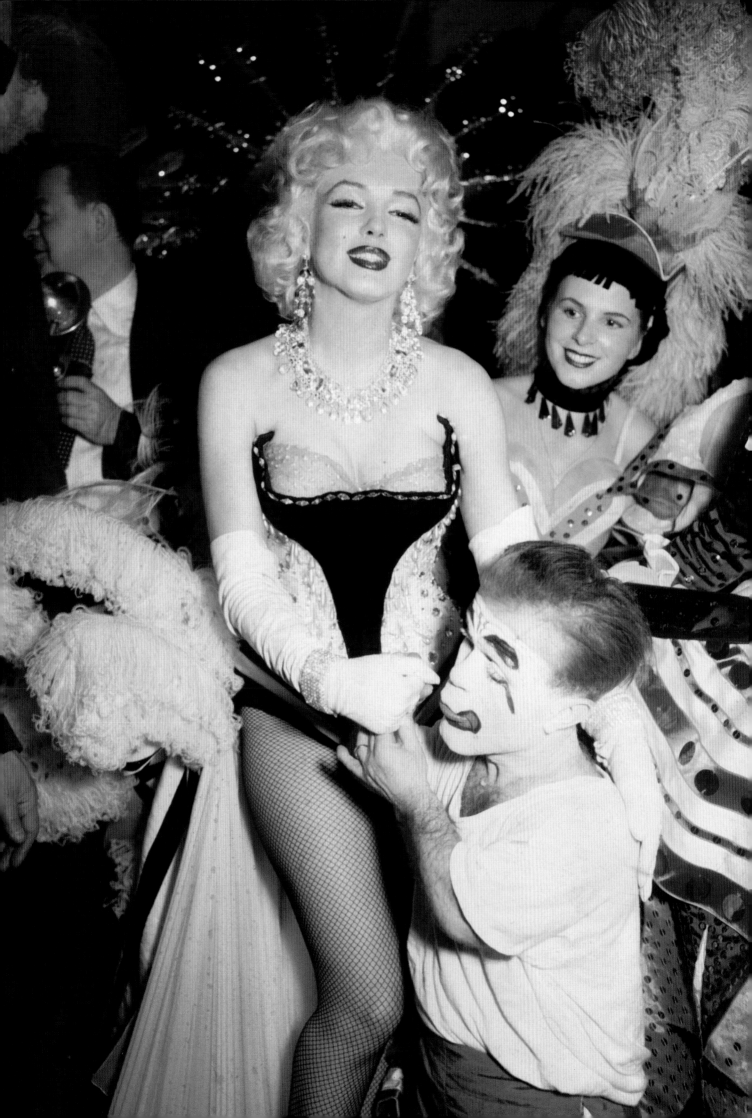

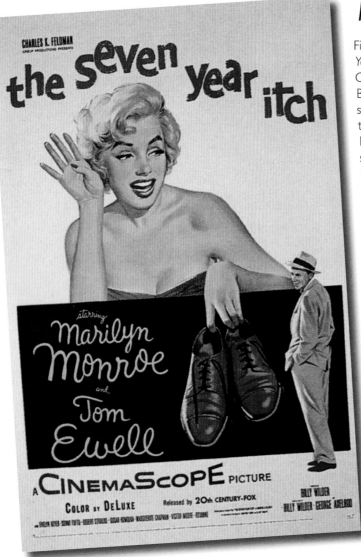

The Seven Year Itch

Filmed between September 1 and November 4, 1954, *The Seven Year Itch* was the only Billy Wilder movie released by Twentieth Century-Fox. The screenplay was adapted from the original Broadway show, which was written by George Axelrod and starred Tom Ewell (who reprised his role as Richard Sherman in the film) and Vanessa Brown, who was replaced by Marilyn. Marilyn was electrifying—but behind the scenes, as we have seen, her marriage to Joe DiMaggio was on the rocks. She was late on set, fluffed her lines and the budget swelled to $1.8 million, as it ran late.

The movie was a great success. *Variety* noted, "The screen adaptation concerns only the fantasies, and omits the acts, of the summer bachelor, who remains totally, if unbelievably, chaste. Morality wins if honesty loses, but let's not get into that."

Marilyn attended the June 1 premiere at Loew's State Theater on Times Square with Joe DiMaggio. A huge poster of her, skirt billowing, adorned the cinema frontage. "That's the way they think of me," Marilyn said, "with my skirt over my head."

Cast & Credits

Marilyn Monroe: The Girl
Tom Ewell: Richard Sherman
Evelyn Keyes: Helen Sherman
Sonny Tufts: Tom MacKenzie

Director: Billy Wilder
Producer: Charles Feldman & Billy Wilder
Writer: Screenplay by Billy Wilder and George Axelrod from Axelrod's play.
Music: Alfred Newman
Cinematography: Milton R Krasner
Studio: Twentieth Century-Fox
General release date: June 3, 1955

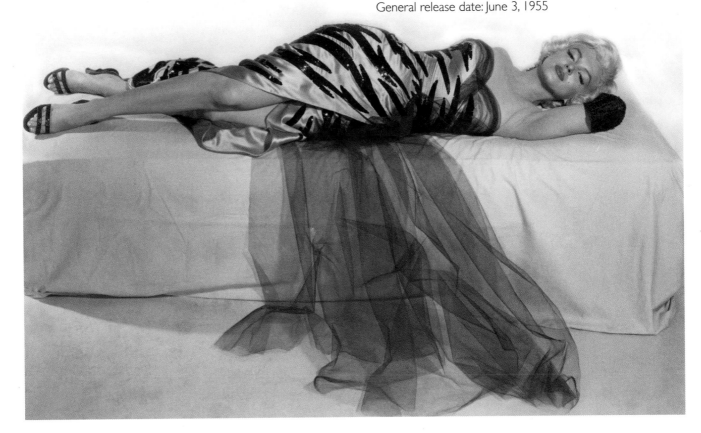

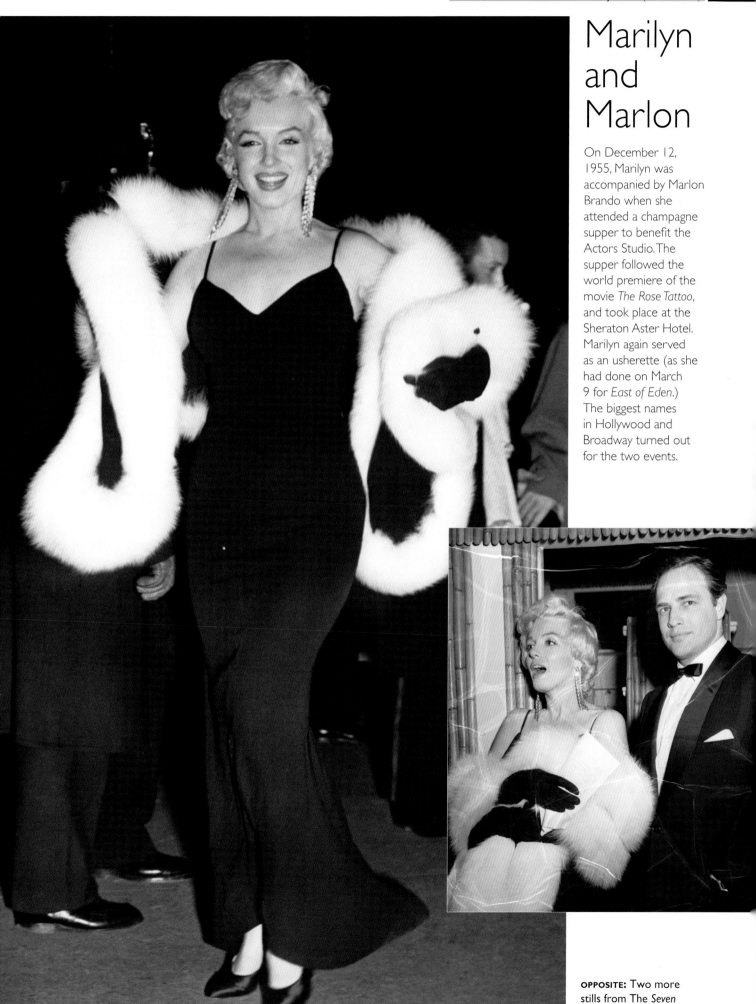

Marilyn and Marlon

On December 12, 1955, Marilyn was accompanied by Marlon Brando when she attended a champagne supper to benefit the Actors Studio. The supper followed the world premiere of the movie *The Rose Tattoo*, and took place at the Sheraton Aster Hotel. Marilyn again served as an usherette (as she had done on March 9 for *East of Eden*.) The biggest names in Hollywood and Broadway turned out for the two events.

OPPOSITE: Two more stills from The *Seven Year Itch*.

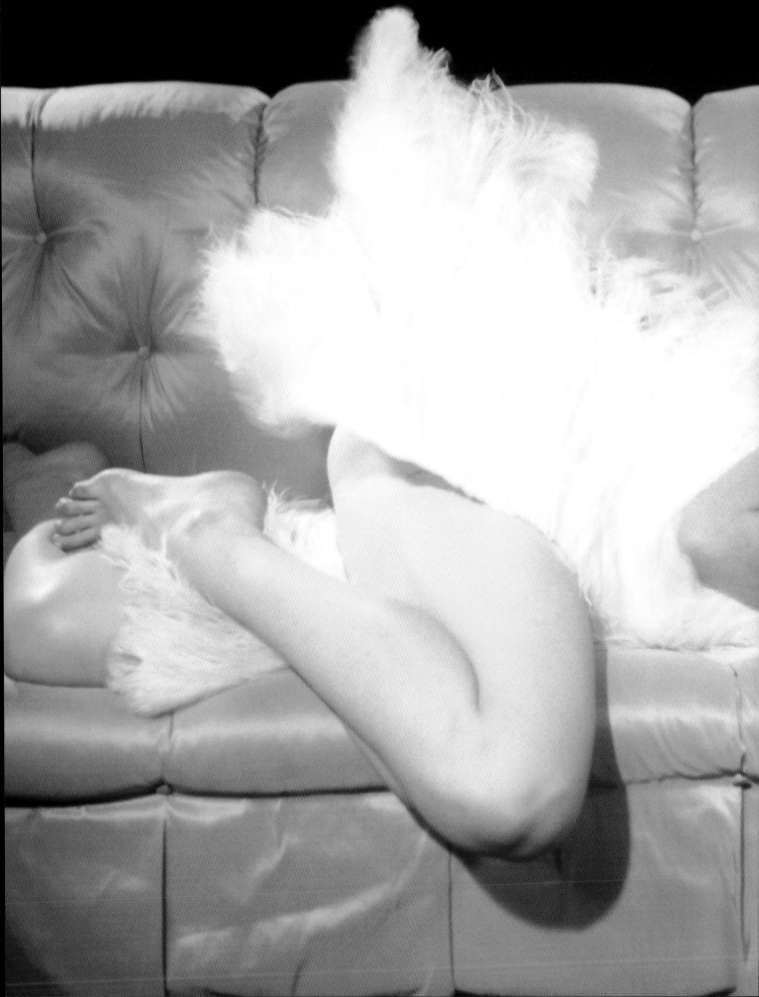

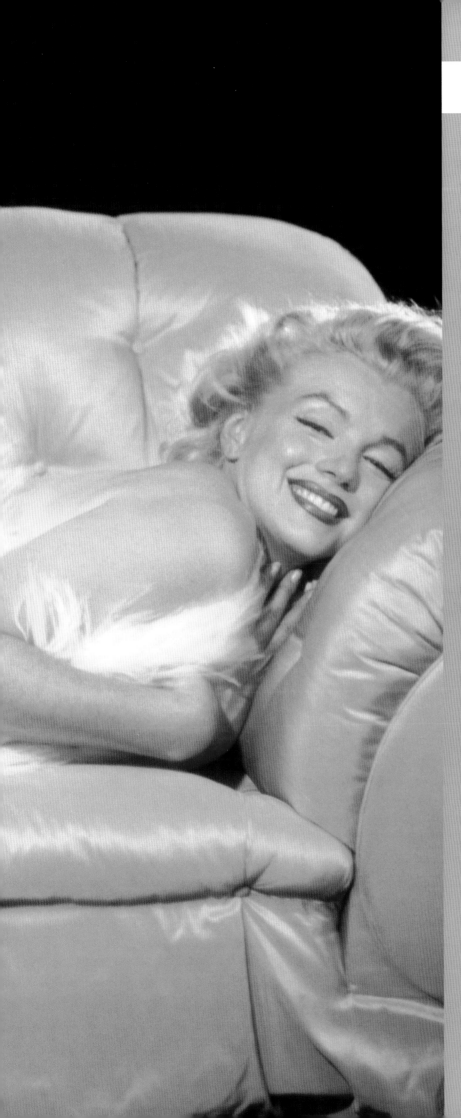

CHAPTER 4

Happy Birthday, Mr President (1956–1962)

1956 saw the release of *Bus Stop*, the first movie made by Marilyn Monroe Productions for Twentieth Century-Fox. From now until the end of her life she would only make one movie, or less, per year.

Again, it looked like Marilyn might find lasting happiness when, in June 1956, she married Arthur Miller, but the honeymoon ended abruptly. With her husband under investigation by the communist-hunting House Committee on Un-American Activities the couple left for the UK where Marilyn began taking drugs for sleeplessness and her nerves while shooting *The Prince and the Showgirl* with Laurence Olivier.

The last years of her life were frequently chaotic and depressing. Afraid of inheriting her mother's mental illness, Marilyn slipped slowly into drug addiction and suffered three miscarriages that further increased her fragility. Her behavior on set deteriorated and she was often late and unprepared, and, to make matters worse, conducted affairs with her co-stars. Even so, she managed to turn in some of the best performances of her career, especially as Sugar Kane in Billy Wilder's *Some Like it Hot*—the role for which she is remembered more than any other.

After divorcing Miller in late 1960, Marilyn seemed to unravel. Dependent on drink, she was admitted to a mental hospital, embarked on an ill-fated affair with the nation's president, and was sacked by Twentieth Century-Fox midway through her last movie. Late at night on August 4, 1962, she died, succumbing to a massive overdose of drugs.

LEFT: Marilyn on the set of *The Prince and the Showgirl*, which starred and was directed by Laurence Olivier.

Timeline 1956–1962

1956

February 9 *The Prince and the Showgirl* is announced at a press conference with Laurence Olivier at the Plaza Hotel, 768 Fifth Avenue, NY.

February 23 After getting an order from the City Court of the State of New York, Marilyn legally changes her name to Marilyn Monroe.

February 25 Marilyn returns to Hollywood after her "exile" in New York.

March 3 Shooting begins on *Bus Stop*.

May 14 *Time* magazine features Marilyn on the cover.

June 10 Arthur's divorce comes through.

June 21 Arthur Miller is questioned by the House Committee on Un-American Activities.

June 29 Marilyn and Arthur Miller marry in a civil ceremony at Westchester County Court House.

July 10 HUAC decides to charge Miller for contempt of Congress for not naming actors who are communists.

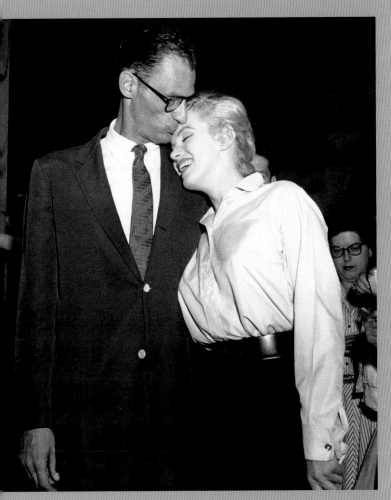

July 13/14 Marilyn and Miller travel to London for the start of filming *The Prince and the Showgirl*.

August 31 *Bus Stop* released. "Marilyn Monroe has finally proved herself an actress," said the review in *The New York Times*.

October 29 Marilyn and Arthur attend the Royal Film Performance of *The Battle of the River Plate*, and Marilyn is invited to join the line-up to meet Queen Elizabeth II.

November 20 Marilyn returns to the US.

1957

January 3–19 A late honeymoon in Jamaica.

May 31 Arthur is convicted of contempt of Congress for refusing to name alleged communists writers. The case immediately goes to appeal.

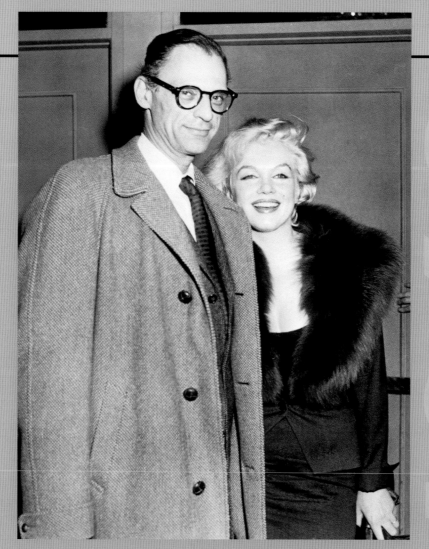

BELOW LEFT: Arthur Miller kisses his fiancee outside her Manhattan apartment. They met the press for the first time since their marriage intentions became known.

RIGHT: Marilyn at Loew's Lexington Theatre in her first public appearance since making *Some Like it Hot*. Marilyn was accompanied by her husband.

June 13 *The Prince and the Showgirl* premieres at Radio City Music Hall in New York. Nominated for a BAFTA, she won major awards in Italy and France for the movie.

July 8 Marilyn and Sir Laurence Olivier appear on the cover of *Life* magazine.

November Marilyn and Arthur meet 90-year-old Frank Lloyd Wright to discuss his designing a house for them in Roxbury, Connecticut. (It was adapted and built for a golf club on Maui, HI.)

1958

April 4 Marilyn signs up for *Some Like It Hot*.

August 4 Marilyn starts working on *Some Like It Hot*.

August 7 Arthur's conviction is quashed.

November 6 Filming of *Some Like It Hot* overruns—in part because of Marilyn's innumerable takes. A contributing factor is that she is pregnant.

December 16 Marilyn goes to Manhattan Polyclinic Hospital where she miscarries.

Timeline 1956–1962

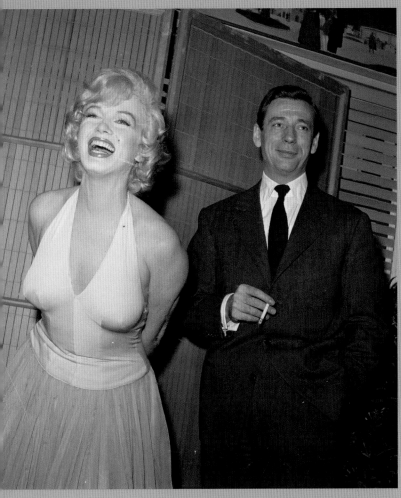

ABOVE: Marilyn at cocktail party with Yves Montand, January 16, 1960. She had a passionate affair with the Frenchman.

December 22 *Life* magazine carries Arthur Miller's article "My Wife Marilyn" with Richard Avedon photos and Marilyn recreating the look of Marlene Dietrich, Lillian Russell, Theda Bara, Jean Harlow, and Clara Bow.

1959

February 26 Marilyn receives the Crystal Star Award as Best Foreign Actress for *The Prince and the Showgirl* at the French Consulate in New York.

March 29 Premiere of *Some Like It Hot* at Loew's Capitol Theater on Broadway. The movie will be voted the greatest American comedy of all time by the American Film Institute in 2000.

May 13 Another honor for her role in *The Prince and the Showgirl*. Marilyn receives Italy's version of the Oscar, the David di Donatello Award.

September 19 Marilyn attends the Twentieth Century-Fox dinner for Soviet Premier Khrushchev at the Café de Paris.

September Casting for Truman Capote's *Breakfast at Tiffany's* takes place. Capote wants Marilyn but the role goes to Audrey Hepburn.

1960

February 9 Marilyn was awarded her Star on the Walk of Fame.

March 8 Receives Golden Globe Award for Best Comedy Actress for *Some Like It Hot*.

End April While his wife, Simone Signoret, is in Europe and Arthur in New York, during the shooting of *Let's Make Love*, Marilyn and costar Yves Montand have an affair.

July 18 Shooting starts on *The Misfits*.

August 26 Marilyn goes into hospital suffering from exhaustion. On the 29th shooting stops after the crew is told she is having a nervous breakdown. She returns on September 6.

September 8 Release of *Let's Make Love.* "Monroe, of course, is a sheer delight," says *Variety* magazine.

Late October Marilyn and Arthur agree to divorce. A public announcement is made on November 11.

November 4 Final shoot for *The Misfits.*

November 16 Clark Gable dies of coronary thrombosis. His widow blames the "eternal waiting" on set, but he had crash dieted for the part and that can't have helped. Marilyn, however, is stricken with guilt.

Christmas Joe DiMaggio stays with Marilyn.

1961

January 20 Marilyn and Arthur go to Mexico for a quick divorce. He keeps the Connecticut home; Marilyn stays in the New York apartment.

January 31 Premiere of *The Misfits* at the Capitol Theater in New York City. Kate Cameron says in the *New York Daily News*: "Gable has never done anything better on the screen, nor has Miss Monroe."

February 7 Marilyn enters the Payne Whitney Psychiatric Clinic, then moves to Columbia Presbyterian Hospital.

March 5 Marilyn leaves hospital and later in the month visits Joe in Florida .

April 2 Marilyn returns to New York with her sister, Berniece.

LEFT: Marilyn leaves Columbia Presbyterian Hospital, March 5, 1961. She had spent three weeks there, visited every day by Joe DiMaggio; at the end of the month she joined him in Florida.

Timeline 1956–1962

April Returns to the West Coast, taking an apartment at 882 North Doheny Drive, Beverly Hills.

May Enters the Cedars of Lebanon Hospital in Los Angeles with endometritis.

June 25 Marilyn returns to New York City.

June 28 Enters the Manhattan Polyclinic Hospital with cholangitis.

July 11 Leaves hospital and recuperates in New York with Berniece . . .

August 8 . . . before returning to the West Coast.

November 19 Attends a dinner at Peter Lawford's house with President Kennedy.

1962

February 2 Marilyn travels to New York. There, she meets the President at a friend's dinner party.

March 4 Marilyn receives the World Film Favorite in 1961 award from the Golden Globe Awards.

March 8–9 Joe helps her move into her new house at 12305 Fifth Helena Drive in Brentwood.

April 23 Shooting starts on *Something's Got to Give*.

May 19 Marilyn sings "Happy Birthday" and "Thanks for the Memory" for JFK at Madison Square Garden.

May 23 Marilyn films the famous nude swimming pool scenes.

June 7 Fox fires Marilyn for breach of contract.

June 22 Marilyn appears on the cover of *Life* magazine for the last time during her lifetime.

June 23–25 Bert Stern shoots five photo sessions for *Vogue*—known today as "The Last Sitting."

July 4 Marilyn attends a Peter Lawford barbecue on Independence Day; RFK is one of the guests.

July 25 Fox say that the lawsuit is to be dropped and she is to be reinstated.

August 4 Marilyn's last day alive includes a long session with her psychiatrist; an injection from her doctor; and large numbers of prescription drugs.

August 5 Police are called to Marilyn's home where she is found dead.

RIGHT: Marilyn on the set of *Something's Got To Give*.

Meeting Olivier

On February 9, 1956, Marilyn and Sir Laurence Olivier (right) announced to the Press in New York that they would be teaming up together in *The Prince and the Showgirl*, a movie based on the stage play *The Sleeping Prince* by Terence Rattigan. Marilyn Monroe Productions had bought the rights to the screenplay and Marilyn chose Olivier for the male lead and director; Olivier agreed to do so on the proviso he would co-produce. Warners (Marilyn with Jack Warner, below) would handle distribution. It all sounded so easy …

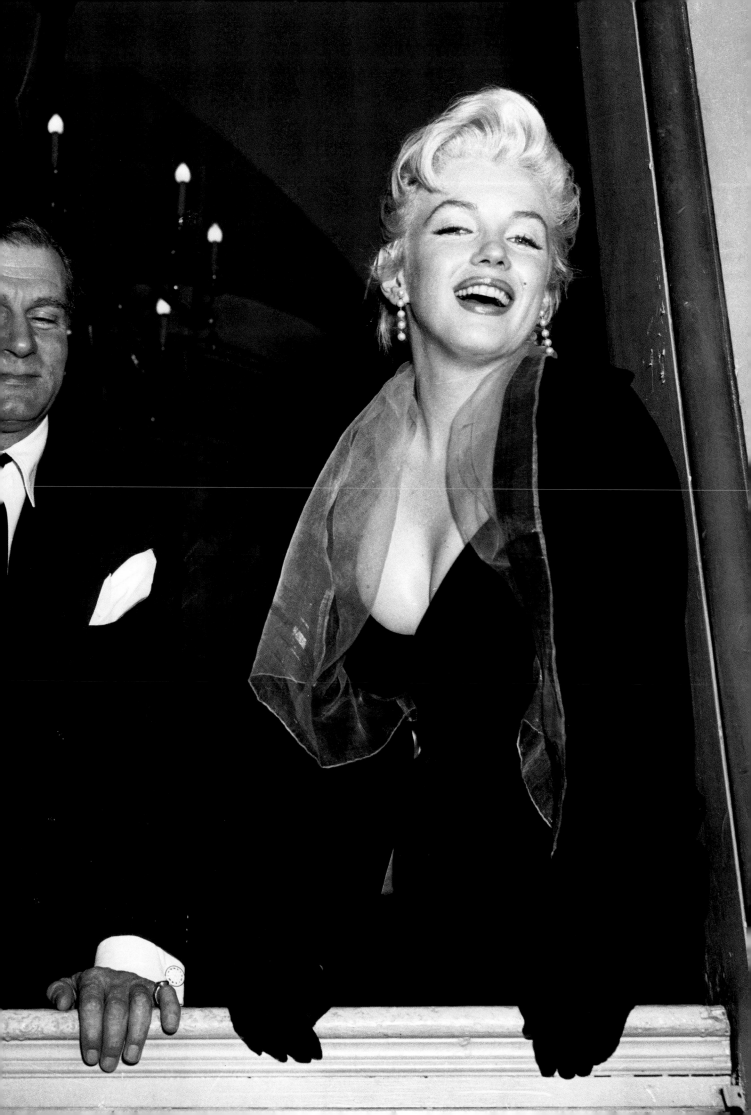

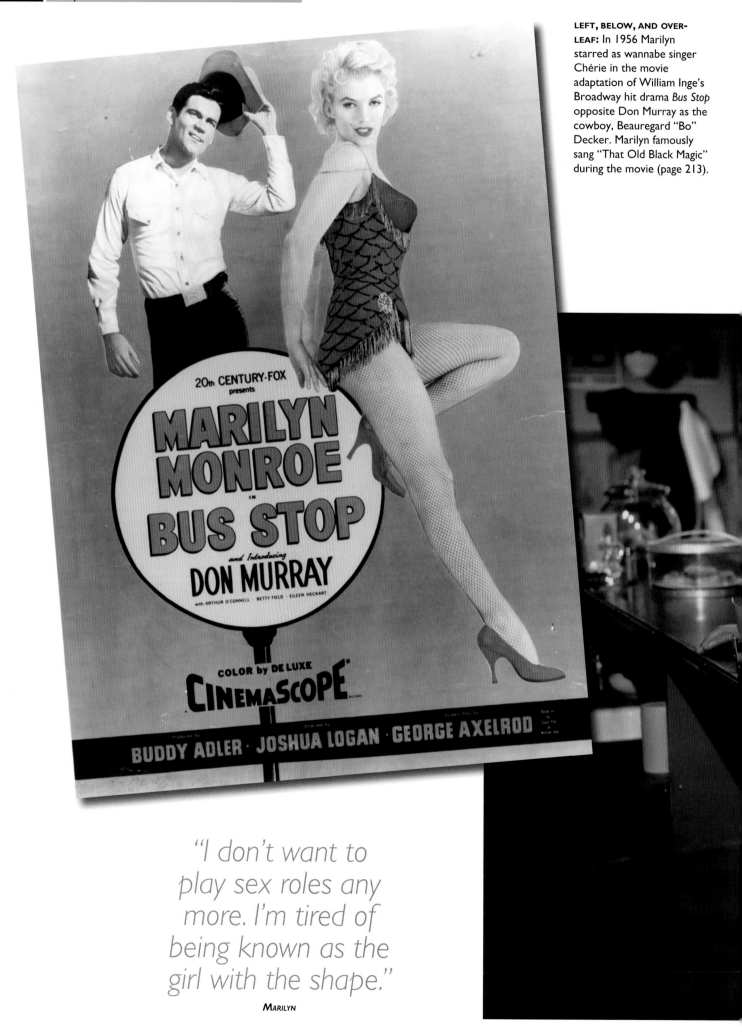

**LEFT, BELOW, AND OVER-
LEAF:** In 1956 Marilyn
starred as wannabe singer
Chérie in the movie
adaptation of William Inge's
Broadway hit drama *Bus Stop*
opposite Don Murray as the
cowboy, Beauregard "Bo"
Decker. Marilyn famously
sang "That Old Black Magic"
during the movie (page 213).

*"I don't want to
play sex roles any
more. I'm tired of
being known as the
girl with the shape."*

MARILYN

Bus Stop

Marilyn chose *Bus Stop* as the first solo outing for Marilyn Monroe Productions. With it she wanted to show she had become a serious actress in her first performance since training with Lee Strasberg. She used a convincing hillbilly accent for her character Chérie, who hailed from the Ozarks, clothes she found in the .costume department (she rejected the specially designed ones), and wore pale, unflattering make up. The movie earned Marilyn some of the best reviews of her life—but Hollywood wanted their sex bomb back instead, and refused to even nominate her for an Academy Award.

Cast & Credits

Marilyn Monroe—Chérie
Don Murray—Beauregard "Bo" Decker
Arthur O'Connell—Virgil Blessing
Betty Field—Grace
Hope Lange—Elma Duckworth
Eileen Heckart—Vera

Director: Joshua Logan
Producer: Buddy Adler
Writer: Screenplay by George Axelrod from the play by William Inge
Music: Alfred Newman & Cyril Mockridge
Cinematography: Milton Krasner
Studio: Twentieth Century-Fox and Marilyn Monroe Productions
General release date: August 31, 1956

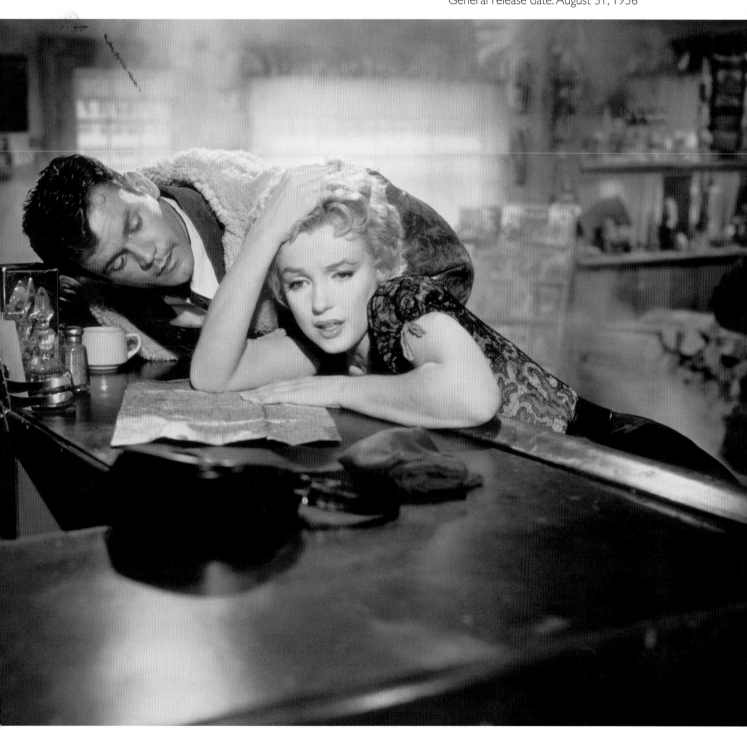

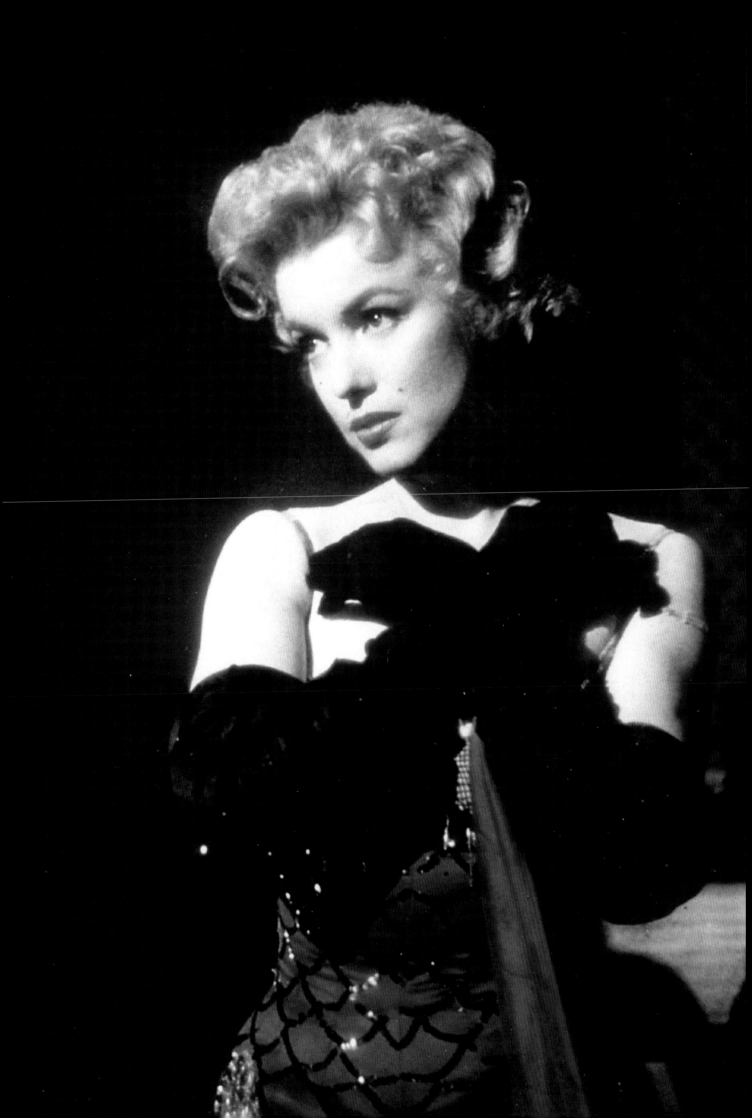

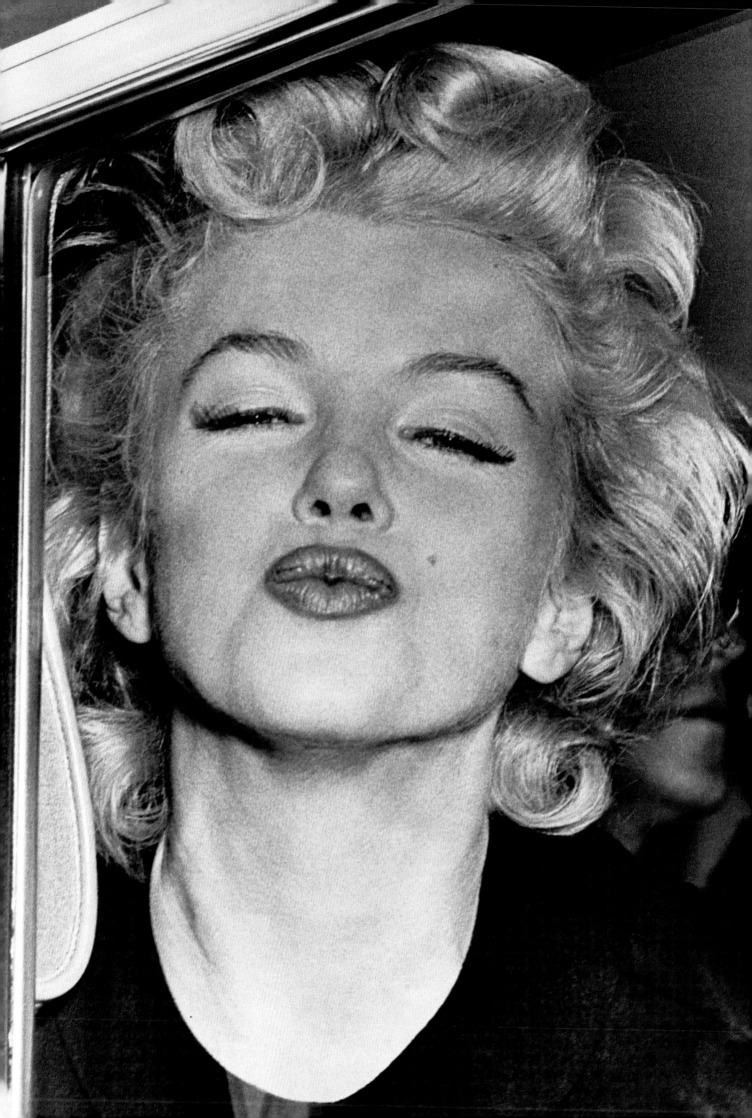

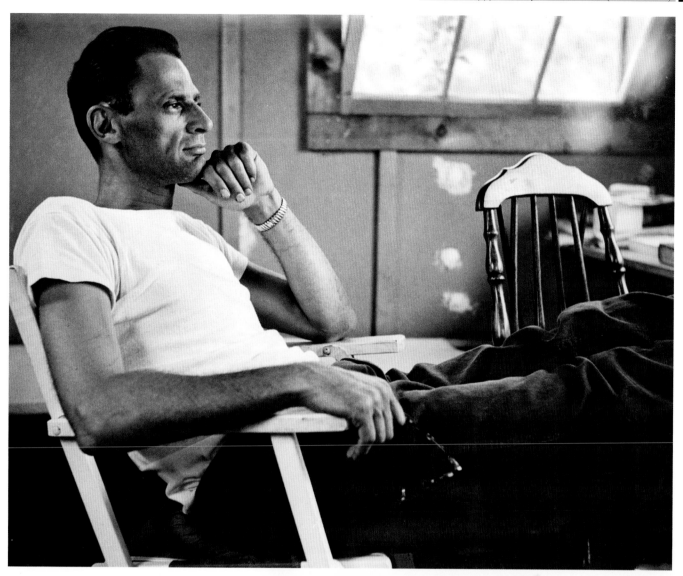

"The Egghead and the Hourglass"

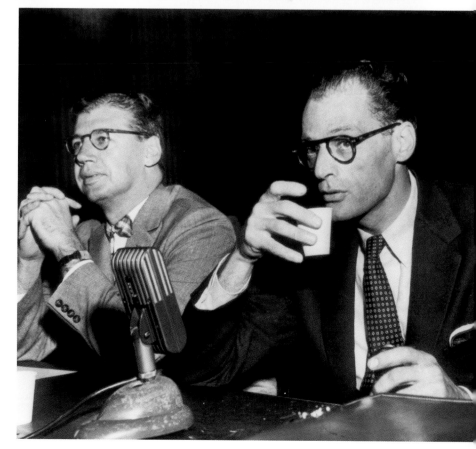

Marilyn first met Arthur Miller—the most celebrated playright in America—on April 23, 1951. She was on set filming *As Young As You Feel* and Miller was the guest of Elia Kazan who brought him along to meet the movie's director Harmon Jones. Although Marilyn was recovering from an overdose of sleeping pills, the attraction between the screen goddess and the already married intellectual was instantaneous. They kept in loose contact until summer and fall 1955 when they develped their secret relationship. He was in thrall to her beauty and thought her a far better actress than she was given credit for. For her part, Marilyn loved his intelligence and intellectual gravitas that gave her the extra credibility that she craved as a serious actress.

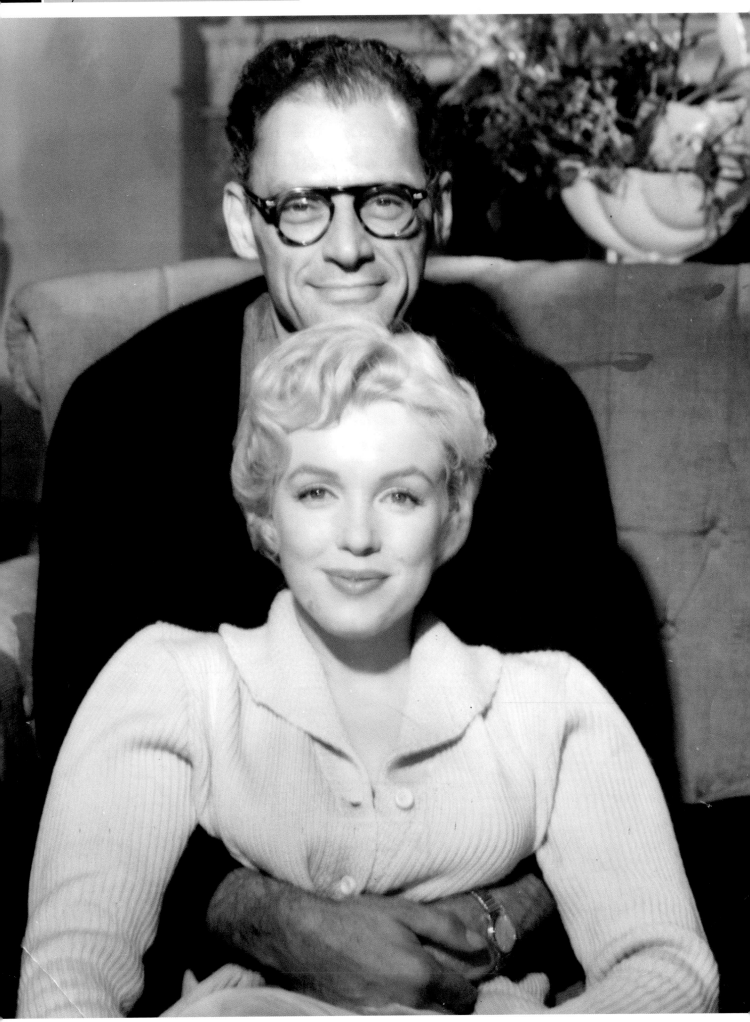

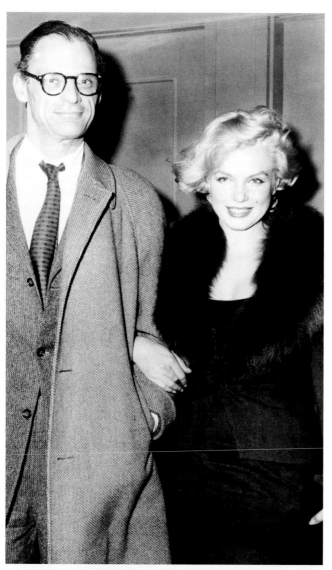

Married Life

By the time Miller was interrogated in Washington by the House Un-American Activities Committee, their affair was well known, although Marilyn only quietly supported him from the wings. It was rumored that she even helped to pay his legal bills, but Miller never confirmed this. The Pulitzer prize-winning author said he supported communist causes in the late 1940s because "it suited the mood I was in," but flatly denied to the subcommittee that he ever was under red discipline. His refusal to name friends with similar leanings—in spite of being promised that he would not be asked to do so—led to a contempt of court conviction in May 1957 that was subsequently quashed in 1958.

Miller left his wife, Mary, at the beginning of June and within days, on June 29, 1956, married Marilyn in a civil ceremony in White Plains, New York. On July 1 they married again in a Jewish ceremony in Waccabuc, Westchester at the home of Miller's literary agent in front of about 30 friends and family. Marilyn quickly became close to her parents-in law, Isidore and Augusta, and was soon calling them "Mom" and "Dad." She remained close to them, especially Isidore, even after her divorce from Miller.

Marilyn and Miller initially settled into domestic bliss on Long Island, but a second failed pregnancy led Marilyn to suffer from depression and resort to more drugs: their relationship started to suffer. Their estrangement started within a few months of marriage while they lived in England as Marilyn filmed *The Prince and the Showgirl*. Marilyn felt Miller was not sufficiently supportive and, much to his annoyance, increasingly turned for such bolstering to Paula Strasburg instead. In the end they were together for 12 years during which time they became almost completely alienated. After Marilyn died it emerged that she had kept every letter he sent her; he on the other hand, had kept almost nothing from her.

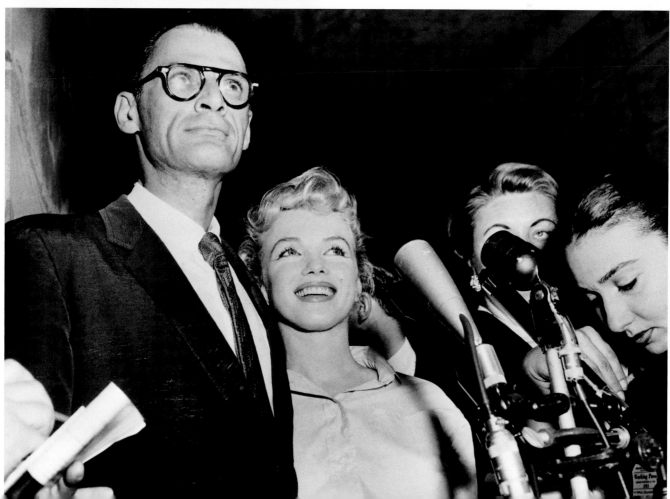

The Prince and the Showgirl

Filmed in London, the movie starred Marilyn opposite Laurence Olivier. Marilyn was hugely intimidated by Olivier's grandeur and found herself almost paralysed with fear. She resorted to taking prescription barbiturates to calm her nerves, but they put her into a paranoid stupor and she was consistently late on set. Olivier, who had confidently expected to have an affair with her, became increasingly exasperated with what he considered her lack of professionalism, and especially her Method coach, Paula Strasberg, who was the only person able to communicate with Marilyn. During filming Miller returned to New York to see his children, Marilyn felt abandoned, and in late August lost the

"That little girl is the only one here who knows how to act before a camera."

DAME SYBIL THORNDIKE

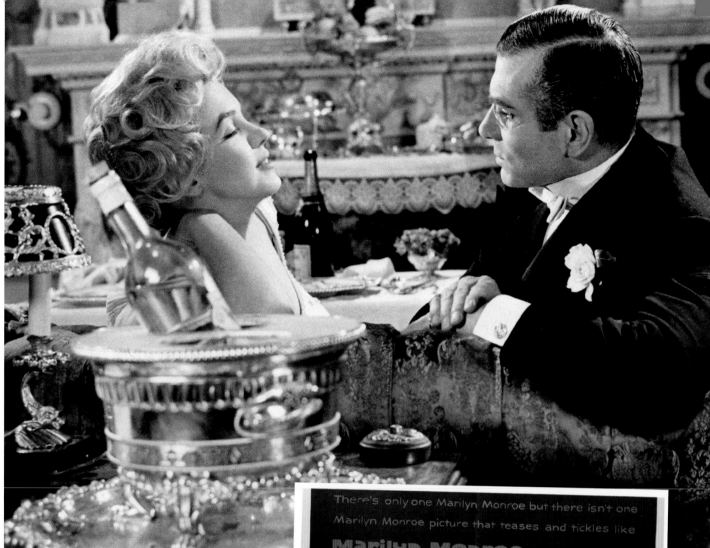

baby she had only just discovered she was carrying. The entire four-month shoot was an unhappy experience for everyone and the press loved the rumors of discord. On wrapping the movie Marilyn and Miller went on a late honeymoon to Ocho Rios in Jamaica to recover, after which they moved to their farmhouse at Amagansett, Long Island to spend the summer of 1957.

Cast & Credits
Marilyn Monroe—Elsie Marina
Sir Laurence Olivier—Charles, the Prince Regent
Sybil Thorndyke—The Queen Dowager
Richard Wattis—Northbrook

Director: Sir Laurence Olivier
Producer: Sir Laurence Olivier, with Milton Greene & Anthony Bushell
Writer: Screenplay by Terence Rattigan of his own play The Sleeping Prince
Music: Richard Adinsell
Cinematography: Jack Cardiff
Studio: Warner Bros. Pictures & Marilyn Monroe Productions
General release date: June 13, 1957

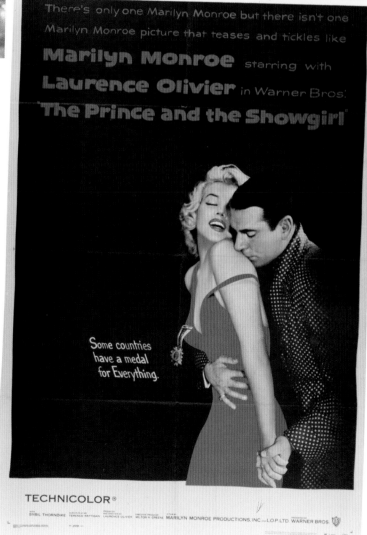

There's only one Marilyn Monroe but there isn't one Marilyn Monroe picture that teases and tickles like

MARILYN MONROE starring with
Laurence Olivier in Warner Bros.
The Prince and the Showgirl

Some countries have a medal for Everything.

TECHNICOLOR®

SYBIL THORNDIKE TERENCE RATTIGAN LAURENCE OLIVIER MILTON H. GREENE MARILYN MONROE PRODUCTIONS, INC. L.O.P. LTD. WARNER BROS.

PICTURE POST

WEEK ENDING 14 JULY 1956

POLAND'S REVOLT
—Exclusive pictures

PIRIE'S
GLORIOUS 'FAILURE'

DORS in
HOLLYWOOD

BRITAIN'S
ATOMIC
COALMINE

TYSON and
EVANS

BEDTIME WITH MARILYN
See inside

4^D HULTON'S
NATIONAL
EVERY
WEDNESDAY WEEKLY

PICTURE
POST

MONDAY 22 OCTOBER 1956

TAMING THE MAU MAU—
Dramatic Picture Exclusive

THE MOTOR SHOW—
The new ideas

Marilyn makes
headlines again
See inside

4D HULTON'S
NATIONAL
WEEKLY

ON SALE
FRIDAY
OCT. 19

Cover Girl

Picture Post used Marilyn as a cover girl a number of times
in the 1940s and 1950s—including twice in 1956 (that at
left taken by her business associate Milton Greene).

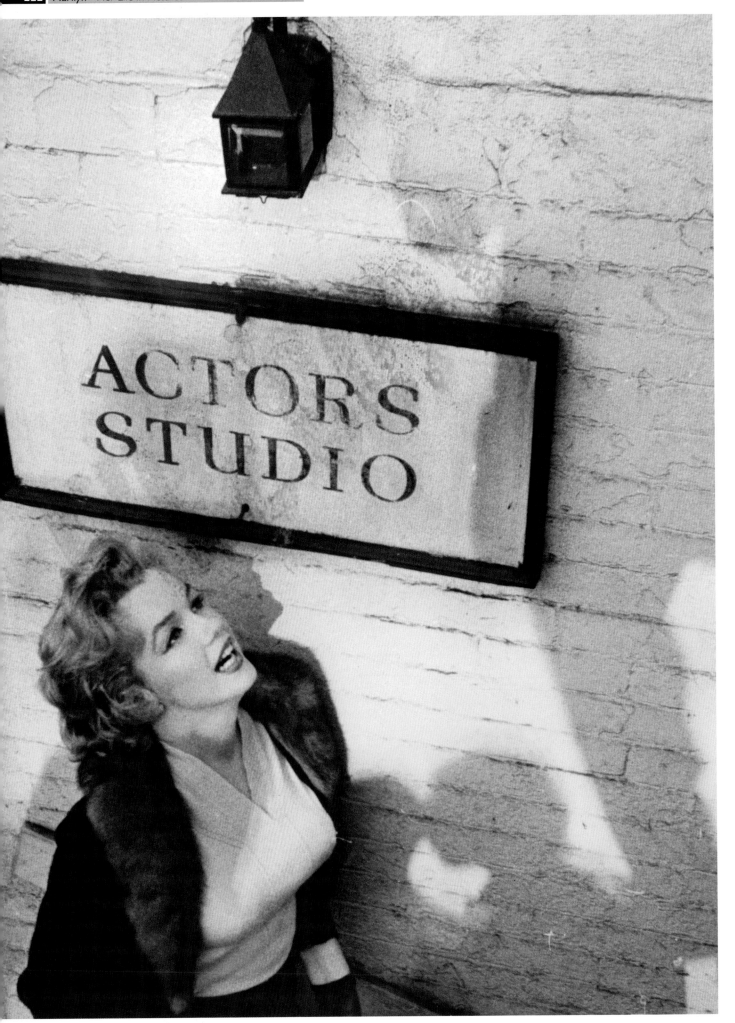

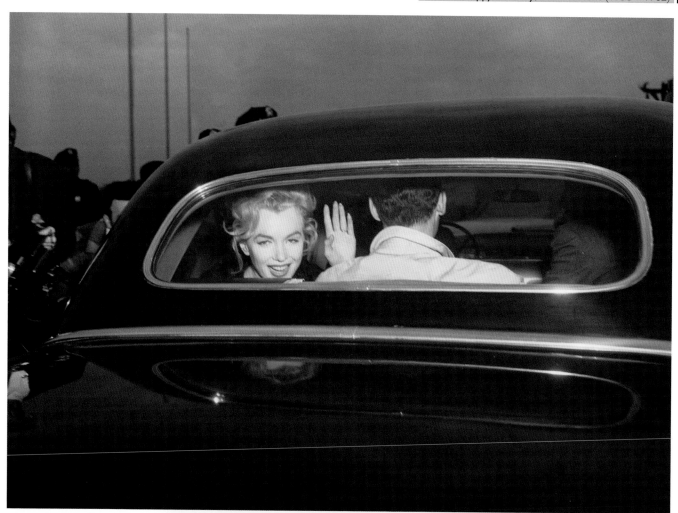

ABOVE: Shooting of *The Prince and The Showgirl* ended on November 17 and on the 21st the Oliviers accompanied the Millers to the airport: they put on a good show for the onlookers, but the experience had been awful—Marilyn wouldn't make another movie for two years. Here, Marilyn and Arthur depart Idlewild airport after arriving back from London on November 22. A few days later she went to the Actors Studio (left). Paula Strasberg had been with her in London—for a large fee—and had almost continuously clashed with Olivier.

RIGHT: With Arthur behind her, Marilyn puts on a brave face as she leaves Doctor's Hospital in an ambulance on August 10, 1957. Nine days earlier she had surgery to end a tubal pregnancy. With Arthur's HUAC problems and this devastating loss of a baby, 1957 was a difficult and unhappy year.

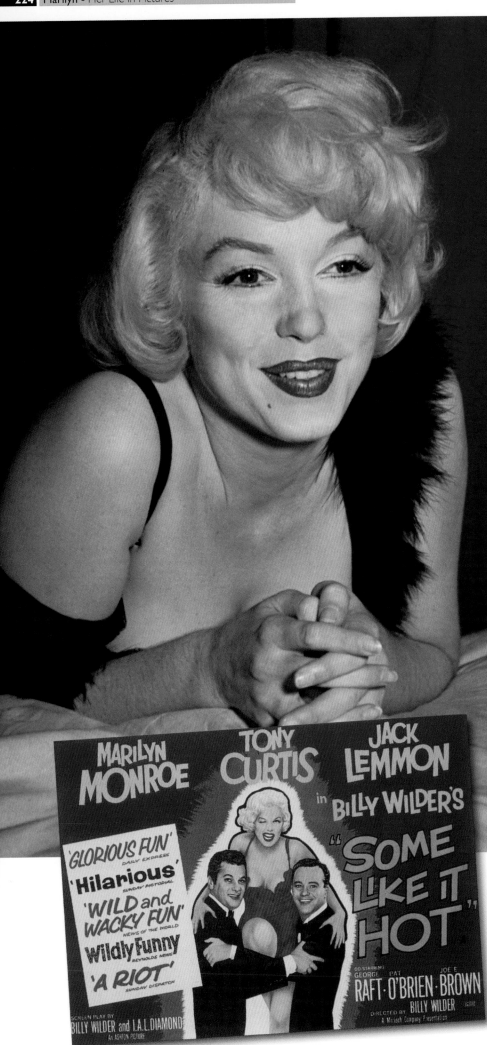

Some Like It Hot

After the trials and tribulations of 1957, Marilyn couldn't wait to get back to Hollywood. She arrived there on July 8 and soon was back at work in what was, arguably, her greatest role: Sugar Kane, the sweetly kooky singer for Sweet Sue's Society Syncopators in the movie *Some Like It Hot*. Throughout the shoot Marilyn was chronically late on set and when she appeared needed hours to get ready and then numerous takes before getting it right. One time Jack Lemmon bet Tony Curtis that she would require 15 takes to get a scene right: Curtis figured it would be 34: both were wrong—Marilyn needed 59 takes. Director Billy Wilder said, "With this girl you take a lot more takes than you think necessary, but when she's finally got a scene right, it's worth it." To add to the insult, Curtis and Lemmon often felt their best work as a consequence was lost on the cutting room floor. Marilyn's iconic role didn't even win her an Oscar nomination.

Cast & Credits

Marilyn Monroe—Sugar Kane Kowalczyk
Tony Curtis—Joe (Josephine & Junior)
Jack Lemmon—Jerry (Daphne)
George Raft—Spats Colombo
Pat O'Brien—Detective Mulligan

Director: Billy Wilder
Producer: Billy Wilder with I.A.L. Diamond & Doane Harrison
Writer: Screenplay by Billy Wilder and I.A.L. Diamond from a story by R. Thoeren and M. Logan
Music: Adolph Deutsch
Cinematography: Charles Lang
Studio: United Artists
General release date: March 29, 1959

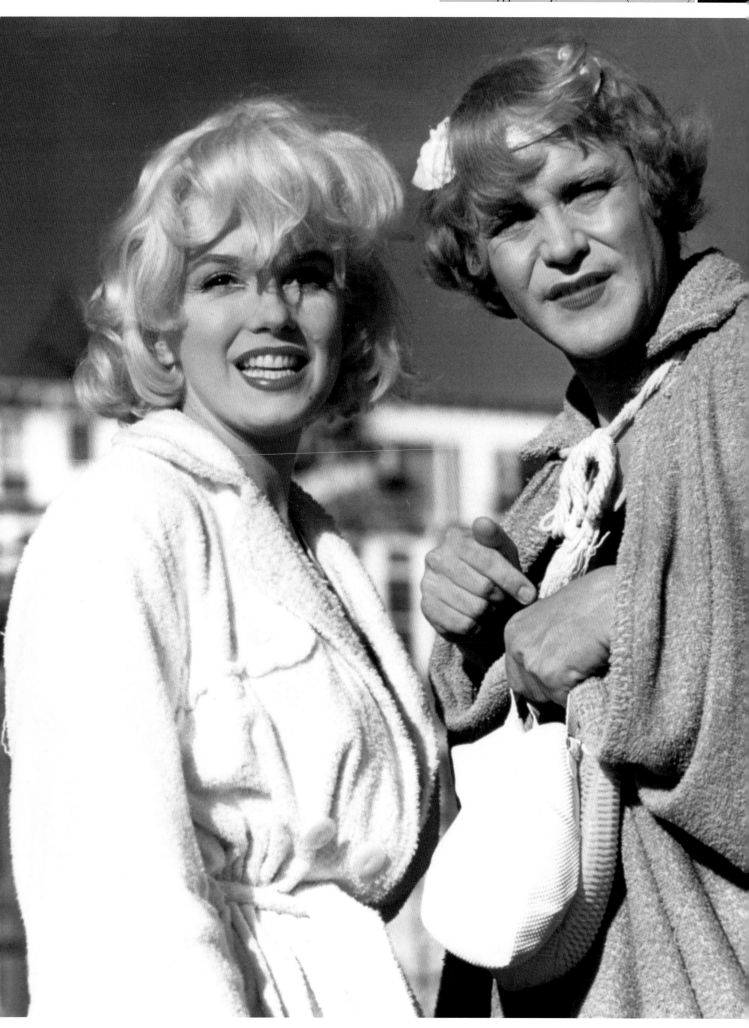

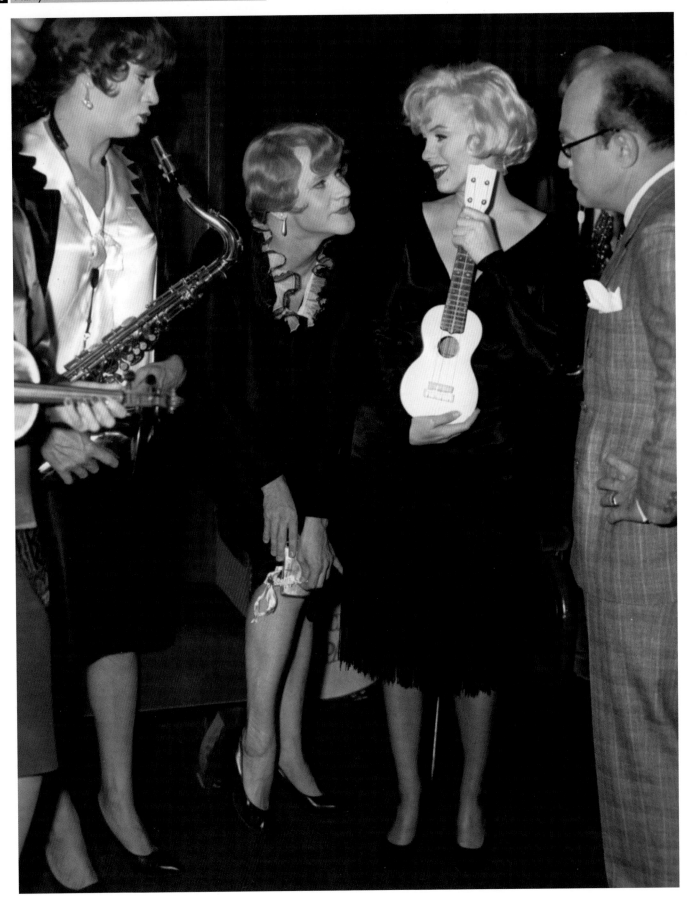

"Sex is part of nature—I go along with nature."

MARILYN

ABOVE: On the set of *Some Like It Hot*.

RIGHT: Marilyn travels from LaGuardia to Chicago to attend the premiere there of *Some Like It Hot*, March 18, 1959.

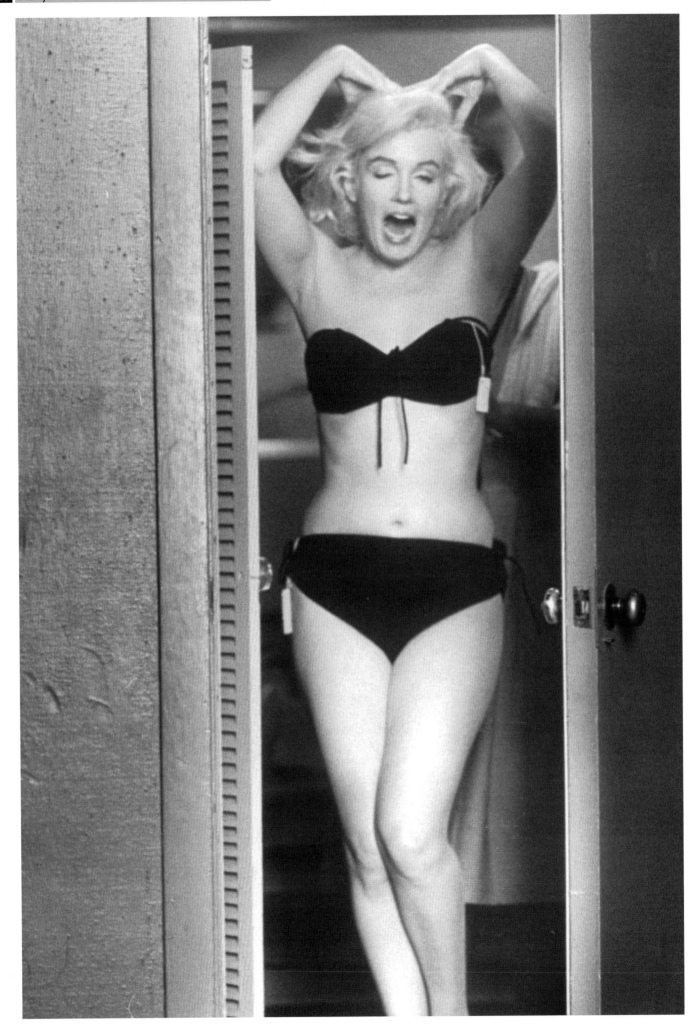

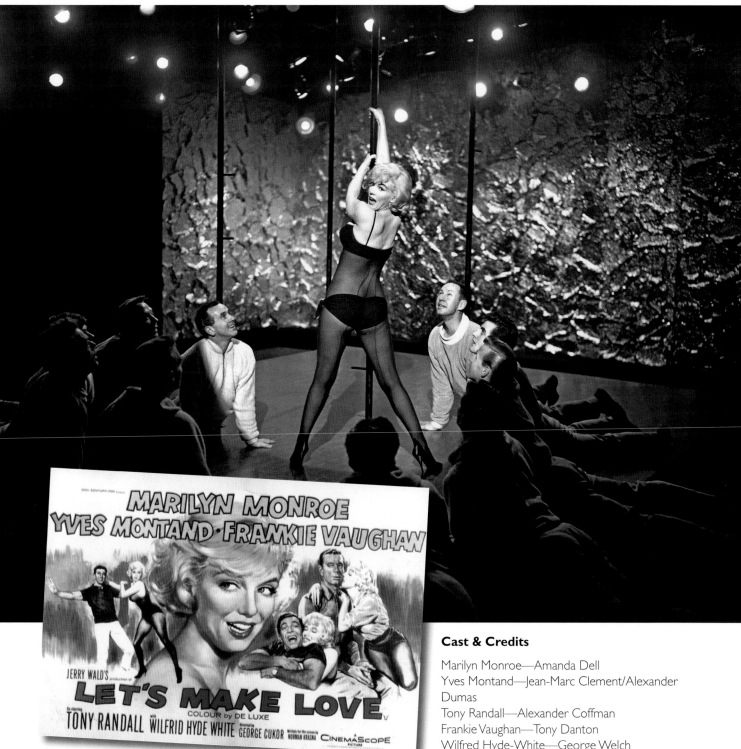

Let's Make Love

Costume fitting took place at the end of 1959 for Marilyn's next movie and shooting started in January, but her chronic inability to appear on set on time, coupled with a six-week Screen Actors Guild strike that added 28 extra days to the schedule, reportedly put $1 million dollars onto the movie's costs. Marilyn's last take was on June 20, 1960. To improve the flimsy script Marilyn persuaded Miller to rework it, but her co-star, Gregory Peck, disliked his alterations and pulled out. Numerous other leading men refused the part (primarily because of Marilyn's reputation), until finally French star Yves Montand took the role. Although both were married, they had a barely concealed affair through the run of the shoot, though Montand quickly returned to his wife Simone Signoret after the movie wrapped. The critics didn't like the movie and were harsh about both it and Marilyn.

Cast & Credits

Marilyn Monroe—Amanda Dell
Yves Montand—Jean-Marc Clement/Alexander Dumas
Tony Randall—Alexander Coffman
Frankie Vaughan—Tony Danton
Wilfred Hyde-White—George Welch

Director: George Cukor
Producer: Jerry Wald
Writer: Screenplay by Norman Krasna and Hal Kanter, revised by Arthur Miller
Music: Lionel Newman
Cinematography: Daniel L. Fapp
Studio: Twentieth Century-Fox
General release date: September 8, 1960

OVERLEAF: Marilyn and Yves Montand had a steamy affair during shooting.

LIFE

A DRAMA OF SUBURBANITES
AND A NEGRO NEIGHBOR

MARILYN'S CO-STAR:
YVES MONTAND,
IDOL OF FRANCE

REG. U. S. PAT. OFF.

AUGUST 15, 1960

The Misfits

Arthur Miller wrote *The Misfits* as a starring vehicle for Marilyn to prove her prowess as an actor, but the work was a long time in pre-production because Twentieth Century-Fox insisted on Marilyn fulfilling her contract to them first. She arrived in Nevada on July 20, 1960, and when the movie finally appeared it had cost $4 million to shoot, at the time one of the most expensive ever. The Millers' marriage was virtually over and tensions on set were high with the couple openly fighting—they divorced two month after shooting finished. To make matters worse, Marilyn rarely appeared before lunch, keeping the crew and co-stars hanging around in the blazing Nevada heat. The strain got to the elderly Gable whose death from a heart attack the day after he finished his last shot for the movie was in part blamed on Marilyn. She had also made continual attempts to seduce Gable—her long-time fantasy father—but he was not interested. Throughout filming Marilyn was drinking heavily and taking increasing amounts of drugs until by the end of August she became virtually incapacitated and had to be sent to Westside Hospital in Los Angeles for ten days to detox. Production on the movie was shut down until her return.

Cast & Credits

Clark Gable—Gay Langland
Marilyn Monroe—Roslyn Taber
Montgomery Clift—Perce Howland
Thelma Ritter—Isabelle Steers
Eli Wallach—Guido

Director: John Huston
Producer: Frank Taylor
Writer: Screenplay by Arthur Miller
Music: Alex North
Cinematography: Russell Metty
Studio: United Artists
General release date: February 1, 1961

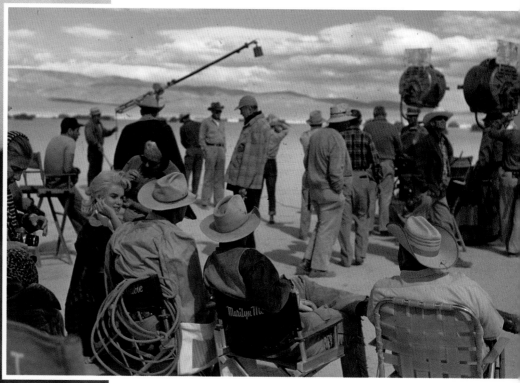

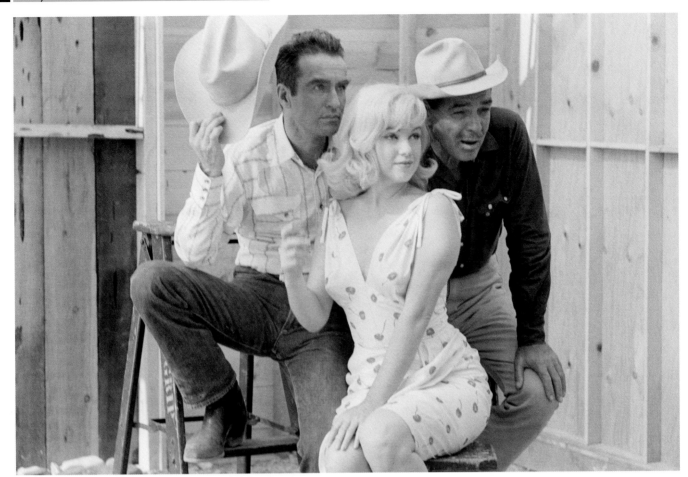

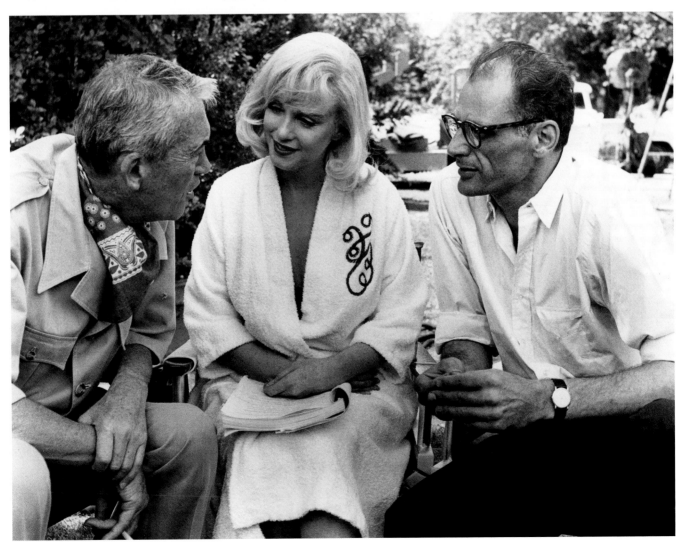

ABOVE LEFT: Marilyn with costars Montgomery Clift and Clark Gable.

LEFT: Director John Huston, Marilyn, and Arthur Miller.

ABOVE: Marilyn and Montgomery Clift were great friends. Marilyn described him as, "The only person I know who is in worse shape than I am." Here they attend the premiere of *The Misfits*, in 1961.

"He could have written me anything, and he comes up with this. If that's what he thinks of me, well, then, I'm not for him and he's not for me."

MARILYN

Something's Got To Give

Fox took a gamble on Marilyn delivering at the box office and put her to work again despite her fragile physical and mental health. However, cast opposite Dean Martin, she was as notoriously unreliable as ever, and out of 33 days when she should have been on set, she only appeared 12 times. On June 8 she was fired and the movie was quickly cancelled and written off as a $2 million loss. Marilyn was devastated, claiming in the press that she had done everything she could to make it a success and couldn't understand why it was dropped. Many of the movie crew who had lost their jobs clubbed together and took out an advertisement in *Variety* sarcastically thanking Marilyn for her actions.

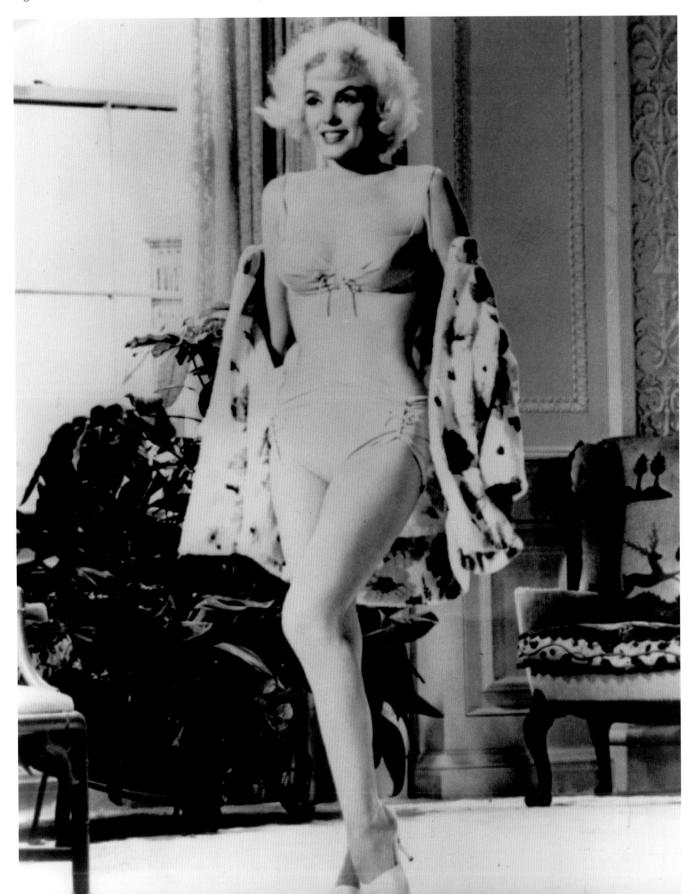

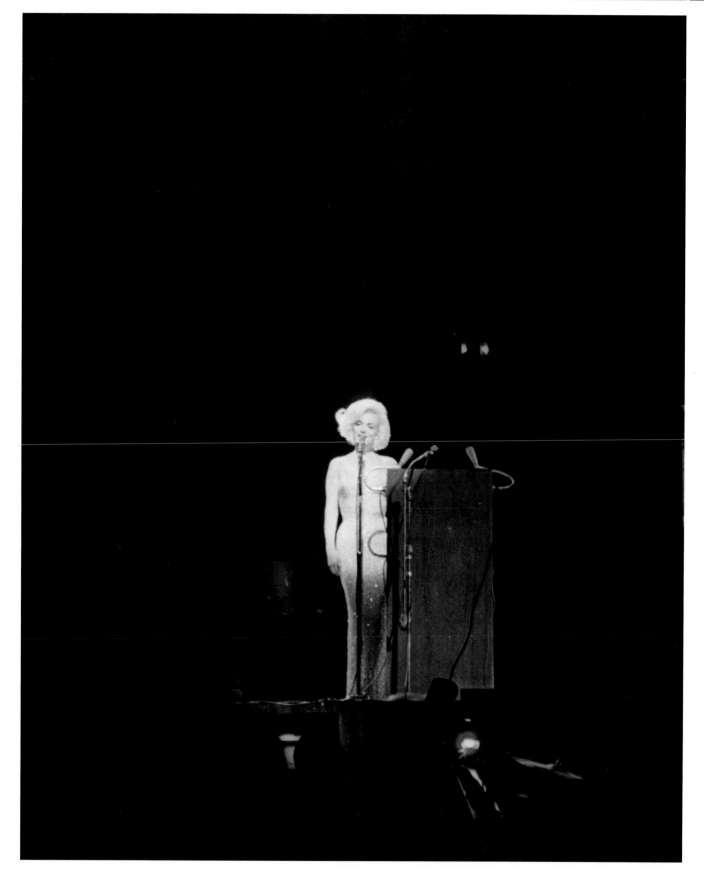

"Happy Birthday Mr President"

Marilyn took a previously authorized break during filming to fly to New York at Peter Lawson's (JFK's brother-in-law) request to sing for the President at a special birthday celebration in Madison Square Garden. Although she had been ill and hadn't worked for a year and should have been on set, Marilyn still went ahead with the engagement. She was escorted by her former father-inlaw, Isidore Miller. But back at Fox they were furious with Marilyn, if she was too ill to shoot the movie, she was certainly too ill to perform for the president, on her return to Hollywood she was fired from her last movie.

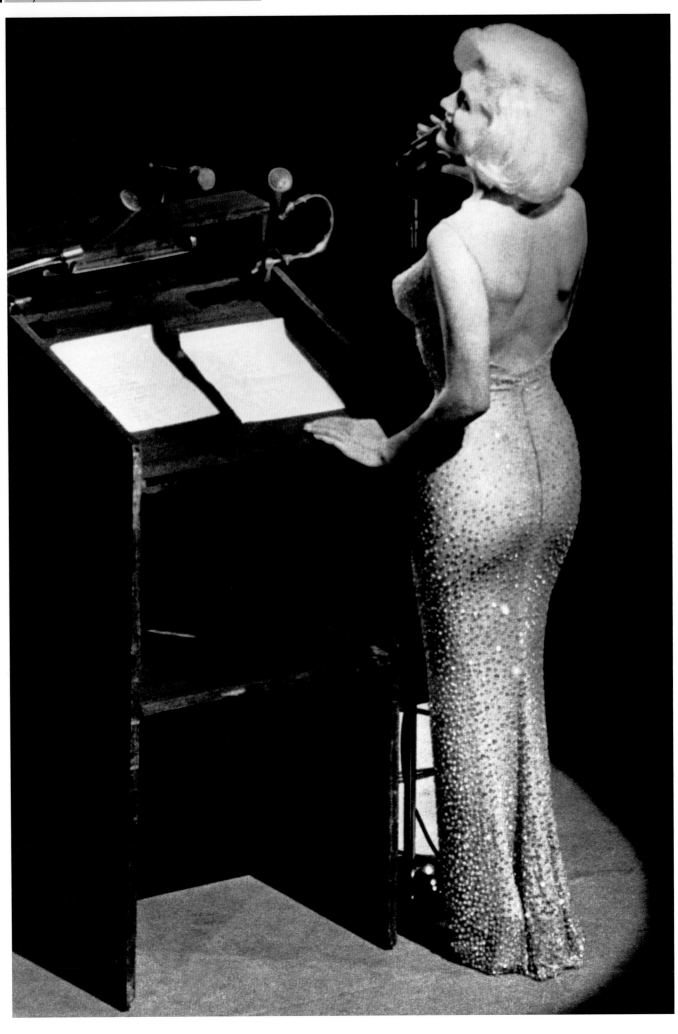

Dressed to thrill

For his forty-fifth birthday fundraising gala, President Jack Kennedy and 15,000 supporters—but not his wife Jackie—heard Marilyn give a breathily sultry rendition of *Happy Birthday*. Marilyn wore a figure hugging flesh-colored gauze dress designed by Jean Louis that was covered with 2,500 rhinestones and that left little to the imagination. The dress was so tight that she wore no underwear and had to be sewn into it.

"A wise girl knows her limits, a smart girl knows she has none."

MARILYN

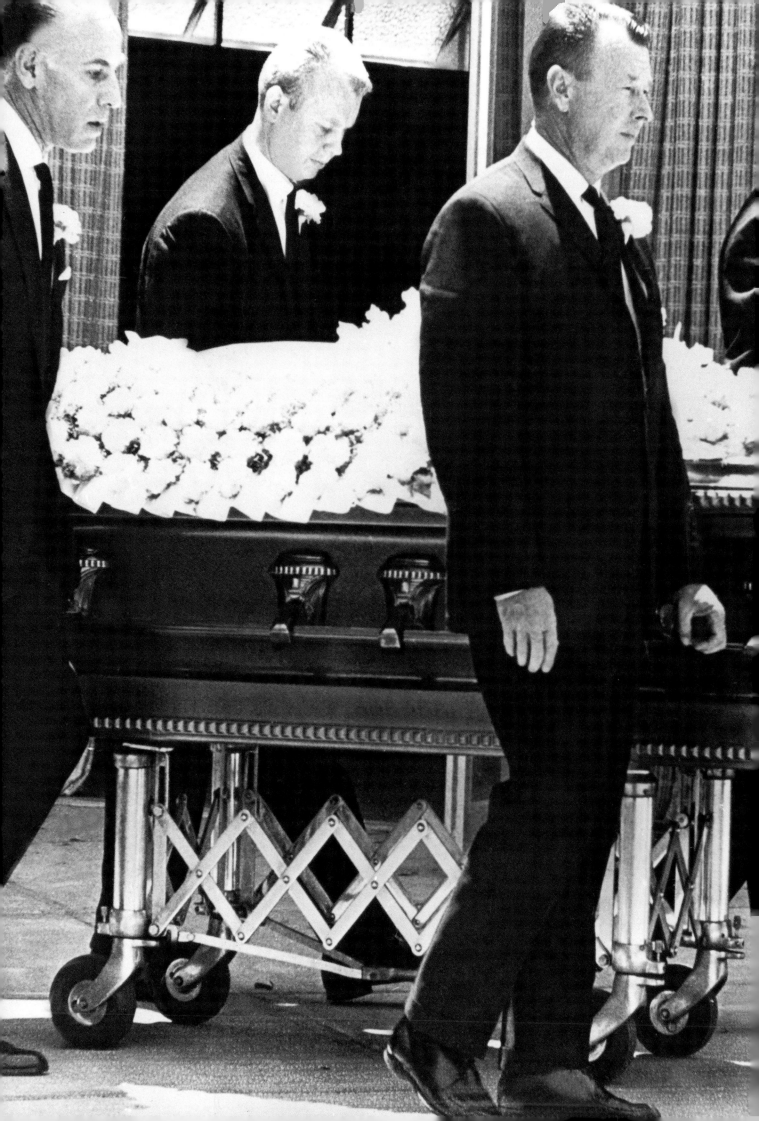

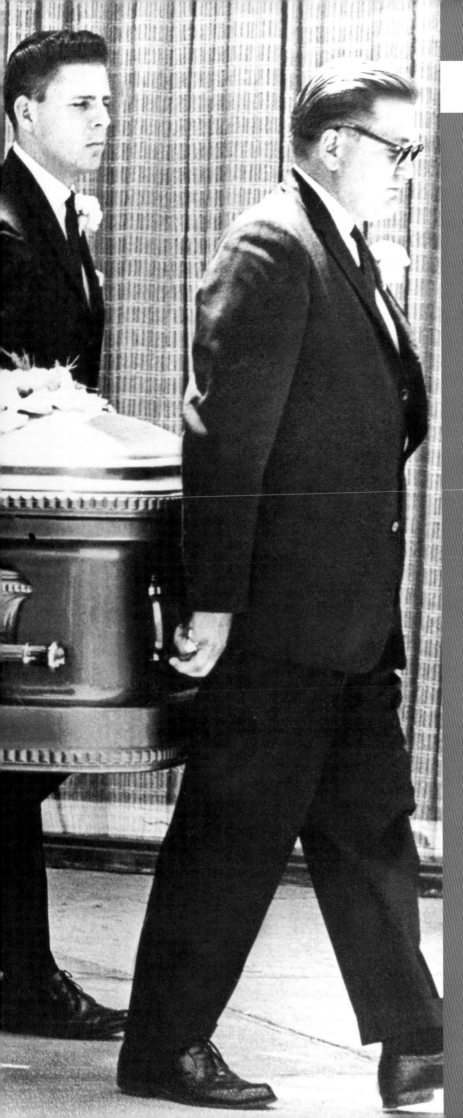

The Legend

Like a handful of other great stars of the twentieth century, since her death Marilyn has transcended mere celebrity and become a legend. The events around her passing are shrouded in a mystery that has given rise to numerous conspiracy theories and seen hundreds of books on the subject published. Meanwhile, Marilyn's story, her glamor, her incandescent beauty, and her vulnerabilities have captured the hearts of millions of new fans. She still attracts the same fascination that she did in life and has inspired songs including Elton John's "Candle in the Wind" as well as endless new books, documentaries of her life, and movies including *My Week with Marilyn*, which was based around the fraught shoot for The *Prince and the Showgirl*. Actress Michelle Williams gave an excellent performance as Marilyn and was awarded a Golden Globe for Best Actress in a Musical or Comedy. Marilyn would have been pleased—it was the only major American award she ever won.

"I never wanted to be Marilyn—it just happened. Marilyn's like a veil I wear over Norma Jeane."

MARILYN

LEFT: The pallbearers were four members of the funeral company. Sidney Guilaroff (extreme left) and Allan "Whitey" Snyder (third from left).

Timeline After 1962

1962

August 8 Marilyn's funeral takes place at 13:00 at Westwood Medical Park Cemetery. Lee Strasberg delivers the eulogy.

August 17 *Life* magazine's cover story is "Memories of Marilyn."

August 28 Marilyn's death certificate is signed.

Shortly after her death, Andy Warhol starts work on silkscreens of Marilyn based on a 1953 publicity still from *Niagara*. These and other works are hugely valuable today: on November 2, 2012, one of Warhol's *Marilyn* prints sold for $1,650,500.

1963

April 18 Fox releases *Marilyn*, a compilation of clips from Marilyn films starting in the early days (*A Ticket to Tomahawk*) through her unfinished *Something's Got To Give*.

1973

July 16 *Time* magazine's cover story is "Monroe meets Mailer." His book *Marilyn: A Biography*, sells well. His thesis, that Monroe was killed by government agents, has been the stuff of conspiracy theories ever since.

1980

November 23 Dr Marianne Kris dies and bequeathes her share of Marilyn's estate to the Hampstead Child-Therapy Clinic of London, now known as the Anna Freud Center for the Psychoanalytic Study and Treatment of Children.

1982

February 17 Lee Strasberg dies. His share of Marilyn's estate will end up in 2010 with a commercial enterprise, the Estate of Marilyn Monroe LLC.

1984

March 11 Marilyn's mother, Gladys, dies.

1999

March 8 Joe DiMaggio dies.

June 16 The American Film Institute votes Marilyn the sixth-greatest female star of all time.

October 27–28 The dress in which she sang "Happy Birthday" to JFK sells for over $1 million at Christie's.

2000

Some Like It Hot is voted the greatest American comedy of all time by the American Film Institute.

2005

February 10 Arthur Miller dies.

August 15 James Dougherty dies.

2011

Forbes magazine rates Marilyn as the third highest moneymaker in its list of top-earning dead celebrities with an annual income of $27 million.

October 9 *My Week With Marilyn* premieres at the New York Film Festival. It tells the story of Colin Clark's involvement with Marilyn during the shooting of *The Prince and the Showgirl*.

OPPOSITE: Marilyn's final resting place.

LEFT: Marilyn Monroe's famous "Happy Birthday Mr. President" dress at the Christie's Auction House in Beverly Hills, CA, as part of a preview of the auction in New York, October 27–28, 1999. On sale as well as the rhinestone-encrusted dress were photographs, earrings, cowboy boots, and two Golden Globe awards.

FINAL

DAILY ⬚ NEWS
NEW YORK'S PICTURE NEWSPAPER ®

5¢

Vol. 44. No. 36 Cbpr. 1962 News Syndicate Co. Inc. New York 17, N.Y., Monday, August 6, 1962★ WEATHER: Fair.

MARILYN DEAD

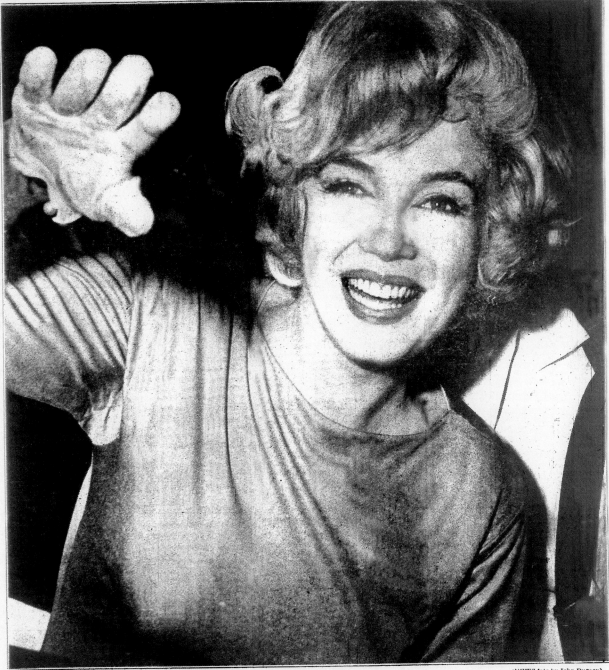

(NEWS foto by John Duprey)

Marilyn Monroe: "I was never used to being happy."

THE MONROE SAGA: 7 PAGES OF STORIES AND PICTURES

Death

Marilyn died of an overdose of chloral hydrate pills (a sedative and sleep aid) and Nembutal (a proprietary barbiturate used as a sedative and anesthetic), drugs she was prescribed for her chronic insomnia. She had seen her psychiatrist Dr Ralph Greenson that day and in the evening talked to numerous people on the phone in her bedroom. Her live-in psychiatric nurse saw the light on in her room at 9.30pm, but did not disturb her. However, by midnight she was worried enough to call Dr Greenson, he came round immediately and broke down Marilyn's door. Too late, she was naked and dead, still holding the phone.

> *"We should all start to live before we get too old. Fear is stupid. So are regrets."*
>
> *MARILYN*

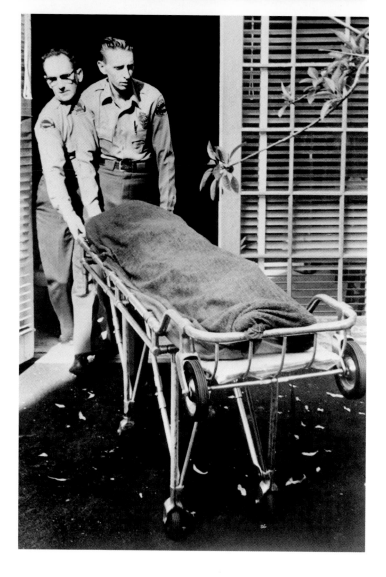

LEFT: The Press had a field day after Marilyn's death was made public. The *Daily News* followed the front page with seven pages inside.

ABOVE: An aerial view of the house in Brentwood, California, where Marilyn died, taken in 2002 on the 40th anniversary of her death.

RIGHT: Police take away the body.

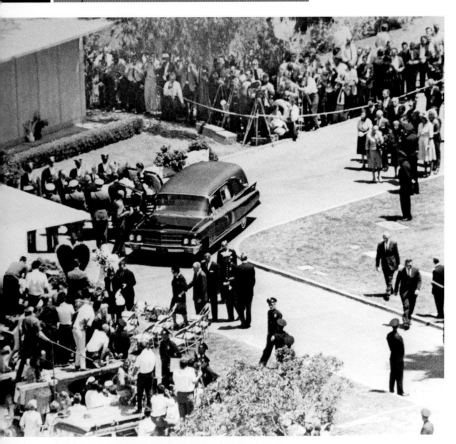

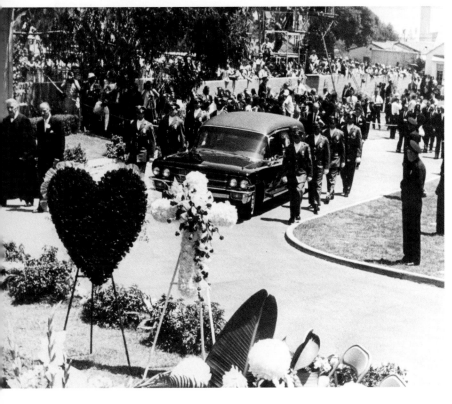

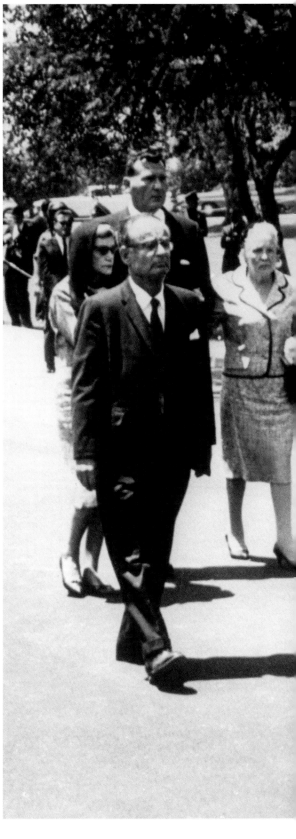

"Hollywood is a place where they'll pay you a thousand dollars for a kiss, and fifty cents for your soul."

MARILYN

ABOVE LEFT AND LEFT: The hearse passed hundreds of onlookers and press before the casket was removed.

ABOVE: Part of the funeral procession. From back left to front: May Reis, Ralph Roberts, Agnes Flanagan; G. Solotaire; Joe DiMaggio and his son Joe Jr; Pat and Inez Melson; Rev. F. Darling and Berneice Miracle.

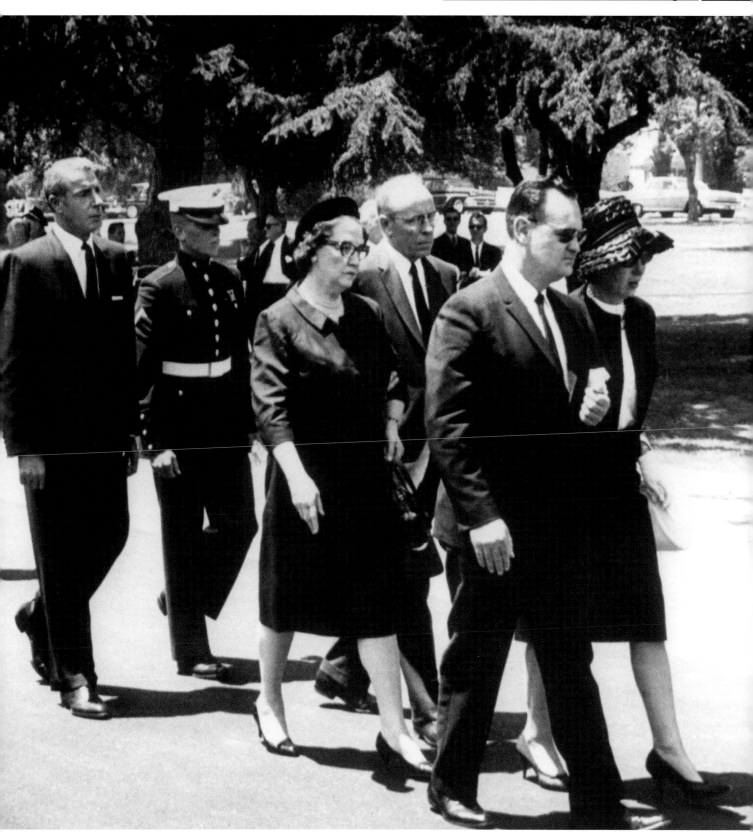

Funeral

Marilyn's funeral was organized by Joe DiMaggio with help from Marilyn's half sister Berniece Miracle. It took place at 1pm at the Westwood Village Mortuary Chapel in the grounds of Westwood Memorial Cemetery, on August 8, 1962. Only a select few family and friends were invited—DiMaggio specifically excluded her Hollywood "friends." She lay in a part open, champagne-satin covered bronze casket and wore her green Pucci dress accessorized with a green chiffon scarf. Her face was made up by her faithful makeup artist, Allan "Whitey" Snyder, he was also one of her pallbearers (see page 241). The music played was Tchaikovsky's Sixth Symphony and Judy Garland's "Over the Rainbow."

The Legend

Marilyn rests in the Corridor of Memories at Westwood Memorial Park, where Grace Goddard and Ana Lower also lie. Joe DiMaggio sent roses twice a week for twenty years. Since her death Marilyn has not been forgotten: the legend of her life, her beauty, and her work lives on. In books, artwork, and her movies there are few images as iconic as Marilyn's. Collectors spend huge amounts to acquire her possessions; conspiracy theories about the end of her life abound thanks to her connections with the Kennedys. It's hardly surprising. She was, without doubt, the quintessential western sex symbol and she still weaves a sensual spell over all who see her.

"I knew I belonged to the public and to the world, not because I was talented or even beautiful, but because I never belonged to anything or anyone else."

MARILYN

ABOVE: Marilyn's crypt.

RIGHT: Berniece Baker Miracle, Marilyn's half-sister, seen with her daughter, Mona Rae. Together they wrote a powerful book *My Sister Marilyn: A Memoir of Marilyn Monroe.*

LEFT ABOVE: U.S. Postmaster General Marvin Runyon and Anna Strasberg unveil the postage stamp commemorating Marilyn.

LEFT: Marilyn has spawned innumerable imitators. Here, look-alikes compete to be selected to model for the new wax portrait at Madam Tussauds.

That Dress

Anna Strasberg inherited the bulk of Marilyn's estate and in late October 1999 instructed the auction house Christie's to sell most of the items. "The Sale of the Century" offered everything from scripts, to cosmetics, and household objects as well as furs, shoes, and clothes. The highlight was Marilyn's champagne colored sheath dress that she wore to serenade President Kennedy only three months before her death. The sale realized $13 million, with the dress alone selling for $1.26 million. However, this was eclipsed when her famous white subway dress from *The Seven Year Itch* was sent to auction by fellow actress Debbie Reynolds, and fetched a staggering $4.6 million.

RIGHT: Hollywood hasn't forgotten Marilyn's pulling power. Here Hollywood Museum President and Founder Donelle Dadigan—along with Marilyn impersonator Gailyn Addis, and Los Angeles City Council member Tom LaBonge—pose at the opening of "Marilyn Monroe: The Ultimate Hollywood Icon" in 2004.

BELOW: On October 28, 1999, the Daily News headline reported: "IT'S MINE!," as collector Bob Schagrin, paid $1.1 million for That Dress.

OPPOSITE: Black and white contact sheets of Marilyn in her final movie *Something's Got To Give* are displayed during a preview of the 2005 sale.

RIGHT: Sculptor Dominico Neri unveils his Marilyn Monroe statue at the Hollywood Walk of Fame on October 26, 2006.

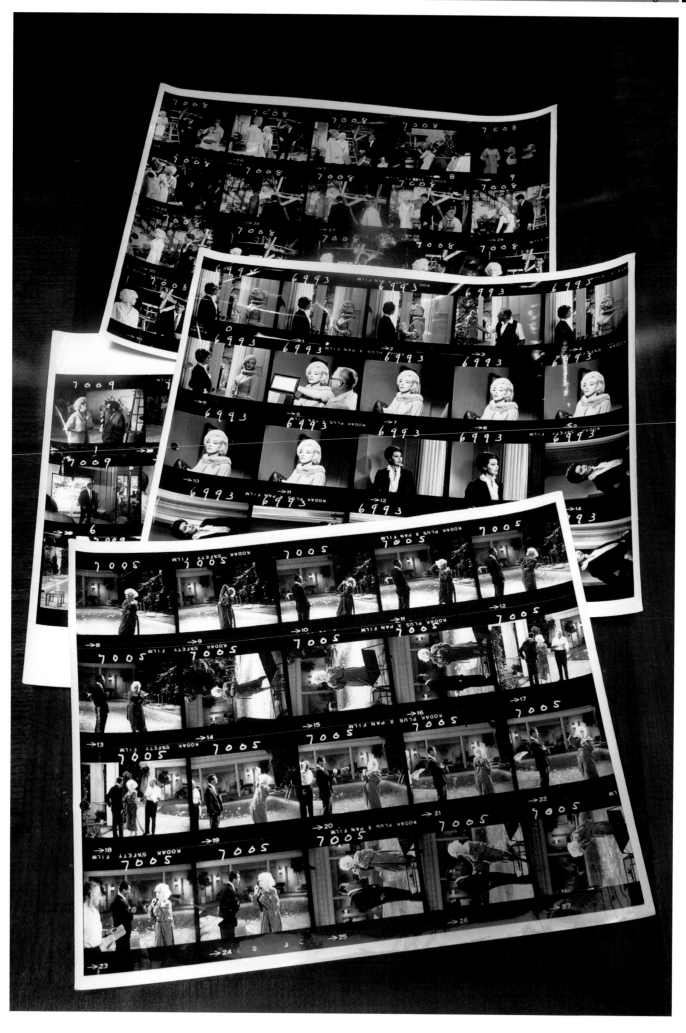

Photo Credits

BELOW: Andy Warhol's Marilyn prints have proved ever popular all over the world—here at the Power Station of Art in Shanghai, in spring 2013.

Index

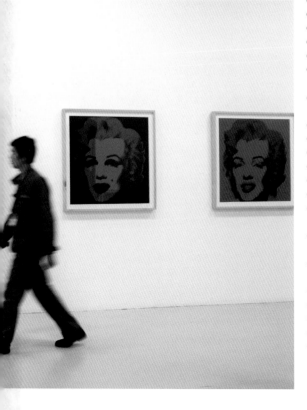